THE AGE OF AMERICAN IMPRESSIONISM

The Age of American

Masterpieces from the
Art Institute of Chicago

Impressionism

EDITED BY JUDITH A. BARTER

WITH CONTRIBUTIONS BY JUDITH A. BARTER, SARAH E. KELLY,
DENISE MAHONEY, AND ELLEN E. ROBERTS

THE ART INSTITUTE OF CHICAGO
YALE UNIVERSITY PRESS NEW HAVEN AND LONDON

CONTENTS

PREFACE AND ACKNOWLEDGMENTS

THE ART INSTITUTE OF CHICAGO has long been known for its extraordinary collection of French Impressionist painting, which was formed during the first decades of the twentieth century. Far less known is the breadth of its American Impressionist holdings. The museum's collection is rich, beginning with major works by Americans living in Europe, such as James McNeill Whistler and John Singer Sargent, and the only American who was officially part of the French group, Mary Cassatt. Dozens of young American artists followed them, studied in France, Holland, and Germany, and returned home and changed the ideas of Impressionism into different visual interpretations of native subjects. The heyday of American Impressionism began in the 1880s and lasted well into the 1920s, undergoing permutations and enjoying a longevity not found in its European counterpart.

American Impressionism was popular in Chicago and was shown regularly at the annual exhibitions organized by the American collector and art agent Sara Tyson Hallowell. She promoted new work by Americans during the 1880s at the Inter-State Industrial Expositions and introduced Chicago collectors Potter and Bertha Honoré Palmer to Impressionism. Their first painting purchases included light-filled paintings by American George Hitchcock. Hallowell tirelessly promoted American Impressionist works at the 1893 World's Columbian Exposition, and some of the pictures shown there came to the newly built Art Institute after the close of the fair. Throughout the following century, curators in the museum's American department have added important pictures to this early start.

The Age of American Impressionism came into being in order to share the Art Institute of Chicago's collection of American Impressionist pictures with a wider public. Although the museum's holdings have depth in this area, many paintings have not been on view because of a lack of gallery space. Numerous others included in this volume are being published for the first time. In reviewing the collection, we found that many works had not been conserved in years, and this catalogue provided a wonderful opportunity to study the technical aspects of American Impressionist paintings and drawings and to make many of these works vibrant once more. Our research and this publication were supported by the generosity of Samuel Mencoff, collector, trustee, and member of the Committee on American Art. I also thank James Cuno, the Art Institute's former director, for his encouragement of this project.

For the extraordinary care given to these paintings and drawings, the curatorial team thanks Faye Wrubel, Painting Conservator, and her colleagues Frank Zuccari, Allison Langley, and Kelly Keegan, and Paper Conservator Harriet Stratis. New photography was required after conservation, and the Imaging Department personnel— Christopher Gallagher, Bob Hashimoto, Robert Lifson, Caroline Nutley, and Amy Zavaleta—provided high-quality images. Our research was made painless by the extraordinary support provided by Jack Perry Brown, Susan Augustine, Melanie Emerson, and Bart Ryckbosch of the Ryerson and Burnham Libraries. In the Department of Prints and Drawings Martha Tedeschi and Emily Ziemba provided curatorial expertise for works of art on paper. The Publications Department, headed by Robert V. Sharp, produced a beautiful volume designed by Joan Sommers, and we thank Sarah Guernsey and Joseph Mohan, as well as Cynthia Newman Edwards, for their technical and editorial expertise.

Finally, I thank the hardworking and productive staff of the Department of American Art: Sarah E. Kelly, Henry and Gilda Buchbinder Associate Curator of American Art; Ellen E. Roberts, Associate Curator of American Art; Denise Mahoney, Collection Manager and Research Assistant; our two interns, Samantha Alfrey and Emily Finlay; and our preparators, Christopher Shepherd and Abraham Ritchie. All research and writing projects involve teams of people, and I am grateful to all those, both within the Art Institute and without, who so willingly shared their expertise and goodwill.

Judith A. Barter
FIELD-MCCORMICK CHAIR AND CURATOR OF AMERICAN ART

JUDITH A. BARTER

INTRODUCTION

"Art for Truth's Sake": American Painters and the Age of Impressionism

"IT IS THE DIFFERENCES that interest us; the similarities do not please, do not forever stimulate and feed as do the differences," wrote Hamlin Garland in his essay "Local Color in Art." The Chicago realist author wrote about American art and literature in a series of essays entitled *Crumbling Idols*, published in 1894. This essay, based upon Garland's encounter with the open-air paintings on view at the World's Columbian Exposition the previous year, was the first major American discussion of the practice of Impressionist painting by artists in this country. At the World's Fair in Chicago Garland saw the works of William Merritt Chase, Childe Hassam, Theodore Robinson, John Singer Sargent, John Twachtman, and many others just as the Impressionist movement was reaching its zenith in the United States. Like those of his French hero Émile Zola and his Boston mentor William Dean Howells, Garland's stories and novels celebrated the content of the world immediately surrounding him, and he believed that the modern American picture should do likewise, focusing unsentimentally on the contemporary world. Modern American subjects abounded, he believed, for they were not reliant on the castles, brigands, monks, or dungeons of the past.

Garland argued that in depicting modern life a picture should be a unified vision, capturing the instantaneous effect of the world upon the eye and truthful to the specific nature of its subject, eschewing idealism, symbolism, or moral judgment. Color used to define light and shade, atmosphere—the momentary effect—served to "catch impressions of delight" and to emulate the retina's perception of planar masses.[1] What Garland celebrated in American Impressionist art was similar to what he espoused in modern literature: truthful specificity. In describing the specific, the local, a picture's appeal becomes universal:

> As I write this, I have just come in from a bee-hunt over Wisconsin hills, amid splendors which would make Monet seem low-keyed. . . . Amid bright orange foliage, the trunks of beeches glowed with steel-blue shadows on their eastern side. Sumach flamed with marvelous brilliancy among deep cool green grasses and low plants untouched by frost. Everywhere amid the red and orange and crimson were lilac and steel-blue shadows, giving depth and vigor and a buoyancy which Corot never saw (or never painted).[2]

The truth of the local, Garland wrote, allowed Claude Monet to paint a haystack in twenty different lights and Frederick Remington to paint the cobalt skies and hot yellow sands of the American West. American Impressionists indeed created what the poet, and Garland's friend, Stanley Markham described in 1892 as an "art for truth's sake"—paintings devoid of all but the concreteness of paint upon canvas, representing the optical veracity and specificity of the moment.[3]

1 Hamlin Garland, "Impressionism," in *Crumbling Idols: Twelve Essays on Art Dealing Chiefly with Literature, Painting, and the Drama*, John Harvard Library (1894; repr., Belknap Press of Harvard University Press, 1960), pp. 97–98.

2 Ibid., p. 103.

3 Jess Sidney Goldstein, "Two Literary Radicals: Garland and Markham in Chicago, 1893," *American Literature* 17, no. 2 (May 1945), p. 157.

For all his emphasis on locality, Garland was not provincial; he was as familiar with French Impressionism as his literary contemporaries on the eastern seaboard. While the original group of French Impressionists exhibited together for only a short period—1874 to 1886—their influence was discussed critically in the American press as early as May 1876, when Henry James reviewed the French Impressionist exhibition at the Durand-Ruel gallery in Paris for the *New York Tribune*. Referring to the Impressionists as the "Irreconcilables" he found their works "decidedly interesting," even if he understood them to be foes of academic ideals of the "beautiful":

> The beautiful, to them, is what the supernatural is to the Positivists—a metaphysical notion, which can only get one into muddle and is to be severely let alone. Let it alone, they say, and it will come at its own pleasure; the painter's proper field is simply the actual, and to give a vivid impression of how a thing happens to look at a particular moment, is the essence of his mission.[4]

Perhaps James was drawn to the Impressionist pictures because of his affinity for the work of Winslow Homer. Reviewing the National Academy of Design exhibition in New York in 1875, James had written that "Homer's little barefoot urchins and little girls in calico sunbonnets, straddling beneath a cloudless sky upon the national rail fence. . . . imply no explanatory sonnet; the artist turns his back squarely and frankly upon literature."[5] James preferred Homer's light-filled modernity and rejection of narrative to the overwrought, historically themed works contained within the same exhibition. Homer, seen today as a precursor to Impressionism, occupied his canvases with contemporary and local subjects; the result is a rural naturalism bathed in light and exhibiting the optical effects of dashes of pure color (see pl. 1).

James, who was sympathetic to the Impressionists' antiacademic stance, might well have visited, from 1878 on, the exhibitions of the younger, more radical painters of the Society of American Artists in New York, where he could have seen the work of John Singer Sargent, whom he did not meet in Paris until six years later. Born of American parents in Florence, Sargent was a cosmopolitan, and although he showed his work in New York, by 1884 he had been living in Paris for a decade. During the 1880s, Sargent made informal portraits of some of his artist friends, including Monet, Auguste Rodin, Paul Helleu, and American Dennis Miller Bunker, and he certainly had knowledge of the work of Edgar Degas and fellow expatriate James McNeill Whistler. Whistler and Sargent both visited Venice in 1879–80 and 1880–82, respectively, and some of their views of quotidian activities along the canals are remarkably similar; they eschewed the well-known monuments and architecture in favor of more ordinary and intimate subjects.

Sargent's early Parisian picture *Rehearsal of the Pasdeloup Orchestra at the Cirque d'Hiver*, 1876/78 (pl. 31), exhibits modernity of subject and the oblique angles, flattened picture plane, and bravura brushwork characteristic of the new painting. For this reason, many French critics questioned whether Sargent could be considered an American painter, as did James himself, saying "that in the line of his art he might easily be mistaken for a Frenchman," while an English critic condemned him as part of the French "dab-and-spot" group.[6]

The only American who became an official member of the French Impressionist circle was Philadelphian Mary Cassatt, who was invited to show with the group in 1879. Like Sargent, she was influenced by Degas and during the late 1870s and 1880s favored informal interior scenes of women drinking tea or reading or views of women at the opera. Since she lived almost exclusively in Paris, Cassatt's early work was seen more in France than in her homeland, although she became an important adviser to American collectors and promoted the works of Monet, Degas, and Camille Pissarro to her New York and Philadelphia friends.

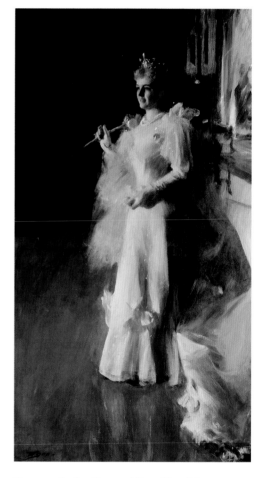

Figure 1. Anders Leonard Zorn (Swedish, 1860–1920). *Mrs. Potter Palmer*, 1893. Oil on canvas; 258 x 141.2 cm (101 ⅝ x 55 ⅝ in.). The Art Institute of Chicago, Potter Palmer Collection, 1922.450.

4 Henry James, *Essays on Art and Drama*, ed. Peter Rawlings (Scholar Press, 1996), pp. 164-65 (originally published as "Parisian Festivity," *New York Tribune*, May 13, 1876, sect. 2, pp. 1-2).

5 Henry James, "On Some Pictures Lately Exhibited," in *Essays on Art and Drama* (note 4), p. 70 (originally published in *Galaxy* 20 [July 1875], pp. 89-97).

6 For both quotations: Simpson 1997, pp. 40-42.

It was not only American expatriates and travelers to France who were exposed to contemporary painting, French Impressionist pictures were also displayed in America. In 1878, Degas's *Rehearsal of the Ballet* (Metropolitan Museum of Art, New York), an experimental gouache and pastel over monotype, purchased by New Yorker Louisine Elder (later Havemeyer) on the advice of Mary Cassatt, was exhibited at the annual exhibition of the American Watercolor Society. Édouard Manet's *Execution of Maximilian* (Kunsthalle Mannheim) toured New York and Boston in 1879–80, and an extensive article on the French Impressionists appeared in *Lippincott's Magazine* in December 1879. Canvases by Monet, Pissarro, Alfred Sisley, and others were shown in Boston at the Foreign Exhibition Association in 1883, and the same year the new painting was exhibited in New York at the Pedestal Fund Art Loan exhibition, organized by William Merritt Chase. Invited by New York's American Art Association and collector James F. Sutton, the Parisian art dealer Paul Durand-Ruel organized an exhibition of 290 paintings and pastels by the Impressionists in New York in 1886. A shrewd arbiter of taste, Durand-Ruel opened a New York gallery in 1888.

In Chicago, also in 1888, the Thurber Gallery exhibited works by Monet, Pissarro, and Sisley, and the following year Potter and Bertha Honoré Palmer began collecting works by Impressionist artists (see fig 1). They had already purchased contemporary, light-filled, ethereal works by George Hitchcock, an American painting in Holland, in 1887 (see pl. 50) and in 1889 purchased Degas's *On the Stage* (fig. 2) from Durand-Ruel. Through their association with the Chicago art agent Sara Tyson Hallowell (who lived in Paris), the Palmers met Mary Cassatt. Mrs. Palmer later invited Cassatt to paint a mural entitled *Modern Woman* for the Woman's Building of the upcoming Chicago World's Fair. Another Chicago collector and Art Institute trustee, Martin Ryerson, purchased his first Monet in 1891 (by 1920 he owned seventeen), and in 1895 the Art Institute hosted the first solo exhibition of Monet's work to be held in a museum.

Hallowell (see fig. 3) also favored the new American Impressionists, the young contemporary American artists she met in France. She was influential in directing the art displays of the Inter-State Industrial Expositions held in Chicago in the 1880s. Between 1881 and 1884, J. Alden Weir, John Twachtman, and Dennis Miller Bunker showed landscapes, and William Merritt Chase exhibited his famous *Portrait of Miss Dora Wheeler,* 1883 (Cleveland Museum of Art). Much indebted to Whistler, Chase's painting had as its subject an American woman student at the Académie Julian. During the years 1885–89, Chase exhibited several of his New York park scenes at the annual expositions, while Bunker, Childe Hassam, and Fernand Lungren also participated. George Hitchcock's *Flower Girl in Holland* (pl. 50) was lent to the exposition by Mrs. Palmer in 1888, and that same year Twachtman exhibited ten landscapes. During 1889, Frank Benson, Henry Ward Ranger, and Irving Wiles showed works; four Twachtman landscapes and five Hassams were exhibited; and over sixty paintings by Chase were included in the show. For the 1890 Inter-State Exposition, Hallowell gathered together over five hundred works, including paintings by Degas, Monet, Pissarro, Sisley, Pierre-Auguste Renoir, and others. Clearly, both French and American Impressionist paintings were displayed in Chicago well before the 1893 World's Fair.[7] American painters had quickly absorbed the new style of painting, incorporating it into their works at home.

By the time Hamlin Garland attended the Chicago World's Fair, Impressionism was more than accepted in the United States, and the new painting had begun its American translation. American artists had gone abroad to study in large numbers during the 1870s. They studied in artist's ateliers and copied Old Masters at the Louvre, hoping to have their pictures exhibited at the Salon in Paris. But usually their forays into experimentalism were

Figure 2. Hilaire-Germain-Edgar Degas (French, 1834–1917). *On the Stage*, 1876–77. Pastel and essence over monotype on cream laid paper, laid down on board; 59.2 x 42.8 cm (23 5/16 x 16 7/8 in.). The Art Institute of Chicago, Potter Palmer Collection, 1922.423.

7 Kirsten M. Jensen, "The American Salon: The Art Gallery at the Chicago Interstate Industrial Exposition, 1873-1890" (Ph.D. diss., City University of New York, 2007). Includes a list of the works exhibited at the Inter-State Industrial Exposition, 1873-90.

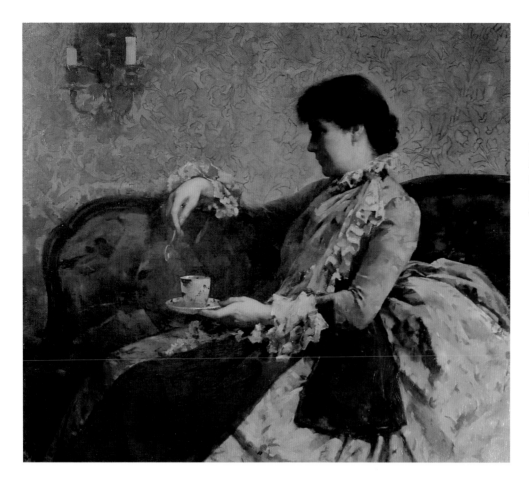

Figure 3. Mary Fairchild (American, 1858–1946). *Portrait of Mlle S. H. (Sara Tyson Hallowell)*, 1886. Oil on canvas; 97.5 x 112.1 cm (38 ¼ x 44 in.). University of Cambridge, The Warden and Fellows of Robinson College.

conservative—tepid knockoffs of Manet and Jean-Léon Gérôme. J. Alden Weir, later to embrace a brand of figural Impressionism, recoiled in horror and left the 1877 Impressionist exhibition.[8] Not until some of these students returned home in the late 1880s to the United States, and to the exhibitions that were then on view in New York, Boston, and Chicago, was Impressionism's impact felt. Those painters, according to one writer, "made use of Paris, instead of letting Paris make use of them."[9]

The first and foremost practitioner was William Merritt Chase, who, as H. Barbara Weinberg has pointed out, did not study in Paris but in Munich and was freer from academic constraints. After meeting John Singer Sargent and his teacher Carolus-Duran in Paris in 1881, Chase combined the dark, bravura brushwork and dramatic highlights of his German training with the informality of the new painting. Chase returned to New York and by 1885 was painting high-keyed, open-air scenes of New York parks (see pl. 76).

Some of the Americans studying in Paris removed themselves to Monet's village, Giverny, to study at the feet of the master. In the late 1880s and early 1890s, Willard Metcalf, Theodore Robinson, Theodore Wendel, and others produced landscapes in the new style, and all became important translators of modern French painting to American subjects and tastes. The area around Giverny lent itself to picturesque landscapes, such as those by Robinson (an admirer of Winslow Homer's rural subjects), who painted in France from 1887 to 1892, although he returned to New York each autumn to show his work at the Society of American Artists. His peasant girls picking apples or herding cows and his views of the village were shown in New York, Chicago, Boston, and Philadelphia. His paintings echo Pissarro's works in their careful composition (Robinson used a grid) and broad, brushy strokes that blur detail (see pl. 47).

8 See Weinberg, Bolger, and Curry 1994, pp. 18–19.

9 R. H. Davis, *About Paris* (New York, 1895), p. 219.

Willard Metcalf, who also studied in Paris, visited Giverny in 1885. He traveled to North Africa during the winter of 1886–87 and then returned to Giverny. His exposure to Monet's work and the hot colors and light-filled landscapes of North Africa may have awakened his interest in modern painting.[10] After his return to the United States in 1888, he concentrated on painting New England landscapes, particularly around Gloucester, Massachusetts (an area he was invited to visit by his friend Childe Hassam). By 1895, he was firmly committed to incorporating Impressionist techniques into his American scenes. In their rich color and loose brushwork Metcalf's landscapes (see pl. 67) are not dissimilar to the paintings of Childe Hassam.

Hassam chose to paint both the urban scene and rural landscapes. His Parisian subjects from 1887 onward are loose and sketchy, inhabited by well-drawn figures hardened by an almost blinding light. By 1890, his treatment of the landscape is one of high-keyed, full-blown Impressionism, as evidenced by the landscapes he painted on Appledore, one of the Isles of Shoals off the coast of New Hampshire (see pl. 57).

During the decade of the 1890s, unlike the French Impressionists, American painters often preferred to include large, well-drawn figures in the landscape. Chase, Hassam, Robinson, Edmund Tarbell, and Frank Benson all included figures that command rather than blend with the landscape—perhaps an indication of their difficulty in completely giving up academic ideals. Benson and Tarbell, who returned from Paris to share a studio in Boston, retained the genteel female figure within the landscape or interior (see pl. 63). Tarbell's *Three Sisters* (fig. 4), for example, was a sensation when exhibited in Boston in 1890, and Sarah Choate Sears, a collector of the work of Mary Cassatt and Edgar Degas and a tireless

10 Gerdts 1984, p. 102.

Figure 4. Edmund Charles Tarbell (American, 1862–1938). *Three Sisters—A Study in June Sunlight*, 1890. Oil on canvas; 89.2 x 101.9 cm (35 ⅛ x 40 ⅛ in.). Milwaukee Art Museum, gift of Mrs. Montgomery Sears, M1925.1.

promoter of American Impressionist artists, gave the picture to the Milwaukee Art Museum some years later. But for other American painters, as the decade progressed, pure landscape began to dominate, and the later landscapes of Chase and Hassam depend on the vocabulary of nature alone (see pl. 60).

The most prominent group of pure landscape painters was the Tonalists; these artists, as the name implies, were influenced by the subtle aesthetics of Japanese art and the paintings of James McNeill Whistler. John Twachtman, the most important member of the group, studied in Munich and at the Académie Julian in Paris. Twachtman returned to the United States during the winter of 1885–86 and by 1890 was permanently located in the area of Greenwich, Connecticut, where he painted one of his earliest Impressionist scenes, *Icebound* (pl. 58). In the pictures of the following decade, landscapes painted on his farm, Twachtman painted rapidly and in all seasons, but his strongest works are those depicting winter. The use of a minimal palette—white (snow), cool blues (frozen water), and spots of bright orange (representing vestiges of still-clinging leaves)—accentuates the abstract shapes and sense of design in these compositions. Twachtman's snow scenes show a debt to Monet's winter landscapes of the 1870s. The artist would have known Monet's work through his friendship with Theodore Robinson, who visited Twachtman upon his return from France in the late 1880s.

Finally, the spread of Impressionist ideas throughout the American art world was the result of artists' colonies and schools. William Merritt Chase, for example, one of the earliest American disseminators of Impressionism, taught from 1878 on at the Art Students' League in New York, as well as at the Pennsylvania Academy of the Fine Arts, and hundreds of students attended his summer *plein-air* (outdoor) painting school at Shinnecock on Long Island during the 1890s. Charles Courtney Curran studied in France during the years 1888–90 and made repeated trips back to Europe; he taught at the National Academy of Design, at the Pratt Institute in Brooklyn, and at the Cragsmoor art colony in New York's Catskill Mountains. Willard Metcalf taught at the Art Students' League and the Cooper Union in New York. John Twachtman, who studied with Chase at the Art Students' League, in turn established summer painting classes in Cos Cob, Connecticut, in 1890; in 1898 taught at the Art Students' League summer school; and, beginning in 1902, led summer classes in Gloucester, Massachusetts. Besides Gloucester, Shinnecock, and Cragsmoor, summer painting colonies flourished at East Hampton, Long Island, because of its proximity to New York City, and across the sound at Old Lyme, Connecticut, where guests often stayed at Florence Griswold's eponymous house, the American version of Giverny's Hôtel Baudy. The Old Lyme colony was originally founded by Henry Ward Ranger around 1899; just after the turn of the century Childe Hassam arrived, and soon other Impressionists were in residence. In other areas of the country, artists stayed closer to home: in Chicago a summer colony formed around the residence of sculptor Lorado Taft, Hamlin Garland's brother-in-law, in Oregon, Illinois. Other midwesterners, such as Adam Emery Albright and T. C. Steele, sought out Brown County, Indiana; in California artists flocked to Monterey or Laguna Beach. In Pennsylvania, the New Hope art colony flourished, frequented by Walter Schofield and Daniel Garber in the first decade of the new century.

Besides spreading the Impressionist method and modern subject matter, the summer colonies served to imbed American Impressionist practice with a therapeutic mentality. As Sarah Burns has pointed out, by the turn of the century Americans were both proud of being characterized as energetic, hard-working engines of technology and progress and at the same time sufferers from neurasthenia and physical exhaustion. Nervousness became a national trait.[11] Painting *en plein air* at the seaside, along rivers, and in the unspoiled countryside was a popular antidote, and one available to a leisured class. So, too, artists worked harder at seeking out the unspoiled landscapes in the midst of the industrial age. Author Sarah Orne Jewett bemoaned the demise of small, self-sufficient, New England

11 Burns 1996, p. 136.

fishing towns, and Hamlin Garland decried the impact of Chicago's sprawl and soot upon midwestern farm communities.[12] Garland wrote that the Impressionist was not only a local painter, dealing with subjects in the present and loving nature and not history, but that he also painted his subject as he saw it, not as others did.[13] Impressionism, an increasingly elastic term, became the perfect form for the late-nineteenth-century viewer. To appreciate such paintings, one did not need a literary education or knowledge of history but rather a capacity for enjoyment and revitalization. By the turn of the century, the shock of the new painting had passed, and American Impressionist pictures bathed the eyes with refreshing sunlight and color, presented charming rural and village scenes that fed American nationalism, and provided collectors with sensual and delectable surfaces in an age obsessed with appearance, pleasure, and leisure. With the 1913 Armory Show, Americans looked to Paris again but with different interests. Ironically, at that moment, Impressionism was subsumed by the modern mentality of constant change and fashionability that it had helped to create. The once new painting was now almost a half-century old, and artists turned their attention to what was more current. No longer the painting of the transient moment of light and color, Impressionism was replaced by a new reality, centered on the picture plane itself, and soon fell from favor.

12 See, for example, Sarah Orne Jewett, *Deephaven* (1877) and *The Country of the Pointed Firs* (1896); Hamlin Garland, *Main-Traveled Roads* (1891).

13 Garland (note 1), p. 104.

ELLEN E. ROBERTS

ONE

Winslow Homer: A Homemade Impressionist

IN HIS REVIEW of the 1879 Watercolor Society exhibition in New York, *New York Times* critic Charles DeKay wrote: "Impressionists are here from Rome and Munich, but there is one Impressionist who is entirely homemade, and to American soil, indigenous. This is Mr. Winslow Homer."[1] Yet today Winslow Homer is not usually considered an Impressionist. In fact, his realism is defined in opposition to the Impressionists' European-derived, lighter-hued style. This view of Homer's art conforms to the way he marketed himself, especially in his later career: as a vigorous, independent, native, and therefore truly American artist.[2] As early as the mid-1850s, at the very beginning of his career, Homer asserted his need to isolate himself, declaring to his friend and fellow artist Joseph Foxcroft Cole: "If a man wants to be an artist, he should never look at pictures."[3] Nevertheless, Homer was aware of developments in both the American and European art worlds, and he reacted to them throughout his career, even if unconsciously. Indeed, although he would never have admitted it, Homer shared the Impressionists' artistic interests, and his forwarding of the same aesthetic goals helped to prepare the American art world to appreciate the style as practiced on both sides of the Atlantic. As the Art Institute of Chicago's collection of Homer's paintings demonstrates, an examination of this artist's connections to Impressionism—rather than detracting from the appreciation of his work—leads to a greater understanding of and admiration for his pictures.

Born to middle-class parents in Boston in 1836, Homer began his artistic career by apprenticing with lithographer John H. Bufford for two years, beginning in 1855. He then went into business as a freelance illustrator, producing drawings to be engraved in the journals *Ballou's Pictorial* and *Harper's Weekly*. In 1859, he moved to New York not just to be closer to his publishers but also to continue his artistic education in the city that was the center of the American art world. While continuing to support himself through illustration, Homer enrolled in life-drawing classes at the National Academy of Design in 1859, 1860, and 1863. He also began to paint, studying with Frederick Rondel in 1861 and creating oil sketches in nature that summer.

In 1860, Homer's older brother Charles gave him a copy of French chemist and color theorist Michel-Eugène Chevreul's *De la loi du contraste simultané des coleurs et de l'assortiment des objets colorés,* which had been newly translated into English. In this text, Chevreul sought to help artists, as he described it, "to perceive and to imitate promptly and surely the modifications of light on the model."[4] His revolutionary insights into how the human eye actually sees color under real light and how an artist can juxtapose hues for maximum aesthetic effect

1 Charles DeKay, "The Water-Color Society: A Brilliant Show at the Twelfth Exhibition," *New York Times*, Feb. 1, 1879, p. 5.

2 Burns 1996, pp. 187–217.

3 Winslow Homer to Joseph Foxcroft Cole, 1850s; quoted in Goodrich 1944, p. 6.

4 Michel-Eugène Chevreul, *Chevreul on Colours: The Laws of Contrast of Colour and Their Application to the Arts*, trans. John Spanton (Routledge, Warnes, and Routledge, 1859), p. 88. On Homer and Chevreul, see Judith Walsh, "Winslow Homer and the Color Theories of Michel-Eugène Chevreul," in Tedeschi 2008, pp. 199–205.

had a profound influence on both Homer and the Impressionists. Inspired by Chevreul, these artists worked to portray the way color actually looks in light and atmosphere and to use it decoratively to intensify and bring harmony to their paintings. Somewhat paradoxically, while attempting to capture atmospheric effects realistically, Homer and the Impressionists also sought to make their works effective two-dimensional designs, simultaneously windows on the world and new objects in their own right. Homer continued to follow these objectives set out by Chevreul throughout his career; as late as 1903, when asked about Chevreul's book, he declared, "It is my Bible."[5]

When he first read Chevreul's text in 1860, Homer was already aware of modern French painting. The Barbizon School realism of such artists as Camille Corot and Jean-François Millet was greatly admired in his native Boston.[6] Perhaps because of this early exposure, Homer explored realism from the beginning of his career. When *Harper's Weekly* hired him as an artist-correspondent during the Civil War, he produced few conventionally heroic battle scenes, focusing instead on everyday camp life, as he did in his c. 1863 painting *Home, Sweet Home* (private collection). The lack of an organizing narrative allies these paintings with French realist works like Gustave Courbet's *Burial at Ornans* (1849–50; Musée d'Orsay, Paris). Impressionists such as Édouard Manet and Claude Monet would also adopt this realist approach.

After the war, Homer continued to portray everyday life but concentrated on views of bourgeois leisure that often feature women, as in his *Croquet Scene* of 1866 (pl. 1). Homer's subjects in these pictures are the active, independent, self-assured women who began to enter the public sphere in greater numbers after the Civil War. American poet Walt Whitman described these women in 1856, writing: "They know how to swim, row, wrestle, shoot, run, strike, / retreat, advance, resist, defend themselves, / They are ultimate in their own right— they are calm, clear, well possess'd of themselves."[7] These women's new, more public, leisure pursuits became a favorite subject for painters like Homer and the Impressionists, who sought to capture modern life in their art.

Croquet Scene is one of five paintings devoted to women playing this game that Homer created between 1865 and 1869.[8] Croquet was relatively new in the United States; it became popular among the American upper classes in the 1860s because it allowed women and men to compete on an equal footing. A writer for the periodical *The Nation* reported in 1866: "Of all the epidemics that have swept our land, the swiftest and most infectious is croquet."[9] In focusing on croquet, Homer consciously chose a theme that was up-to-date. As he had in his scenes of army life, he portrayed this modern subject in a modern way, making no attempt to tell a story. Like the Impressionists, he experimented with incorporating Chevreul's theories of art and vision into the painting, juxtaposing the red dress with the complementary green of the grass and trees.

The seriality of Homer's croquet pictures also allies them with contemporary French artistic practice. Painting in series allowed Homer both to work through compositional possibilities and to portray his subject in different ways. In his 1863 essay "The Painter of Modern Life," French poet and art critic Charles Baudelaire had defined modernity as "the ephemeral, the fugitive, the contingent" and later as a "transitory, fugitive element, whose metamorphoses are . . . rapid."[10] A modern painting, by extension, could only represent one moment in time. In order to capture modern life more fully, artists like Homer and later, famously, Monet, worked in series. Multiple views also allowed these artists to explore different light effects. Homer would continue to follow this Impressionist practice of working in series throughout his career.

5 John W. Beatty, "Recollections of an Intimate Friendship"; reprinted in Goodrich 1944, p. 223.

6 On the appreciation of Barbizon painting in Boston, see Erica E. Hirshler, "Impressionism in Boston," in Hirshler and Stevens 2005, pp. 17–22.

7 Walt Whitman, "A Woman Waits for Me," in *Leaves of Grass* (1855; repr., Signet Classic, 1980), p. 105.

8 See, for example, Homer's *Croquet Players*, 1865, oil on canvas, Albright-Knox Art Gallery, Buffalo, N.Y., and *A Game of Croquet*, 1866, oil on canvas, Yale University Art Gallery, New Haven, Conn.

9 "American Croquet," *Nation* 3 (Aug. 9, 1866), p. 113.

10 Charles Baudelaire, *The Painter of Modern Life and Other Essays*, ed. and trans. Jonathan Mayne (Phaidon, 1964), p. 13.

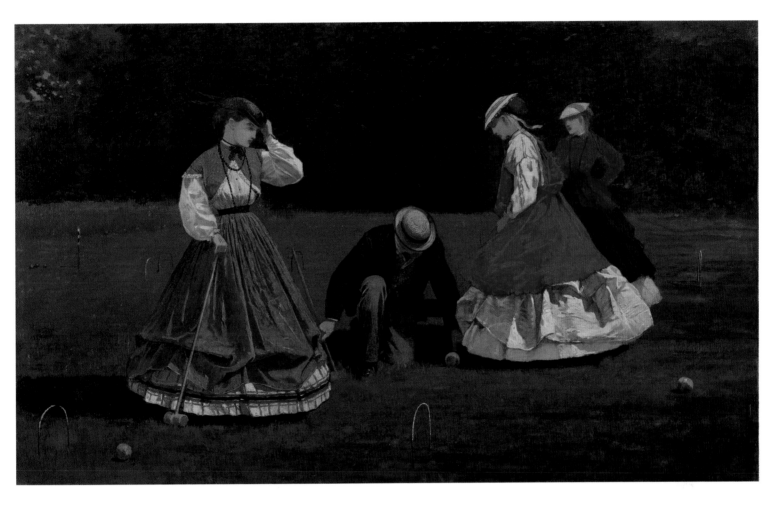

1

WINSLOW HOMER (1836–1910)

Croquet Scene

1866
Oil on canvas; 40.3 x 66.2 cm (15 7/8 x 26 1/16 in.)
Friends of American Art Collection; Goodman
Fund, 1942.35
Signed lower right: *Winslow Homer / -66-*

It is unclear whether Homer knew the work of Monet or other Impressionists when he painted *Croquet Scene* in 1866. He likely saw their paintings immediately afterward, however, during the year he spent working in France beginning in December 1866. Characteristically, Homer was reticent about his time abroad, and so little is known about what he did during his stay. He did report to a friend in August 1867: "I am working hard and have improved much, and when I come home can make money."[11] He had a studio in Montmartre and visited the Louvre and probably the 1867 Paris Salon. He showed two paintings at the 1867 Exposition Universelle and likely saw Monet's early Impressionist pictures when he visited the fairgrounds. He may also have seen the special exhibitions of realist art that Courbet and Manet erected outside the Exposition. Given the significant affinities that Homer's work already had with that of these modernists, it seems likely that he would have been drawn to their paintings when he was in France.

At the Exposition Universelle, Homer probably visited the installation of Japanese art as well, since it was one of the most discussed exhibits there. This display began the widespread French fascination with all things Japanese, or Japanism. Homer emulated Japanese models in his work only a decade later, after this trend became prevalent in the United States, but this interest also linked his work to that of the Impressionists.

In addition, while he was in France, Homer and his friend Joseph Foxcroft Cole visited the artists' colony of Cernay-la-Ville, where Homer painted pictures like *Haymakers* (fig. 5), emulating the warm palette, loose, atmospheric style, and celebration of rural peasant life found in Barbizon works. Cole helped to promote Barbizon painting in Boston and went on to publicize Impressionism there also, acting as a dealer and adviser.[12] He would certainly have encouraged Homer's interest in the Barbizon style, and he may have prompted his friend to experiment with Impressionism as well.

11 Winslow Homer to Charles Vorhees, Aug. 26, 1867, quoted in Goodrich 1944, p. 40. For Homer in France, see Adler, Hirshler, and Weinberg 2006, pp. 118, 245.

12 For Cole's role in promoting Impressionism in Boston, see Erica E. Hirshler, "Impressionism in Boston," in Hirshler and Stevens 2005, p. 23.

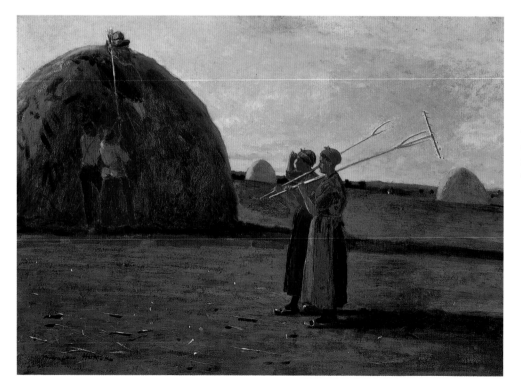

Figure 5. Winslow Homer (American, 1836–1910). *Haymakers*, 1867. Oil on canvas; 33.3 x 46.4 cm (13 ⅛ x 18 ¼ in.) Terra Foundation for American Art, Chicago, Daniel J. Terra Collection, 1989.9.

2

WINSLOW HOMER (1836–1910)

Mount Washington

1869
Oil on canvas; 41.3 x 61.8 cm (16¼ x 24⁵⁄₁₆ in.)
Gift of Mrs. Richard E. Danielson and Mrs.
Chauncey McCormick, 1951.313
Signed lower right: *Winslow Homer / -1869-*

Back in the United States, perhaps because of his experience of Impressionism in France, Homer returned to the subject that had occupied him before his trip—the leisure pursuits of modern bourgeois women. Like the Impressionists, whose work grew out of Barbizon Realism, Homer applied the atmospheric, painterly Barbizon style he had experimented with in France to scenes of everyday middle-class life. In *Mount Washington* (pl. 2), he depicted the popular activity of scenic touring, in which guides led women to designated spots with great views. Mount Washington, the highest peak in the White Mountains in New Hampshire, was a major tourist destination by this time. Homer painted its tamed wilderness throughout the summers of 1868 and 1869, again, as with his croquet scenes, depicting multiple views of the same subject.

In both the Art Institute's picture and another painting of this site, *Bridle Path, White Mountains* (1868; Sterling and Francine Clark Art Institute, Williamstown, Mass.), Homer gave the viewer no sense of his subject's background or story. Instead, he concentrated on depicting how the scene looked in realistic light and atmosphere, just as Impressionists such as Monet were doing at this time. Indeed, the visual connections between these late 1860s Homer paintings and Monet's contemporaneous works, like his 1867 *Women in a Garden* (fig. 6), are striking. Both Homer and Monet focused on bourgeois women at leisure, depicted in brilliant sunlight. Inspired by Chevreul, both combined attention to transient effects of light with a decorative use of brilliant color. Although the term *Impressionism* was not coined until 1874, critics in the late 1860s were already using the word *impression* to describe what Homer was trying to achieve in his art. The writer for the *New York World*, for example, concluded of Homer's *Bridle Path* that it "conveys the impression of objects seen through a hazy medium of some kind."[13] Just as the Impressionists did, Homer attempted to paint as we actually see: through a translucent rather than transparent atmosphere.

In the 1870s, Homer abandoned the theme of bourgeois leisure, focusing instead on typical country pursuits in paintings such as *Peach Blossoms* (pl. 3). Although these works depict contemporary individuals, they lack the obvious modernity of Homer's pictures of the late 1860s, since their subjects are engaged in activities that rural people had always pursued. While these works embody a nostalgia for America's preindustrial past that was antithetical to French Impressionism, in them Homer was still concerned with capturing transient atmospheric effects. In *Peach Blossoms*, he chose to paint a particularly complex moment, when a dark cloud covers most of the sky, transforming how the colors look.

In *Peach Blossoms* Homer also experimented with Japanism, another interest he shared with the French Impressionists. His peach sprigs are reminiscent of the cherry blossoms that frequently appear in traditional Japanese art. While Homer likely first saw Japanese objects at the Exposition Universelle in Paris in 1867, by 1878 he would have had numerous opportunities to view examples in his native country as well. In the United States, the Japanese government's display at the 1876 Philadelphia Centennial Exposition launched a craze for all things Japanese and would have made it virtually impossible for Homer to avoid exposure to Japanese objects. Homer was a savvy marketer of his own work, and his use of Japanesque motifs in late 1870s paintings such as *Peach Blossoms* can be seen as an effort to associate his paintings with this new artistic trend. At the same time, he was drawn to emulate Japanese art for the same reason as the French Impressionists: because Japanese works, with their simplified palettes and beautifully designed compositions, seemed to have the ideally decorative use of color advocated by Chevreul. Homer's Japanism enabled him to create paintings that contemporary critics appreciated for just these ornamental qualities. A writer in the *New York Evening Post* wrote of *Peach Blossoms*: "Its answering harmonies of color constitute one element of its artistic and decorative worth."[14]

Figure 6. Claude Monet (French, 1840–1926). *Women in a Garden*, 1867. Oil on canvas; 255 x 205 cm (100 x 81 in.). Musée d'Orsay, Paris.

13 "Art Items," *New York World*, Nov. 21, 1868, p. 11.

14 "Art Sales," *New York Evening Post*, Feb. 2, 1880, [p. 2].

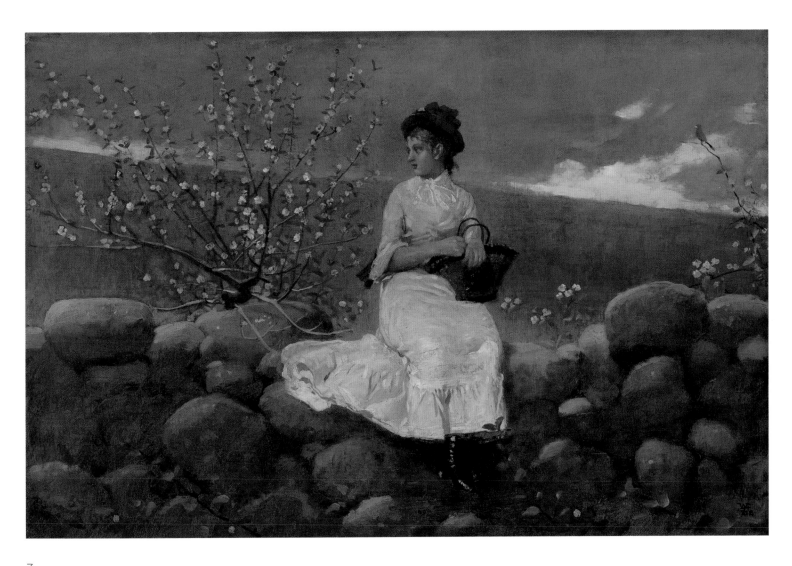

3

WINSLOW HOMER (1836–1910)

Peach Blossoms

1878
Oil on canvas; 33.7 x 49 cm (13¼ x 19⅝ in.)
Gift of George B. Harrington, 1946.338
Signed lower right, with monogram: *W H / 1878*

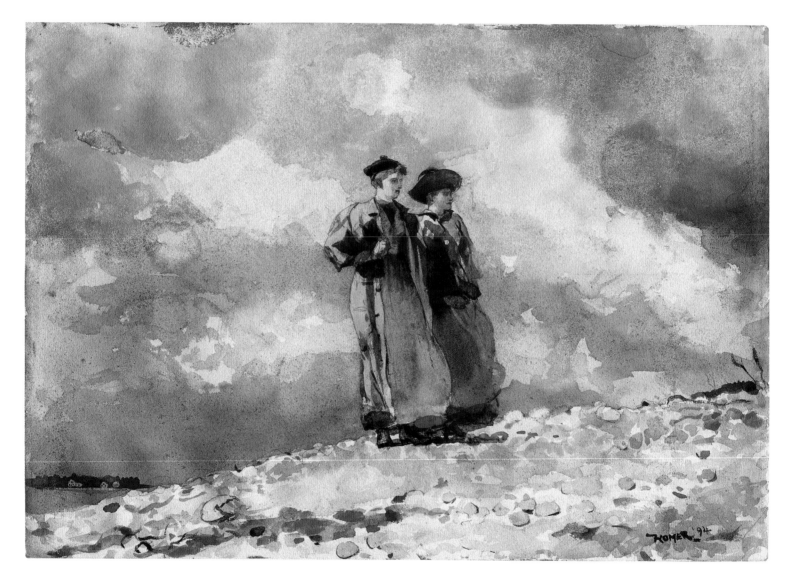

4

WINSLOW HOMER (1836–1910)

The Outlook, Maine Coast

1894
Transparent watercolor, with traces of opaque
watercolor, rewetting, blotting, spatter, and traces
of scraping, over graphite, on moderately thick,
slightly textured, ivory wove paper; 35.4 x 50.5
cm (13 $^{15}/_{16}$ x19 $^{7}/_{8}$ in.)
Mr. and Mrs. Martin A. Ryerson Collection,
1933.1246
Signed lower right: *Homer 94*

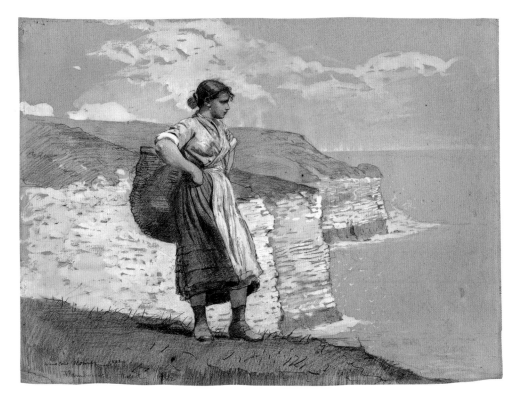

5

WINSLOW HOMER (1836–1910)

Flamborough Head, England

1882
Graphite and opaque white watercolor on
medium-thick, slightly textured, tan laid
paper with red and blue fibers; 45.2 x 60.9 cm
(17 $^{13}/_{16}$ x 24 in.)
Mr. and Mrs. Martin A. Ryerson Collection,
1933.1240
Signed lower left: *Winslow Homer 1882 /
Flamborough Head 1882*

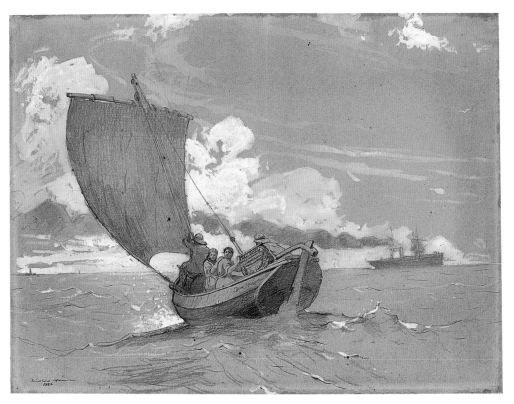

6

WINSLOW HOMER (1836–1910)

Fishing off Scarborough

1882
Graphite and opaque white watercolor, with
traces of black chalk, on medium-weight, slightly
textured, tan laid paper with blue and red fibers;
46.2 x 61.8 cm (18 $^{3}/_{16}$ x 24 $^{5}/_{16}$ in.)
Mr. and Mrs. Martin A. Ryerson Collection,
1933.1239
Signed lower left: *Winslow Homer / 1882*

In 1873, Homer began painting in watercolor, finding the medium helpful in his continuing quest to depict the ephemerality of light. Because of watercolor's transparency, the viewer can see each of Homer's brushstrokes in works such as *The Outlook, Maine Coast* of 1894 (pl. 4). As a result, these pictures appear to have been spontaneously rendered, adding to the sense that they suggest a fleeting moment. Homer used an incredible range of techniques in his watercolors to evoke specific atmospheric effects. In this case, he spattered watercolor across the sky to suggest the humid environment of the coastal location.[15]

Homer declared that his watercolors were "painted out-doors in the sunlight, in the immediate presence of Nature."[16] He frequently worked *en plein air* in order to capture how color and form look in sunlight and shade. In 1876, French poet and art critic Stéphane Mallarmé indicated the widespread impact of this idea in an article on Manet and the Impressionists, declaring: "The open air . . . influences all modern artistic thought."[17] Homer described his devotion to working *en plein air,* writing:

> I prefer every time a picture composed and painted out-doors. . . . Out-doors you have the sky overhead giving one light; then the reflected light from whatever reflects; then the direct light of the sun. . . . I can tell in a second if an outdoor picture with figures has been painted in a studio. When there is any sunlight in it the shadows are not sharp enough; and when it is an overcast sky, the shadows are too positive. . . . these faults [cannot be] avoided when such work is done indoors. . . . The very fact there are walls around the painter that shut out the sky shows this. I couldn't even copy in a studio a picture made out-doors; I shouldn't know where the colors came from, nor how to reproduce them.[18]

Homer may have presented himself as a *plein-air* painter in part so that he could market his work as modern.[19] However, following Chevreul, he also believed that painting *en plein air* was the most effective way to capture how the world actually looks.

Homer's ability to use paint to render realistic effects *en plein air* is especially apparent in his watercolors *Flamborough Head, England* and *Fishing off Scarborough*, both of 1882 (pls. 5 and 6). These works have a limited palette consisting of only dark graphite and black chalk, the medium-valued brown paper, and opaque white watercolor. In both pictures, Homer used opaque watercolor to portray the clouds in the sky, against which the foreground action—depicted using the negative space of the brown paper—takes place. His paint strokes suggest the ephemeral movement of the clouds.

Homer also used color decoratively in his watercolors. In *The Return, Tynemouth* of 1881 (pl. 7), for example, he employed touches of vermilion to portray highlights in the figures of the fishermen and the buoys, unifying the composition through color. This work was cut down from a larger work, but, because it was painted with light-fast pigments, it retains its original color scheme, unlike many of Homer's watercolors. As a result, the rosiness of the clouds and warm light of sunrise, when fishermen return from a night's work, are still apparent. Recent research has revealed that other Homer watercolors, including the 1887 *For to Be a Farmer's Boy* (pl. 8), would also have originally had pink skies and a redder cast, in this case to suggest sunset.[20] Most of Homer's red pigments were extremely fugitive and have since disappeared. Nevertheless, the orange and blue throughout both *For to Be a Farmer's Boy* and a related watercolor, *Among the Vegetables* (1887; private collection), illustrate how Homer used color to unify his compositions, creating overall harmony. Moreover, as he had learned from Chevreul, the juxtaposition of the complementary orange and blue serves to intensify their appearance, adding to the works' decorative impact.[21]

By 1880, critics were not only recognizing that Homer sought to capture atmospheric effects and use color decoratively, they were also defining his work as Impressionist. Mariana Griswold van Rensselaer, writing in *Lippincott's* in 1881 declared "Frank 'impressionism'

15 Kristi Dahm, "Spattering," in Tedeschi 2008, p. 130. For more on Homer's watercolor technique, see this catalogue.

16 Winslow Homer, quoted in George W. Sheldon, "American Painters—Winslow Homer and F. A. Bridgman," *Art Journal* 4 (Aug. 1878), p. 227.

17 Stéphane Mallarmé, "The Impressionists and Édouard Manet," 1876; reprinted in *The New Painting: Impressionism, 1874–1886*, exh. cat. (Fine Arts Museums of San Francisco, 1986), p. 32.

18 Winslow Homer, quoted in George W. Sheldon, *Hours with Art and Artists* (D. Appleton and Company, 1882), p. 138.

19 Nicolai Cikovsky, Jr., "Modern and National," in Cikovsky and Kelly 1995, p. 63.

20 Tedeschi 2008, p. 122.

21 For Homer's use of decorative color in these two watercolors, see Kristi Dahm, "Intention and Alteration: Winslow Homer's Watercolor Palette," in Tedeschi 2008, pp. 207, 213.

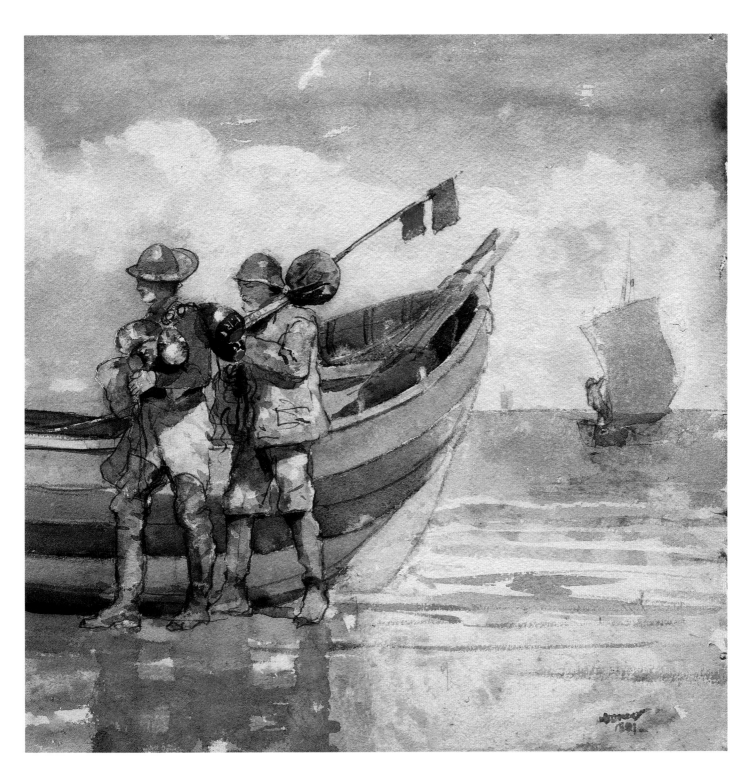

7

WINSLOW HOMER (1836–1910)

The Return, Tynemouth

1881
Transparent watercolor, with touches of opaque
watercolor, rewetting, blotting, and scraping,
heightened with gum glaze, over graphite, on
moderately thick, moderately textured, ivory
wove paper; 34.2 x 34.3 cm (13 1/2 x 13 1/2 in.)
Mr. and Mrs. Martin A. Ryerson Collection,
1933.1251R
Signed lower right: *Homer / 1881*

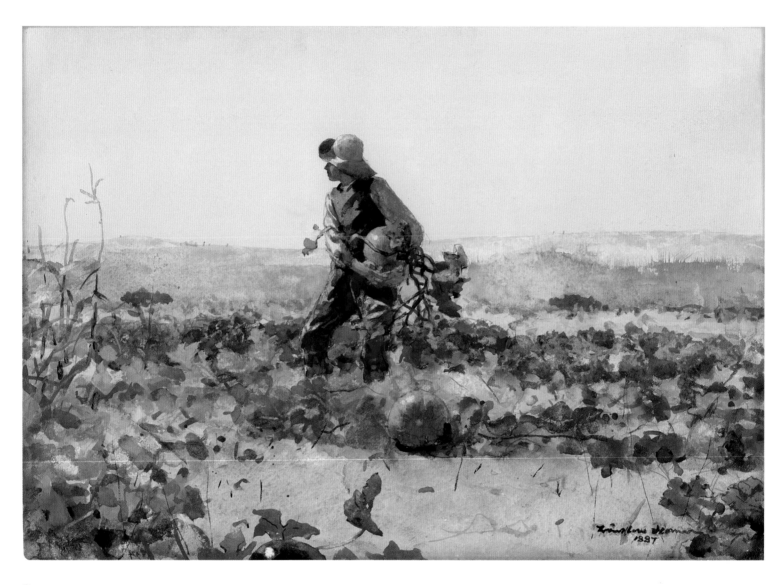

8

WINSLOW HOMER (1836–1910)

For to Be a Farmer's Boy

1887
Transparent and opaque watercolor, with
rewetting, blotting, and scraping, heightened
with gum glaze, over graphite, on thick, rough-
textured ivory wove paper; 35.5 x 50.9 cm (14 x
20 in.)
Gift of Mrs. George T. Langhorne in memory of
Edward Carson Waller, 1963.760
Signed lower right: *Winslow Homer / 1887*

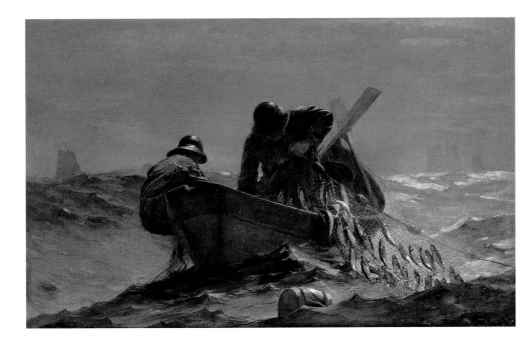

Figure 7. Winslow Homer (American, 1836–1910). *The Herring Net,* 1885. Oil on canvas; 76.5 x 122.9 cm (30 ⅛ x 48 ⅜ in.). The Art Institute of Chicago, Mr. and Mrs. Martin A. Ryerson Collection, 1937.1039.

Figure 8. Winslow Homer (American, 1836–1910). *Study for "The Herring Net",* 1884/85. Black, brown, and white chalk, and brush and opaque white watercolor, on green laid paper; 42.3 x 52.3 cm (16 ⅝ x 20 ⁹/₁₆ in.). Cooper-Hewitt National Design Museum, Smithsonian Institution, New York, Gift of Charles W. Gould, 1916-15-2.

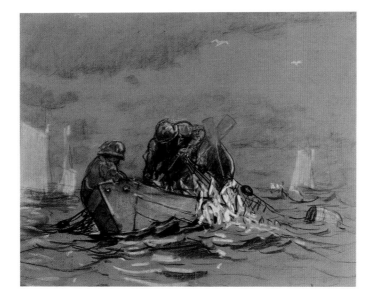

indeed is characteristic now of many of our cleverest men. Mr. Winslow Homer led the list this year."[22] Several critics went further and asserted that Homer was a better Impressionist than the French. Charles DeKay wrote in the *New York Times* that Homer "hits straight at the mark and leaves the unimportant in a picture to take care of itself. This is being an Impressionist in the true and broad sense, not as limited by the exact forms of procedure used by certain artists in France."[23] The success Homer achieved with his particular brand of Impressionism encouraged the next generation of American artists, who would become the American Impressionists.

However, although Homer's watercolors after 1880 retained these connections to Impressionism, his oils began to move in another direction. In 1880, he traveled to Gloucester, Massachusetts, the first of several visits to fishing villages that would profoundly affect his art. The next year, he went to the small coastal town of Cullercoats, England, where he continued the project he had begun in Gloucester—depicting the local people

22 M. G. v. R. [Mariana Griswold van Rensselaer], "Our Monthly Gossip. Art Matters. The New York Water-Color Exhibition," *Lippincott's* 27 (April 1881), pp. 417-18. On the critical reception of Homer's work in the 1870s, see Conrads 2001.

23 DeKay (note 1), p. 5.

engaged in their timeless and often tragic struggle with the sea. In these paintings, perhaps as a result of his study of Michelangelo and Raphael drawings in the British Library, he focused on rendering human anatomy realistically in three dimensions.

In 1883, Homer moved to the isolated town of Prout's Neck, on the coast of Maine, where he continued to explore the subject of humankind's relationship with the sea. While his watercolors *The Return, Tynemouth; Flamborough Head, England; Fishing off Scarborough;* and *The Outlook, Maine Coast* all address this topic, because they were painted *en plein air* in watercolor they retain an immediacy that allies them with the Impressionists' work. In contrast, Homer's oils, such as his 1885 painting *The Herring Net* (fig. 7), are populated by darkly monumental figures that suggest the grim heroism of coastal life. Homer had begun work on this picture by making sketches of herring fishermen (see, for example, *Study for "The Herring Net"*, fig. 8). In the final painting, however, he subtly altered the composition, changing the fishermen's poses so that they balance each other, moving the main figural group to the exact center, and minimizing the boats around them. As a result, while the study, with its flying gulls and cropped elements, looks like an Impressionist scene of a specific moment in time, the darker oil monumentalizes its subject, making it seem more timeless. Rather than focusing on depicting exactly how the scene looked, Homer emphasized the eternal theme of the fishermen's courage in the face of an unchanging and harsh nature, a goal antithetical to the Impressionists' aim to paint transient, everyday life.

The Herring Net is, however, connected to the Impressionists' method in that it is one of a series of three large-scale works depicting the principal fish of the New England fishing industry that Homer produced in 1885. In *The Fog Warning* (Museum of Fine Arts, Boston), the sense of hovering danger seen in *The Herring Net* is more overt. A lone fisherman in a dory, weighed down by two large halibut, looks anxiously at the approaching rain on the horizon, weighing the likelihood of getting back to the schooner before the storm strikes. In the last picture of the series, *Lost on the Grand Banks* (private collection), the worst has happened: two cod fishermen overtaken by fog scan the sea hopelessly for signs of life. In these three pictures, all approximately the same size, Homer painted contemporary life in series, just as he had twenty years earlier with his croquet pictures, again using multiple paintings to illustrate his subject more thoroughly.

In the 1890s, Homer continued to paint in series, focusing on pure landscapes of the Maine coast, such as *Coast of Maine* (pl. 9). Just as Monet did in this same decade with his series of haystacks or the cathedral at Rouen, Homer created multiple works that depict waves on the shore at a specific time of day and year.[24] Although Homer painted some of his oils in the studio and others *en plein air*, he was still seeking to capture how the world looks in real light and atmosphere. He may have been aware of Monet's series paintings in the 1890s: American collectors were enamored of the French painter's work by this time.[25] But whether or not Homer knew Monet's series paintings, he was motivated by similar artistic impulses, as he had been throughout his career. In this sense, he truly was, as Charles DeKay called him, a "homemade" American Impressionist.

24 For Monet's series paintings, see Paul Hayes Tucker, *Monet in the '90s: The Series Paintings*, exh. cat. (Museum of Fine Arts, Boston, 1989).

25 Monet's work was particularly popular among collectors in Homer's native Boston, for example (see Erica E. Hirshler, "Impressionism in Boston," in Hirshler and Stevens 2005, pp. 26–31).

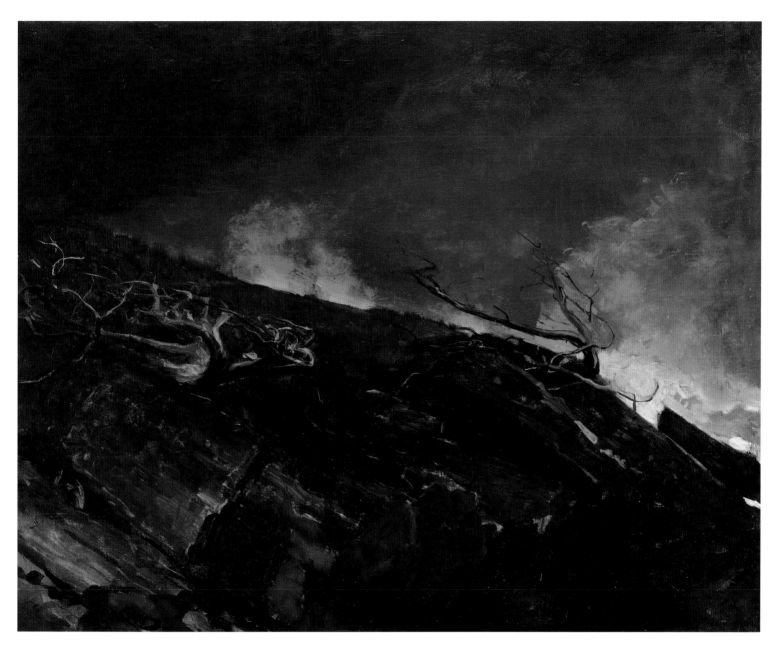

9

WINSLOW HOMER (1836–1910)

Coast of Maine

1893
Oil on canvas; 61 x 76.2 cm (24 x 30 in.)
Arthur Jerome Eddy Memorial Collection,
1931.505
Signed lower left: *Homer 93*

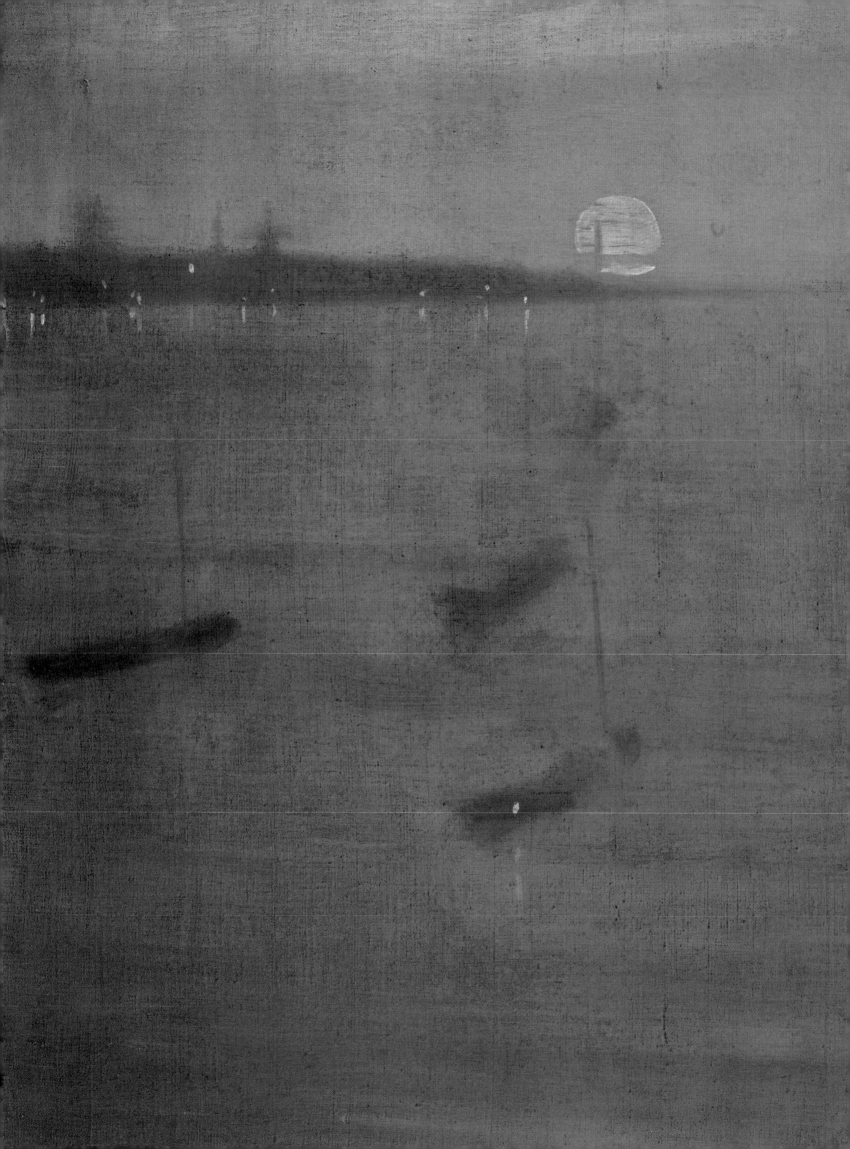

SARAH E. KELLY

TWO

James McNeill Whistler:
"Mr. Whistler Is an *Impressioniste*"

JAMES MCNEILL WHISTLER, painter of quiet portraits and nocturnal views of urban settings, is not generally associated with Impressionism as it was interpreted by later American artists. Instead of light-dappled canvases rich with broken brushwork, he painted ethereal, atmospheric compositions that necessitated a thin, smooth facture. And in his most famous works, the Nocturnes, Whistler relied on a complex process of visual memorization that enabled him to work in the studio rather than *en plein air*. Yet from the 1860s on, reception of his work was framed by a larger debate over the value of the "impression" as a finished work of art. By 1872, he was seen as being affiliated with "the new French school," the forward-thinking artists who would, in 1874, band together to mount the independent exhibition that would give them the name Impressionists.[1] Whistler, an American-born expatriate then living in London, turned down an invitation to join the Impressionists in 1874, preferring to stage his own solo exhibitions. His most avant-garde art, however, reveals that he shared concerns with several of the Impressionists. Whistler, like his French counterparts, placed a premium on personal sensation, emphasized his innovative techniques, and fostered a critical break both with the traditions of art and with the institutions that structured artistic experiences in the nineteenth century. Furthermore, in the second half of his career, he moved increasingly toward capturing his immediate impressions of the natural world.

Born in Lowell, Massachusetts, Whistler traveled to Paris in 1855 and settled in London four years later.[2] He spent his life moving between the two European capitals, never returning to the United States. This peripatetic life exposed him to the latest trends in art, and, influenced by the French artist Gustave Courbet, he initially began working with the language of Realism. He focused on urban subjects in both oil painting and etching, exploring the rough industrial areas of London, especially those along the Thames River. Although his earliest paintings feature a dark palette and a thick impasto of paint, by 1863, when he painted *Grey and Silver: Old Battersea Reach* (pl. 10), he had begun to lighten both elements. Also around this time, he began to focus on depicting changing atmospheric conditions, an interest also held by Claude Monet and the other progressive artists who would later be called Impressionists.

In *Grey and Silver: Old Battersea Reach*, Whistler depicted the view from his London residence at 7 Lindsay Row, Chelsea (now 101 Cheyne Walk), looking west across the river at the numerous factories lining the banks of the Thames. The smokestacks of the Morgan Crucible Company project above the skyline on the opposite bank, emitting a steady stream

1 For "the new French school," see "The Dudley Gallery, Egyptian Hall," *Art Journal*, n.s., 11 (Dec. 1, 1872), p. 309.

2 The literature on Whistler is extensive; useful general resources include Young, MacDonald, Spencer, and Miles 1980 and Dorment and MacDonald 1994; on Whistler and Impressionism, see Lochnan 2004.

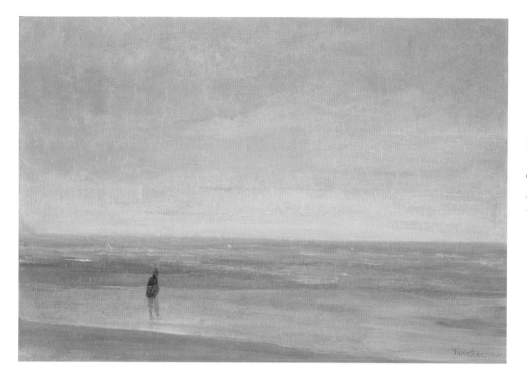

Figure 9. James McNeill Whistler (American, 1834–1903). *Sea and Rain: Variations in Violet and Green*, 1865. Oil on canvas; 77.4 x 100.3 cm (30 ½ x 39 ½ in.). University of Michigan Museum of Art, Ann Arbor, bequest of Margaret Watson Parker, 1955/1.89.

of smoke. London suffered from heavy air pollution at this time; indeed, coal smoke contributed significantly to the denseness of London's famous fogs.[3] Whistler found beauty in such effects and relied on a delicate palette of gray and brown to subtly modulate the atmospheric appearance of the hazy sky and silvery water. He employed quick brushstrokes to delineate the boats, barges, and small figures at work, giving the overall composition a fresh, immediate feeling. Whistler considered compositions like *Grey and Silver: Old Battersea Reach* to be finished works and exhibited them as such, yet many contemporary critics judged his paintings from this period to be little more than large sketches, better intended as preparatory works than as finished, exhibition-worthy paintings. But others associated their sketchiness with the pace of modern life and correspondingly applauded his art. William Michael Rossetti, a critic and friend of Whistler's, noted about *Wapping* (1860–64; National Gallery of Art, Washington, D.C.), "Everything is literal, matter-of-fact—crowded, dispersed, casual. It has all been seen and fixed by a pictorial genius."[4] Rossetti's words convey a sense of instantaneity—that Whistler simply recorded his impressions of a given scene on canvas. Whistler's genius thus lay in rendering the exciting urban environment in an appropriate style.

By exhibiting *Grey and Silver: Old Battersea Reach* and other, increasingly atmospheric paintings as finished works, Whistler pushed against the boundaries of accepted practice in a manner than anticipates the Impressionists. Underlying the reception of his work in England were strong opinions about the function of art; for most critics, the most significant artworks were not meant to express their makers' personal, subjective response to nature but to uplift viewers through moralizing stories conveyed through detailed, highly finished compositions. Sketches, or impressions, were admirable but limited in importance. For example, in 1867, Philip Gilbert Hamerton described Whistler's extraordinarily spare painting *Sea and Rain* (fig. 9) as "an impression of infinite dreariness, precisely the impression that we should feel before such a scene in nature." Whistler's painting thus constituted a brief record of his visual sensations, which would be able to evoke a specific response in the viewer related to that moment in time. But as an "impression," it did not conform to accepted standards of artistic beauty for finished works. Hamerton's acceptance of such impressions therefore depended on

3 Jonathan Ribner, "The Poetics of Pollution," in Lochnan 2004, p. 51.

4 William Michael Rossetti, *Fine Art, Chiefly Contemporary Notices Re-Printed, with Revisions* (Macmillan and Co., 1867), p. 274.

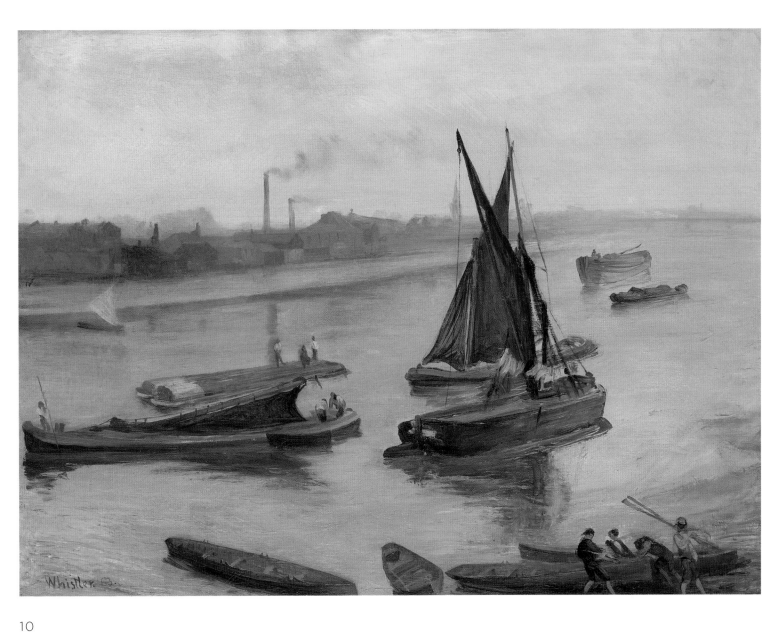

10

JAMES MCNEILL WHISTLER (1834–1903)

Grey and Silver: Old Battersea Reach

1863
Oil on canvas; 50.8 x 68.6 cm (20 x 27 in.)
Gift of Honoré and Potter Palmer, 1922.449
Signed lower left: *Whistler 63*

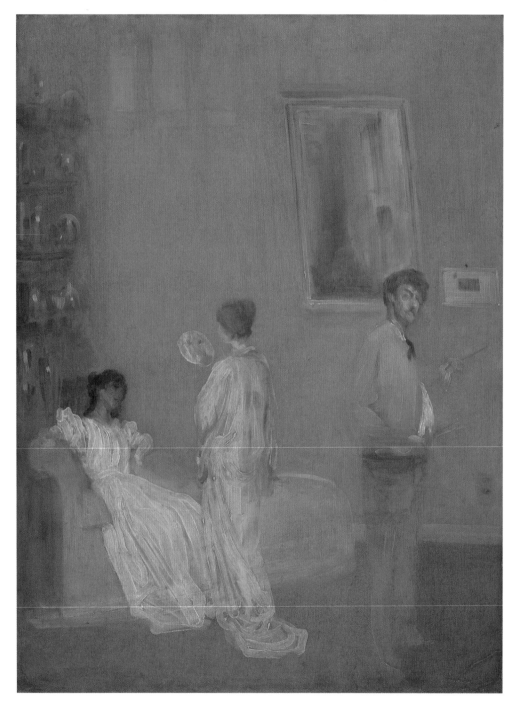

11

JAMES MCNEILL WHISTLER (1834–1903)

The Artist in His Studio

1865/66
Oil on paper mounted on panel; 62.9 x 46.4 cm
(24 3/4 x 18 1/4 in.)
Friends of American Art Collection, 1912.141
Signed middle right: [butterfly monogram]

redefining the meaning and purpose of art: "If the object of art is beauty, this cannot be art; but if we grant to painting the wider function of awakening or reviving impressions of any kind, and by any means in its power, then such work as this is not only art, but art entirely fulfilling its duties to the world."[5]

As Whistler challenged prevailing notions of art, he adopted an art-for-art's-sake aesthetic, proclaiming that his paintings should be appreciated primarily for their formal qualities. Driving Whistler's changing aesthetic was his fascination with Japanese wood-block prints and Chinese blue-and-white porcelain. Artists on both sides of the English Channel, including Édouard Manet and Henri Fantin-Latour in Paris and Dante Gabriel Rossetti and other members of the Pre-Raphaelite Brotherhood in London, began collecting Eastern art in the early 1860s.[6] Whistler moved in both of these circles and had certainly begun acquiring his own collection by 1862, although it is likely that he had encountered examples of Chinese and Japanese art prior to then. During the mid-1860s, Whistler painted several figure subjects that depicted Western models in Asian garb. These genre paintings were essentially European compositions that Whistler enhanced with such additions as kimonos, screens, and porcelain in keeping with contemporary Japanism, and they suggest that he was still grappling with these foreign aesthetics. He documented his new passion in *The Artist in His Studio* (pl. 11) of 1865/66, depicting three Japanese scrolls hanging on the wall and shelves of blue-and-white porcelain in the corner. Even the subject, two languidly posed models, appears to refer to Japanese ukiyo-e prints, or "pictures of the floating world," which often depict beautiful women in intimate settings.

However, as Whistler studied Eastern art more deeply, he began to incorporate Japanese compositional techniques into his works, especially in landscape painting. In 1865, Whistler journeyed to Trouville, France, where he worked alongside Courbet and painted at least five seascapes, including *Trouville* (pl. 12). From Japanese wood-block landscape prints, Whistler adopted a higher horizon line and learned to appreciate the application of large areas of muted color. Such elements are apparent in *Trouville*, in which Whistler used sweeping brushstrokes to depict the water and the sky. Unlike *Grey and Silver: Old Battersea Reach*, which features a diagonal recession into space, in this painting the two horizontally stacked bands of color create little sense of pictorial depth. These reductive compositional choices were deliberately antiacademic, as Whistler sought to flout English artistic traditions.

As early as 1862, however, Whistler had felt frustrated with the difficulties presented by working outdoors, finding that he worked too slowly to achieve the effects he desired. He wrote to Fantin-Latour, "My picture my dear Fantin, is dragging; I am not working quickly enough!" He noted the problems presented by his reliance on the observation and representation of frequently unpredictable natural effects: "I have waited in vain for it [the sea] to be the same colour as the one I started on! It's strange how I feel nailed to this spot."[7] Following his work in Trouville, Whistler spent several years attempting to reconcile the tension between his aesthetic interests and his methods of painting. His quest ultimately led him to a new approach, which he used to paint his most innovative and radical works, the Nocturnes—highly atmospheric portrayals of the Thames and other scenes at night.

Whistler began to paint his Nocturnes, which he initially described as "moonlights," in 1871, returning his focus to the urban riverscapes of London that he had favored during his realist period. He also drew upon the lessons he had learned from his application of Japanese compositional principles to seascape painting. Most importantly, he rejected painting before the motif and developed a process of visual memorization that enabled him to complete his paintings in the studio. *Nocturne: Blue and Gold—Southampton Water* (pl. 13), one of the first Nocturnes to be exhibited, is a tour de force of this newfound painting technique. Whistler

5 P. G. Hamerton, "Pictures of the Year," *Saturday Review*, July 1, 1867, p. 691.

6 An excellent exploration of Whistler's interest in and emulation of Japanese art can found in Toshio Watanabe, *High Victorian Japonisme* (P. Lang, 1991), pp. 211–43.

7 Quotes from Whistler's correspondence (here cited using the GUW record number from the online edition) can be found in *The Correspondence of James McNeill Whistler, 1855–1903*, edited by Margaret F. MacDonald, Patricia de Montfort, and Nigel Thorp; including *The Correspondence of Anna McNeill Whistler, 1855–1880*, edited by Georgia Toutziari. Online edition, University of Glasgow, www.whistler.arts.gla.ac.uk/correspondence. Whistler to Henri Fantin-Latour, [Oct. 14/21, 1862], Library of Congress, Manuscript Division, Pennell-Whistler Collection, PWC 1/33/6; GUW 08028 (accessed Sept. 15, 2009). Whistler wrote to Fantin-Latour in French; all translations in this essay are those provided by the editors of the database.

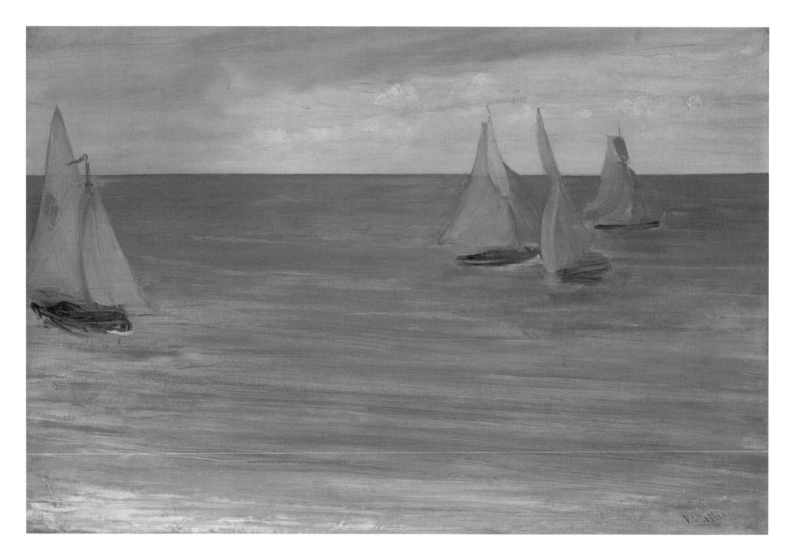

12

JAMES MCNEILL WHISTLER (1834–1903)

Trouville (Grey and Green, the Silver Sea)

1865
Oil on canvas; 51.4 x 77.2 cm (20¼ x 30⅜ in.)
Gift of Honoré and Potter Palmer, 1922.448
Signed lower right: *Whistler*

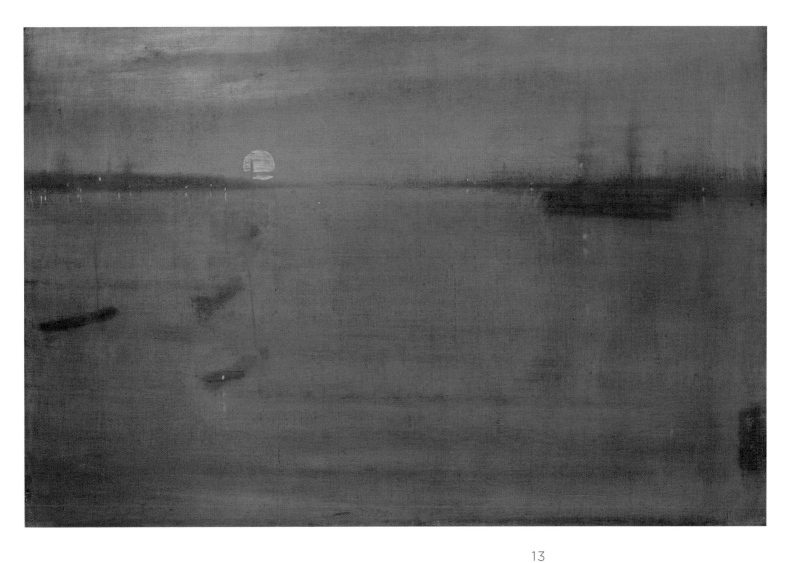

13

JAMES MCNEILL WHISTLER (1834–1903)

Nocturne: Blue and Gold—
Southampton Water

1872
Oil on canvas; 50.5 x 76 cm (19 ⁷/₈ x 29 ¹⁵/₁₆ in.)
Stickney Fund, 1900.52
Signed lower right: [butterfly monogram]

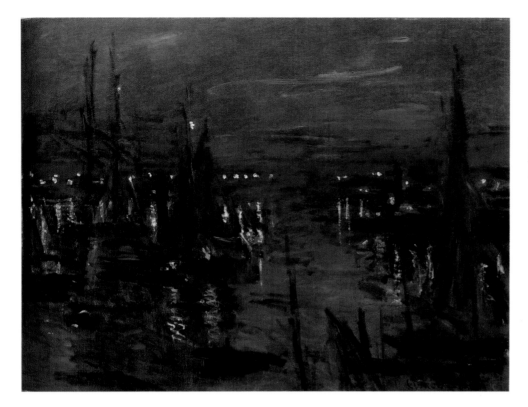

Figure 10. Claude Monet (French, 1840–1926). *Le Port du Havre, Effet du Nuit*, 1873. Oil on canvas; 60 x 81.3 cm (23 ⅝ x 32 in.). Private collection.

depicted the shipping channel at Southampton, yet the subject is secondary to the subtle harmonies of color. Vague shapes can be understood to be ships and barges, but their forms never resolve into detail. Whistler only barely distinguished between sky and water; instead of delineating the horizon with an emphatic line, he smudged on a slightly darker shade of blue to indicate its presence. Whistler balanced the predominantly blue tones of the composition with additions of yellow pigment to suggest the moon, as well as distant lights and their reflections. Despite these bright notes, however, the effect is that of a dense, still atmosphere. Whistler achieved this by rubbing down the surface of the canvas, quite literally blurring or smearing the painted shapes so that they appear to be veiled by the intervening nocturnal atmosphere.

Instrumental to his approach was his use of a thin paint medium, a runny liquid he called his "sauce."[8] Whistler's biographers, Joseph and Elizabeth Pennell, described how "so much 'sauce' was used that, frequently, it [the canvas] had to be thrown flat on the floor to keep the whole thing from running off. He washed the liquid colours on to the canvas, lightening and darkening the tone as he worked."[9] The purpose of the sauce was simple: to enable Whistler to unify the surface and leave no evidence of the process of making the painting. Its liquidity enabled him to blur forms together, producing atmospheric effects without leaving tangible marks in the impasto. It also prevented him from working slowly; he needed to apply the sauce quickly and then blend and rub it together, forming a thin, smooth skin of paint in a relatively brief period of time. Unlike *Grey and Silver: Old Battersea Reach* and *Trouville*, which he painted quickly, but in several distinct passes, with time in between for the paint to dry, Whistler worked on his Nocturnes *au premier coup* (in one sitting), blending wet on wet paint so as not to leave overt brushstrokes.[10] Instead of painting the ships, for example, after the underlying background had dried, Whistler completely integrated their forms into the initial skin of paint, working together the layers by rubbing

8 Elizabeth Robins Pennell and Joseph Pennell, *The Life of James McNeill Whistler* (W. Heinemann, 1908), vol. 1, p. 164.

9 Ibid., vol. 1, p. 165.

10 For helpful discussions of Whistler's materials and technique, see Joyce H. Townsend, "Whistler's Oil Painting Materials," *Burlington Magazine* 136, no. 1099 (Oct. 1994), pp. 690–95; and Stephen Hackney, "Colour and Tone in Whistler's 'Nocturnes' and 'Harmonies,' 1871–72," *Burlington Magazine* 136, no. 1099 (Oct. 1994), pp. 695–99.

the surface, probably with a rag. The result is a seamless appearance—a composition in which a delicate and constant modulation of tones, rather than distinct patches of color or brushwork, is employed to signify various forms. Ultimately, Whistler used this method because he wanted his paintings to appear effortless. As he later wrote, "A picture is finished when all trace of the means used to bring about the end has disappeared."[11]

Whistler was not the only progressive artist to paint moonlit landscapes at this time; Monet, for instance, likewise explored the visual effects of night in *Le Port du Havre, Effet du Nuit* (fig. 10), several months after seeing Whistler's Nocturnes exhibited at the Durand-Ruel gallery in Paris in January 1873.[12] The lively composition conveys the French artist's impressions of evening gloom as defined by man-made illumination; the bristling masts and incandescent flares of light punctuate the obscurity and give shape to the forms in the harbor. This painting, however, illustrates just how dramatically Whistler's technique differed from Monet's Impressionism. The latter artist's interest lay in capturing the optical effects of light, and he used a dark palette, consisting primarily of the deepest blues and blacks, in an attempt to reproduce the mottled appearance of shadows and reflections. Monet executed the painting with a series of jagged, slashing brushstrokes, along with quick touches to add the accent colors. While the animated, rough brushwork of the composition conveys none of the stillness of evening, it does imply Monet's presence at the scene as he worked *en plein air* to render his direct perceptions of the night.

Although Whistler's painting technique diverged from that of Monet, at the most basic level the Nocturnes, like the earlier *Sea and Rain*, are landscapes that embody his visual observations, that is to say, his impressions, of the natural world. Unlike Monet's works, however, Whistler's seemingly effortless paintings do not impart a sense of immediacy through rapid brushwork. Their effaced surfaces suggest a different form of temporality, one formed by a dense accumulation of mental images that expresses duration rather than brevity.[13] Ultimately, the Nocturnes were preceded by and predicated upon Whistler's deliberate capture of a landscape in his mind. If Monet's Impressionist paintings are ostensibly the record of a singular moment in time, Whistler's Nocturnes can in some ways be considered the result of the multiple impressions created by perception and memory. To construct these visualizations, Whistler adopted a system of close observation based on the teachings of the French artist Horace Lecoq de Boisbaudran, who first published his method, *L'éducation de la mémoire pittoresque*, in 1848 (an expanded edition that included techniques for the memorization of color appeared in 1862).[14] Whistler did not study with Lecoq, but he presumably learned of the method through his friendships with Fantin-Latour and Alphonse Legros in the 1850s and 1860s.[15] Intended to supplement the more technical and laborious academic training in drawing, Lecoq's process encouraged students to develop their visual memory, or "stored observation" as Lecoq called it, by carefully studying a chosen object or scene and making mental notes, rather than drawings, of its characteristics. The goal was to progress from simple shapes to complex figures, enabling practitioners to reconstruct entire views from memory.

Whistler's use of this technique in painting his Nocturnes was noted by his contemporaries. The most famous anecdote derives from a lecture and publication by Thomas Way, Whistler's printer. As Way recounted, the two men were walking along the road near the Chelsea Hospital, when Whistler suddenly stopped and indicated an appealing scene. Way offered the artist his notebook, which Whistler refused, telling Way to be quiet as he studied the forms and colors. In Way's anecdote, after Whistler made his observations, he returned home for the evening, deliberately avoiding other appealing views for fear of weakening

11 "Propositions—No. 2," in James McNeill Whistler, *The Gentle Art of Making Enemies* (1890; repr., New York: Dover Publications, 1967), p. 115.

12 Brettell 2000, p. 126. For further information on this painting, see Daniel Wildenstein, *Claude Monet: Biographie et catalogue raisonné* (La Bibliothèque des arts, 1974), cat. 264.

13 This is an idea I have earlier expressed in my dissertation; see Sarah E. Kelly, "Camera's Lens and Mind's Eye: James McNeill Whistler and the Science of Art" (Ph.D. diss., Columbia University, 2010), pp. 90–91.

14 Horace Lecoq de Boisbaudran, *L'éducation de la mémoire pittoresque* (Paris: Librairie sociétaire, 1848). For an analysis of his method, see Petra ten-Doesschate Chu, "Lecoq De Boisbaudran and Memory Drawing: A Teaching Course between Idealism and Naturalism," in *The European Realist Tradition*, ed. Gabriel P. Weisberg (Indiana University Press, 1982), pp. 242–89.

15 Virtually every study of Whistler's life or works discusses this technique because several of his followers, namely Otto Bacher, Mortimer Menpes, and Thomas Way, record witnessing Whistler's use of it. The Pennells included such anecdotes as well; see Pennell and Pennell (note 8), vol. 1, pp. 107–08, 162. For Legros's use of the technique, as well as a more general discussion of the role of memory in French painting, see Veerle Maria Thielemans, "The Afterlife of Images: Memory and Painting in Mid-Nineteenth Century France" (Ph.D. diss., Johns Hopkins University, 2001).

his impressions.[16] He would not put paint to canvas until the next day, allowing his memory to elide details and construct an enduring, if selective, image in his mind's eye, which he mentally projected onto a canvas before he began painting. The practice had one very practical purpose—it permitted him to work in the studio rather than outdoors.

Time was no longer a pressing concern when the desired image could be simply remembered rather than directly observed. Whistler could memorize a scene and paint it much later, relying on his visualization without having to depend on the changing appearance of nature as seen *en plein air*. This enabled him to work both slowly and quickly: slowly in the creation of an image in his mind, and quickly in his actual application of paint. Indeed, when asked about the duration of his process, he responded, "I completed the mass of the picture in one day, after having arranged the idea in my mind."[17] Thus, Whistler achieved atmospheric effects without requiring the immediate stimulus of nature.

In 1872, Whistler wrote to his patron Frederick Leyland, "I say I can't thank you too much for the name 'Nocturne' as a title for my moonlights! You have no idea what an irritation it proves to the critics and consequent pleasure to me—besides it is really so charming and does so poetically say all I want to say and *no more* than I wish!"[18] The occasion of his letter was the exhibition of several paintings at London's Dudley Gallery, including *Nocturne: Blue and Gold—Southampton Water*, then titled "Nocturne in Grey and Gold." By employing musical terminology, Whistler hoped to further divorce his paintings from narrative interpretation. His stance was deliberately provocative to the British art world, and his works incited puzzlement among critics unfamiliar with such abstracted imagery. Yet despite the fact that his Nocturnes were mediated by his memory—a fact not widely known at the time—they were seen by his contemporaries as true to nature. As paintings thought to be directly observed landscape impressions, they required, as one critic noted, "an exceptional fineness and certainty of perception to seize and record the changing conditions and light and shade."[19] Whistler's concerns were thus understood as being similar to those of some of the Impressionists, although executed in a different manner. Indeed, by 1878, the London *Times* would proclaim:

> Mr. Whistler is an *Impressioniste*, almost the only one we have on this side of the Channel, and much outdoing in the qualities of this school those who are regarded as its leaders in France. He stands apart from them also in that rare feeling for colour which is his best endowment. But he is one with them in striving to reproduce the impressions of things in a way that appears as unstudied and artless as the formless tune of birds.[20]

Yet Whistler's Nocturnes, particularly *Nocturne in Black and Gold: The Falling Rocket* (1875; Detroit Institute of Arts), also incited the scandalized reaction of John Ruskin, the Slade Professor of Art History at Oxford and one of the preeminent critics of the day.[21] Ruskin considered Whistler's paintings to be simply rapid sketches or daubs that lacked artistic merit as finished works. After Ruskin accused Whistler of simply "flinging a pot of paint in the public's face," the artist sued the critic for libel.[22] Whistler won the resulting trial, yet was bankrupted when he was not awarded damages. He painted few Nocturnes thereafter, embarking instead upon a new phase of his career.

In the fall of 1879, following the trial, Whistler fled to Venice, where he embarked upon an innovative series of pastels of the city's street life. Whistler had come to Venice intending to produce a series of etchings for London's Fine Arts Society.[23] When the onset of cold weather prevented him from etching outside, he turned to pastel, which he could execute quickly in the open air. While Whistler shared his interest in pastel with the Impressionists Mary Cassatt and Edgar Degas, he developed his own unique, highly abbreviated approach. In works such as *Corte del Paradiso* (pl. 14), instead of applying the pastel medium liberally to

16 Thomas R. Way, *Memories of James McNeill Whistler, the Artist* (John Lane, 1912), pp. 67–68.

17 Quoted in Merrill 1992, p. 152. Whistler said this while testifying at the *Whistler v Ruskin* trial. No official transcript of the trial survives; Merrill's study synthesizes all known news reports and commentary.

18 Whistler to Frederick R. Leyland, [Nov. 2/9, 1872], Library of Congress, Manuscript Division, Pennell-Whistler Collection, PWC 6B/21/3; GUW 08794 (accessed Nov. 29, 2010).

19 "The Society of French Artists," *Pall Mall Gazette*, April 25, 1876, p. 10.

20 Untitled article, *The Times* (London), Nov. 27, 1878, p. 9.

21 For a thorough analysis of the respective positions of Ruskin and Whistler, and an accounting of the trial, see Merrill 1992.

22 John Ruskin, Letter LXXIX, June 18, 1877, *Fors Clavigera*, in *The Works of John Ruskin*, ed. E. T. Cook and Alexander Wedderburn (George Allen and Longmans, Green, 1903–12), vol. 29, p. 160.

23 For more on Whistler's time in Venice, see A. I. Grieve, *Whistler's Venice* (Yale University Press, 2000) and MacDonald 2001. For further discussion of the Art Institute's pastel, see Martha Tedeschi, "Corte del Paradiso," *Art Institute of Chicago Museum Studies* 30, no. 1 (Jan. 1, 2004), pp. 80–81.

14

JAMES MCNEILL WHISTLER (1834–1903)

Corte del Paradiso

1880
Chalk and pastel on gray wove paper; 29.9 x 14.7 cm (11 3/4 x 5 13/16 in.)
Walter Aitken, Margaret Day Blake, Harold Joachim Memorial, Julius Lewis and Sara R. Shorey endowments; Sandra L. Grung, Mr. and Mrs. David C. Hilliard, and Julius Lewis Funds; restricted gifts of William Vance and Pamela Kelley Armour; through prior acquisitions of Katherine Kuh, 2002.679
Signed center left: [butterfly monogram]; inscribed lower left: *No 38. 5 5/8 x 11 1/2*; inscribed lower right: *Corte del Paradiso*

15

JAMES MCNEILL WHISTLER (1834–1903)

Green and Blue: The Dancer

c. 1893
Transparent and opaque watercolor, over traces
of black chalk, on brown wove paper, laid down
on card; 27.5 x 18.3 cm (10 $^{13}/_{16}$ x 7 $^{3}/_{16}$ in.)
Restricted gift of Dr. William D. Shorey; through
prior acquisitions of the Charles Deering
Collection and through prior bequest of
Mrs. Gordon Palmer, 1988.219

fully cover the sheet, and then blending the colors together to create graduated tones, he delicately denoted details of the architecture and figures with small, thin strokes of black chalk that remain readily apparent. Brilliant touches of turquoise, orange, and red enliven the otherwise spare picture. Whistler also purposefully incorporated the paper into his design, allowing much of its brown surface to remain uncovered so that it functions as a subtle element of the composition. Whistler's skillful, elegant handling of the pastel medium in *Corte del Paradiso* is typical of his Venetian works and endows them with an appealing freshness and simplicity of form. Because pastel as a medium for finished works was not wholly accepted at this time, Whistler's originality again stymied British critics.[24] Harry Quilter, for instance, contrasted Whistler's abbreviated technique with that of more traditional approaches, concluding, "Yet, nevertheless, we must own it is a far more artistic and interesting mode of expression; it is a method that commends itself to an impressionist, and conveys to us the feeling and perception of transient beauties."[25] Not unlike Hamerton previously, Quilter understood these small, delicate works to be more akin to sketches than finished works and thus deftly suited to conveying visual sensations.

Following his trip to Venice, and for the rest of his life, Whistler embraced this more spontaneous aesthetic in his watercolors and small-scale oil paintings, although he continued to paint large, formal portraits in oil, such as *Arrangement in Flesh Color and Brown: Portrait of Arthur Jerome Eddy* (1894; Art Institute of Chicago). Watercolor, like pastel, allowed him to work freely, capturing movement and atmospheric effects with rapid ease. Although his oil portraits often convey a sense of stillness or quietude, Whistler expressed his interest in the ephemeral effects of figural motion in watercolors such as *Green and Blue: The Dancer* (pl. 15). Dance was a subject that held his attention throughout the 1890s, and he explored dancing forms across a variety of media. He shared this interest with other Impressionist artists, most notably Edgar Degas, but unlike Degas, who portrayed dancers in public settings, often rehearsing or performing, Whistler depicted them in the studio, divorced from their public context. The dancers' momentary gestures thus became the primary subject of his work, as they would move around the studio until Whistler glimpsed an attractive pose. In *Green and Blue: The Dancer*, Whistler captured the flow of the model's diaphanous gown with sweeping washes of transparent and opaque watercolor, once again relying on the paper to enhance the composition. The impression is one of delicate grace, with Whistler's artistry echoing the fleeting nature of dance.

Such transitory effects also appear in his streetscapes and small seascapes of the 1880s and 1890s. In the watercolor *Chelsea Shop* (pl. 16), Whistler loosely rendered the street scene with transparent washes of color. The architecture is only barely defined, yet small details, such as the cluttered window of the shop front, are apparent. Whistler's handling of the figures was equally brief, yet he nevertheless deftly conveyed the recognizable forms of the shopkeeper, a young girl carrying a baby, and the back of a child who stares in the window. For *Coast Scene, Bathers* (pl. 17), Whistler employed a thin pigment medium, which he unevenly applied to the wood panel support. He skillfully rendered the flow of the water with long streaks of blue and then added curling strokes of white to suggest the breaking surf. Finally, using a small brush, he touched in numerous small figures, who stroll the beach or dabble in the water. The small format of the panel allowed him to work in the open air, reflecting his renewed interest in observing and capturing the fleeting effects of the sea and the movement of figures. As Whistler's career progressed, he thus increasingly demonstrated his commitment to working *en plein air*, seeking to capture his impressions of nature's ephemeral qualities.

Although Whistler was never officially a member of the Impressionists, his career demonstrates his ever-evolving affiliation with the movement. From his earliest years, he

24 For a more thorough discussion of the reception of Whistler's Venetian pastels, see Lynne Bell, "Fact and Fiction: James McNeill Whistler's Critical Reputation in England, 1880–1892" (Ph.D. diss, University of East Anglia, 1987), pp. 75–115.

25 [Harry Quilter], "Mr. Whistler's Venice Pastels," *The Times* (London), Feb. 9, 1881, p. 4.

challenged critics and collectors to redefine their conception of the purpose of art and accept that a brief impression could be considered a finished work. As a flamboyant and innovative painter, he dedicated himself to representing his personal experience of the natural world, whether he worked directly in front of his subject or relied on his memory. In 1893, however, after years of painting outdoors solely in watercolor or on small panels, Whistler returned to a large canvas for *Violet and Silver—The Deep Sea* (pl. 18), one of his most impressionistic paintings. According to Chicago collector Arthur Jerome Eddy, Whistler painted this work while boating off the coast of Brittany, directly observing and recording the appearance of the sea and sky as a crewman steadied the vessel.[26] His brushwork is unusually broad for a work of this scale, as he boldly denoted the clouds and gently cresting waves. Thick, calligraphic touches of paint contrast with almost bare patches of the canvas, an indication of the rapidity of his work. The palette of rich blues and violet demonstrates his continued passion for the myriad relationships of color visible in the ever-changing sea. *Violet and Silver— The Deep Sea* and two other works painted during this trip to Brittany were the last large seascapes Whistler painted, and they were received with acclaim. Whistler himself clearly enjoyed this latest direction of his art, writing to the dealer Edward Guthrie Kennedy, "They are, so all the world are agreed, the finest things of the kind I have painted."[27]

26 Arthur Jerome Eddy, *Recollections and Impressions of James A. McNeill Whistler*, 4th ed. (Philadelphia: J. B. Lippincott Company, 1903), pp. 274–75.

27 Whistler to Edward Guthrie Kennedy, [July 13, 1894]. Edward Guthrie Kennedy Papers, Manuscripts and Archives Division, New York Public Library, Astor, Lenox, and Tilden Foundations, E. G. Kennedy I/50; GUW 09717 (accessed Jan. 13, 2011).

16

JAMES MCNEILL WHISTLER (1834–1903)

Chelsea Shop

1897/1900
Watercolor, with touches of gouache, on cream
wove paper; 12.6 x 21 cm (5 x 8¼ in.)
Gift of Mrs. Kate L. Brewster, 1933.210

17

JAMES MCNEILL WHISTLER (1834–1903)

Coast Scene, Bathers

1884–85
Oil on panel; 13.8 x 22.1 cm (5 7/16 x 8 11/16 in.)
Walter S. Brewster Collection, 1933.208
Signed lower right: [butterfly monogram]

18

JAMES MCNEILL WHISTLER (1834–1903)

Violet and Silver—The Deep Sea

1893
Oil on canvas; 50.2 x 73.3 cm (19 $\frac{3}{4}$ x 28 $\frac{7}{8}$ in.)
Gift of Clara Margaret Lynch in memory of John
A. Lynch, 1955.743
Signed lower right: [butterfly monogram]

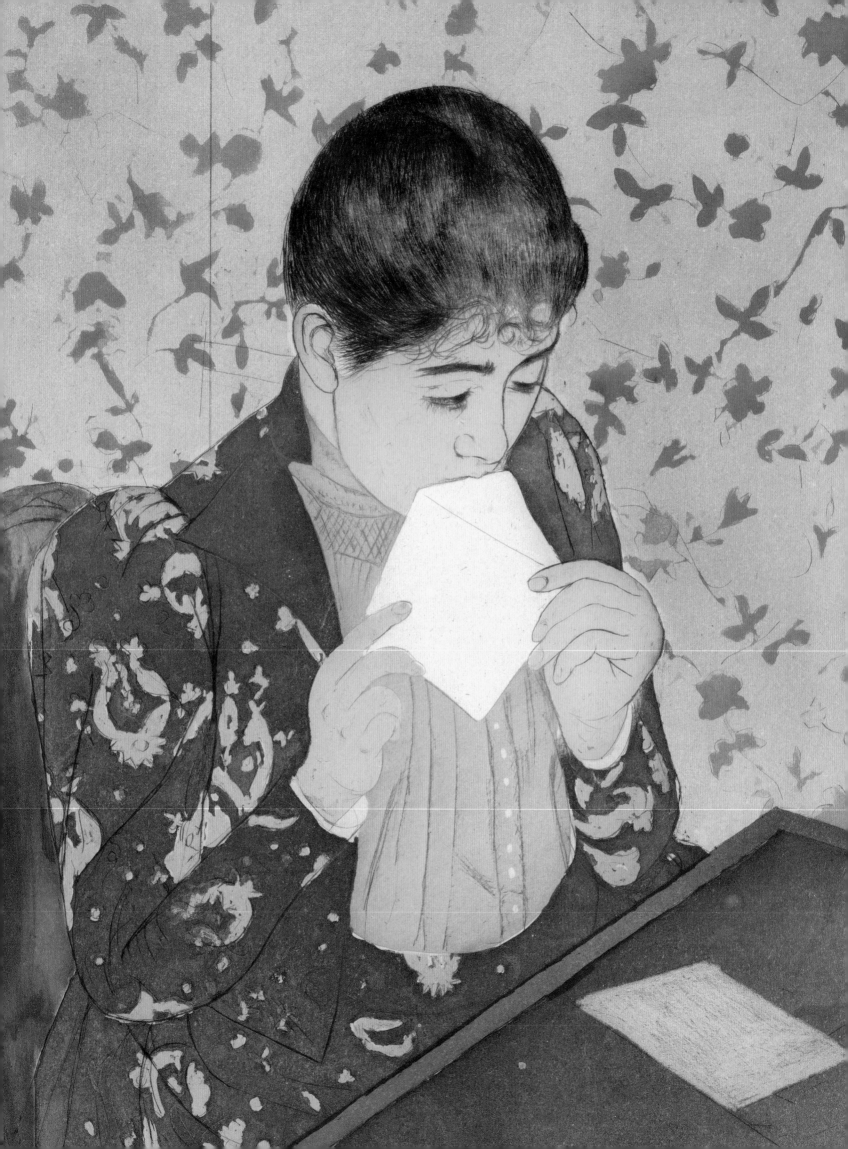

THREE

Mary Cassatt: The Only True American Impressionist

MARY CASSATT WAS THE ONLY AMERICAN to become part of the circle of radically independent French artists known as the Impressionists, which formed in Paris in the early 1870s. Despite the great impact Impressionism would have on modern art in the following decades, the group showed their work jointly for a relatively short period—1874 to 1886— in just eight exhibitions. That Cassatt, a woman and a foreigner, was invited to join the group is a testament to both her talent and her intelligence. Her collecting friend Louisine Havemeyer called her the most intelligent woman she had ever met, and Edgar Degas wrote: "No woman has the right to paint like that."[1]

Unable to receive the kind of art education she desired in her hometown of Philadelphia, Cassatt first came to Paris in 1865 with her friend Eliza Haldeman. There she attended Charles Chaplin's art classes for women and copied paintings in the collection of the Louvre. By 1868, Cassatt had been accepted for study with Jean-Léon Gérôme, and the following year she relocated north of Paris, near Écouen, to study landscape painting with Thomas Couture. A stay in Rome was cut short when the Franco-Prussian War broke out in July 1870 and forced her to return to Pennsylvania. In December 1871, Cassatt returned to Europe and by the following fall had settled in Spain, setting up a studio in Seville. Like Édouard Manet, whose visit to Spain preceded hers by some seven years, she painted groups on balconies, peasants, bullfighters in costume, and, as in Manet's paintings, the moody chiaroscuro of the Spanish Old Masters filled her works. Manet showed *Le Balcon* in the 1869 Paris Salon, and in 1872 Cassatt painted her version of this subject, originally entitled "The Flirtation: A Balcony in Seville" (*On the Balcony*, Philadelphia Museum of Art). Her picture *After the Bullfight*, 1873 (pl. 19), shows affinities to Manet's *A Matador,* 1866–67 (Metropolitan Museum of Art, New York); in both works the application of paint is thick and vigorous and the colorful details of the costume are carefully rendered. *A Matador* was rejected by the Paris Salon and subsequently shown in Manet's exhibition of his own work at the Place d'Alma.[2] Cassatt very likely saw the exhibition in 1867, and much later, in 1898, she urged her friends the Havemeyers to buy Manet's *Matador*.

Cassatt's Spanish pictures reveal great sensuality. In *Offering the Panal to the Bullfighter* (Sterling and Francine Clark Art Institute, Williamstown, Mass.), a companion picture to *After the Bullfight*, a young woman seductively offers water to the matador. He plunges his *panal* (honeycomb) into the water for sweet refreshment. *After the Bullfight* depicts the same matador, now alone, smoking a cigarette, his cape thrown aside; the implications—the

1 Mary Cassatt to Homer Saint-Gaudens, Dec. 28, 1922; quoted in Mathews 1984, p. 335.

2 Françoise Cachin and Charles Moffett, in collaboration with Michel Melot, *Manet: 1832–1883*, exh. cat. (Metropolitan Museum of Art, New York, 1983), pp. 302, 240.

19

MARY CASSATT (1844–1926)

After the Bullfight

1873
Oil on canvas; 82.5 x 64 cm (32 ⅛ x 25 ³/₁₆ in.)
Bequest of Mrs. Sterling Morton, 1969.332
Signed lower left: *M.S.C. / Seville / 1873*

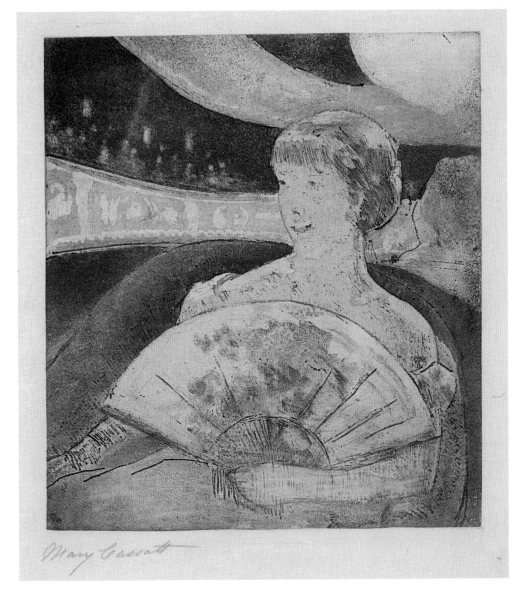

20

MARY CASSATT (1844–1926)

In the Opera Box, No. 3

1880
Soft-ground etching and aquatint on cream
laid paper; 19.5 x 17.5 cm (7 ¹¹/₁₆ x 6 ⁷/₈ in.)
Restricted gift of Gaylord Donnelley and the
Print and Drawing Club Fund, 1970.424
Signed lower left: *Mary Cassatt*

conclusion of a romantic encounter and subsequent solitude and relaxation—are inescapable and far removed from the thoughtful dignity and tension of Manet's figure.

Cassatt settled permanently in Paris in 1874, recognizing that it was the center of the modern art world and the place where her career would be made. After she encountered pastels by Edgar Degas in a shop window on the boulevard Haussmann, Cassatt's work changed radically. Drawn to the spectacle of modern, urban existence that was the subject of his art, Cassatt sought out Degas, who became her mentor and closest collaborator. During the years 1879–80, they experimented with contrasts in light and dark in printmaking, effectively practicing a black-and-white Impressionism in technically complex compositions created in the media of drypoint and rich aquatint. In these early prints and in her paintings of the same period, Cassatt explored the visual sensations of light and form and the art of seeing itself. She painted women watching opera while being watched themselves; mirrors and chandeliers that reflected light and created colorful, optical effects (see pl. 20). But in addition to scenes set in public spaces, she painted portraits of women in their interior, private world: the home.

Her domestic subjects were usually friends and family. Cassatt served as quasi-head of household for two aging parents and a sister who was ill with Bright's disease, all of whom had relocated to Paris to live with her. Her subject matter was the daily household life around her. Living and working near the place Pigalle, Cassatt had daily encounters with the Impressionist painters who shared her neighborhood and frequented the Café de la Nouvelle Athènes across the street from her studio. As a member of a protected and well-to-do middle-class home, Cassatt herself did not participate in café society, which was reserved for men, but the Cassatt household was neither provincial nor unworldly. The modernity of Cassatt's domestic scenes is demonstrated in their striking parallels to illustrations in contemporary fashion magazines, such as *Le Mode illustrée,* or *Le Moniteur de la mode.* Yet Cassatt's interior subjects are not about fashion. Her titles—*Tea, Portrait of a Lady, Woman Reading, On a Balcony*—describe domestic activities, and her subjects are shown half-length rather than full-length, so that dresses are partially obscured; they pose casually, wearing morning or at-home dresses. Cassatt locates her subjects between genre and portraiture—she avoids emphasizing defined personalities, making the experiences portrayed universal rather than specific.

On a Balcony (pl. 21) depicts a woman in a light, loose-fitting morning dress at home on her apartment balcony. An iron railing is barely perceptible behind her head, and a screen of flowers and foliage encloses her in a private world of nature and concentrated reading. In this picture, which was shown at the 1880 Impressionist exhibition, Cassatt focused on surface pattern and on narrowing the spatial field, evidence of the influence of the Japanese wood-block print on the Parisian art world in general and the Impressionists specifically. The *Gazette des beaux-arts* reported on the Japanese objects at the 1878 Exposition Universelle and of the many artists of the Impressionist circle who collected Japanese prints, including Degas, Manet, Félix Bracquemond, Théodore Duret, Claude Monet, Alfred Stevens, and James Tissot.[3] Cassatt's knowledge of Japanese prints contributed to the visual techniques she developed to create fresh images of domestic life. Cassatt, herself a collector of such prints, assimilated and reinterpreted several aspects of Japanese art: lack of perspective, strong contours, flattened spaces and shapes, and bold color. The critic Armand Silvestre, writing in 1880 about her submissions to the fifth Impressionist exhibition, praised the way in which peonies frame the model's head in *On the Balcony* and lauded the picture as "a true model of Japanese art in its absence of distant space and the happy mixture of color in an entirely pleasant range."[4]

While observers rightly recognized the influence of Japanism in Cassatt's work, often overlooked was her debt to the Rococo. She admired the pastels of such eighteenth-century masters as Jean-Baptiste-Siméon Chardin and Maurice Quentin de La Tour and modified her technique to imitate the effects they achieved. Cassatt probably experimented in pastel as early as the late 1870s. Her pastels are sophisticated, the colors pure and unmuddied, the line strong. In a rare few, her fingerprints are still evident from working the pastel manually. She made use of new materials, sometimes combining gouache, paint, and colored papers. Many of these colored papers contained aniline dyes and have faded from their original blue-gray to tan, thus affecting how we view Cassatt's pastels today.[5]

By the late 1880s, the date of the Art Institute's *Young Mother* (pl. 22), Cassatt had perfected her pastel technique. She formed the flesh tones and effects of light and shadow on the skin of her sitters by using shades of green and blue pastel both over and under stumped sections of peach, pink, and white pastel. Sometimes making her facial tones seem greenish, or "dirty," as one reviewer put it, Cassatt may well have been inspired by thirteenth-century Italian masters, whose delicately modeled flesh tones covered green-earth underpainting.[6]

3 Ernest Chesneau, "Le Japon à Paris," *Gazette des beaux-arts* 18 (1878), p. 385.

4 Armand Silvestre, "Le Monde des arts: Exposition de las rue des Pyramides (premier article)," *La Vie Moderne* (April 24), pp. 262, 264; reprinted in *The New Painting: Impressionism, 1874–1886: Documentation,* ed. Ruth Berson (Fine Arts Museums of San Francisco/University of Washington Press, 1996), vol. 1, pp. 307–08.

5 Harriet Stratis, "Innovation and Tradition in Mary Cassatt's Pastels: A Study of Her Methods and Materials," in Barter 1998, pp. 216–17.

6 Ibid., p. 217.

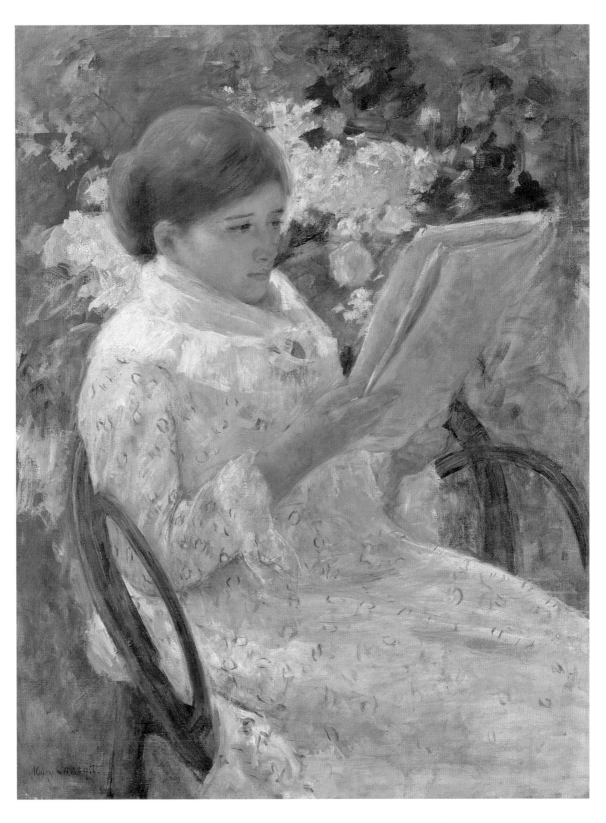

21

MARY CASSATT (1844–1926)

On a Balcony

1878/79
Oil on canvas; 89.9 x 65.2 cm (35 ¹/₂ x 25 ⁵/₈ in.)
Gift of Mrs. Albert J. Beveridge in memory of
her aunt, Delia Spencer Field, 1938.18
Signed lower left: *Mary Cassatt*

While willing to experiment with new techniques, Cassatt was a well-educated connoisseur who relished early Renaissance painting. Indeed, her portraits of women with children bring to mind Renaissance compositions of the Madonna and Christ Child. Critics such as Joris Karl Huysmans thought her portraits of children were fresh and personal and found them free of sentimentality.[7]

Huysmans also documented the new interest in the depiction of children and mother-hood that then prevailed throughout Europe. Cassatt's focus on mothers and children from the mid-1880s on was timely. The politics of the period reflected a concern for the rights of both mothers and children. Child labor laws came into being in France in the mid-1870s; in 1880 girls were provided with free, secular elementary education; by the mid-1880s women could seek divorce and children could be removed from abusive parents. Advice books on the care of children, and particularly on the merits of breast feeding (which had been abandoned in favor of the wet nurse), proliferated. Beginning in the second half of the nineteenth century, childhood as a separate and distinct period of life was celebrated in new books for children, called "toy books"; those by Randolph Caldecott, Walter Crane, and Kate Greenaway were exhibited at the 1881 Paris Salon. Thus it is no accident that Cassatt produced her most important images of children and maternity during the decades of the 1880s and 1890s.

Her best pictures from this period are infused with naturalism and an elemental and nonsexual sensuality. Indeed, in the upper-class Parisian world of Cassatt's day, motherhood was the only acceptable form of female sexuality. Paintings of mothers and children literally infantilized female sexuality and thus made it unthreatening. But for Cassatt even more compelling than this sensuality was the connection between adult female caregivers and the children under their protection. Her depictions of children being hugged, dressed, or bathed reflect advanced ideas about the importance of maternity, the raising of children, and the sensual, physical link between adults and children (see pl. 23). As she concentrated on her images of women and children, Cassatt narrowed her focus, enlarging the figures of the women, emphasizing physical contact, and bringing the composition closer to the viewer.

In *The Child's Bath*, 1893 (pl. 24), the figures look not at each other but down at their reflections in the water in the bowl. Faces are conjoined, a hand and foot tenderly touch, attesting to the emotional bond between child and caregiver. The pink and green stripes of the woman's dress pull the green wallpaper and painted dresser closer to the patterned rug. Cassatt's flattening of the picture plane, tilting the room toward the viewer, and the paint-ing's overall patterning and bold coloration, serve to make the scene more immediate and intimate.

While best known today for her compositions of women and children, Cassatt did not altogether abandon the scenes of other domestic activities that she had embraced in the 1870s and 1880s. In May 1890, Cassatt eagerly attended an exhibition of Japanese graphic arts at the École des beaux-arts. Organized by the dealer Siegfried Bing, the display featured more than seven hundred ukiyo-e prints and four hundred illustrated books. Cassatt wrote excitedly to her friend and fellow female Impressionist Berthe Morisot:

> I dream of it and don't think of anything else but color on copper. [Henri] Fantin [Latour] was there the first day I went and was in ecstasy. I saw Tissot there who is also occupied with the problem of making color prints . . . You must see the Japanese—come as soon as you can.[8]

That summer at Septeuil, in a country house not far from that of Morisot, Cassatt began her own series of color prints, "à la japonaise." She was inspired not only by the bold linearity and evocative color harmonies of the prints but also by their predominant theme—the

7 J. K. Huysmans, "L'Exposition des independents en 1880," in *L'Art moderne* (Paris, 1883); reprinted in Berson (note 4), vol. 1, pp. 285–93.

8 Cassatt to Berthe Morisot, [1890]; quoted in Mathews 1984, p. 215.

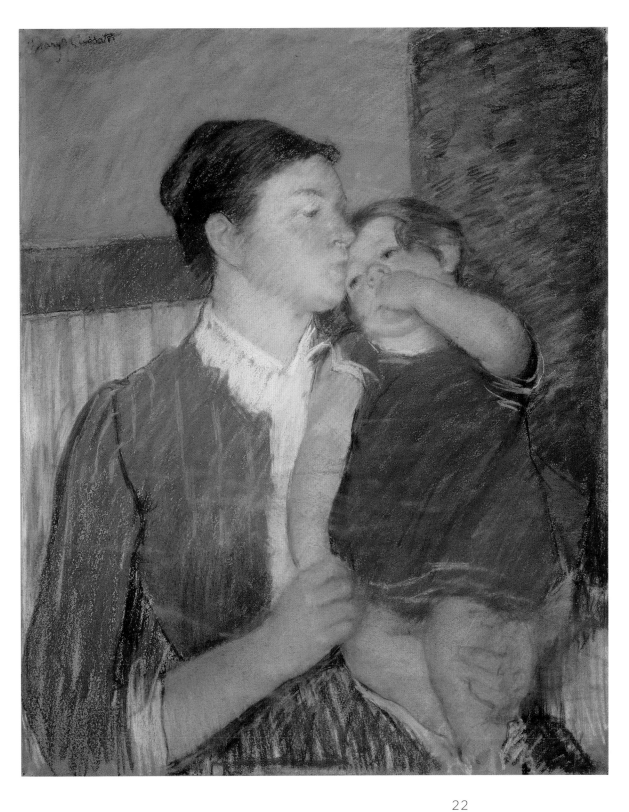

22

MARY CASSATT (1844–1926)

Young Mother

1888
Pastel on blue-gray wove paper (faded to
tan), mounted on canvas, on a strainer; 84 x
73.8 cm (33 1/16 x 29 1/16 in.)
Potter Palmer Collection, 1922.421
Signed upper left: *Mary Cassatt*

everyday lives and ordinary activities of women. She was especially drawn to the work of the eighteenth-century master Kitagawa Utamaro, who depicted courtesans washing and dressing, bathing children, and drinking tea. Utamaro produced seventeen sets of prints, including the Twelve Hours in the Pleasure Quarter of the Yoshiwara, a series that may have constituted the model for Cassatt's suite of color prints.[9]

Unlike the Japanese works she so admired, Cassatt's prints are not woodcuts. They are drypoints and aquatints, made from copperplates covered with printer's inks, that approximate the soft diffuse tones—pale roses, greens and yellows, deep blues, browns, grays and blacks—of Japanese prints. A dozen years after her first print experiments with Degas, Cassatt returned to printmaking on her own. She employed the printer M. Leroy to help her prepare the plates. She first made a pencil drawing and then traced the lines from the drawing into the soft ground coating the plate, which was then etched. To strengthen the line, she used drypoint. She usually prepared two or three copperplates to hold the finely grained aquatint that provided color and pattern. The plates were inked by hand, and then printed, each successive plate carefully aligned atop the paper via pinholes. Approximately twenty-five sets of prints were made, and they vary in character because of selective inking and pressure. The beauty of the prints as well as their stunning technical achievement caused Camille Pissarro to comment: "The result is admirable, as beautiful as Japanese work, and it's done with printer's ink."[10]

Cassatt took the Japanese themes and modernized them. Utamaro's beauty blotting her lips becomes Cassatt's young woman licking an envelope (see pl. 25). A formal serving of tea turns into an afternoon tea-drinking visit between friends (see pl. 26). For some of Cassatt's modern themes, there was no equivalent in the Japanese prints, as when she shows women and children outside the home or riding the Paris omnibus (see pl. 27). In *Woman Bathing* (pl. 28) Cassatt works with the same elements of pitcher and bowl, striped dress and patterns, that she will reuse two years later in *The Child's Bath*. There is a sense of reverie in these color prints that would inform Cassatt's work of the following decade. By the early 1890s, Cassatt was becoming a Symbolist, not only in her choice of subject and mood, the placement of her figures in landscape, and the introduction of flowers in her compositions, but in the larger and larger areas of color and the abstracted patterns of her pictures. In late compositions after the turn of the century, she attempted to address universal themes, referencing the models of Italian Renaissance painting, but modern issues. She wrote to her friend Theodate Pope in 1911 that she sought to convey universal meanings while avoiding the descriptive, the ornamental, or the sentimental: "Almost all my pictures with children have the mother holding them, would you could hear them talk, their philosophy would astound you."[11] For Cassatt, whose vast knowledge of art history inspired her compositions, the Renaissance models represented unchanging themes of intimacy.

It is ironic that the Impressionist Cassatt had little to do with the American painters who later associated themselves with the style. There are several reasons for this. First, most of these Americans were landscape painters, while Cassatt always focused on the human form. Second, since she lived most of her adult life in France she was far better known there than in the United States, and even in France as a woman painter, she was marginalized, no matter her professionalism and talent. Finally, her career was on the wane by the time a young generation of American Impressionists began theirs. Nevertheless, her intelligence and knowledge were universally acknowledged. The young American artist George Biddle made a pilgrimage to her château north of Paris and described her as possessing "electric vitality."[12] As Cassatt wrote a year before her death: "Ever since my mother's death thirty years ago I have lived alone. Carrying on this place and working here on my art."[13] Hers was

9 See Barbara Stern Shapiro, "Mary Cassatt's Color Prints and Contemporary French Printmaking," in Mathews and Shapiro 1989, p. 65; and Colta Ives, *The Great Wave: The Influence of Japanese Woodcuts on French Prints* (Metropolitan Museum of Art, New York, 1974).

10 Camille Pissarro to Lucien Pissarro, April 3, 1891; quoted in *Camille Pissarro: Letters to His Son Lucien,* ed. John Rewald, 3rd rev. ed. (Paul P. Appel, Publisher, 1972), p. 160.

11 Cassatt to Theodate Pope, February 19, 1911; quoted in Mathews 1984, p. 306.

12 George Biddle, "Some Memories of Mary Cassatt," *The Arts* 10, no. 2 (Aug. 1926), pp. 107–11.

13 Cassatt to Mary Gardner Smith, [c. March 8, 1925]; quoted in Sweet 1966, p. 207.

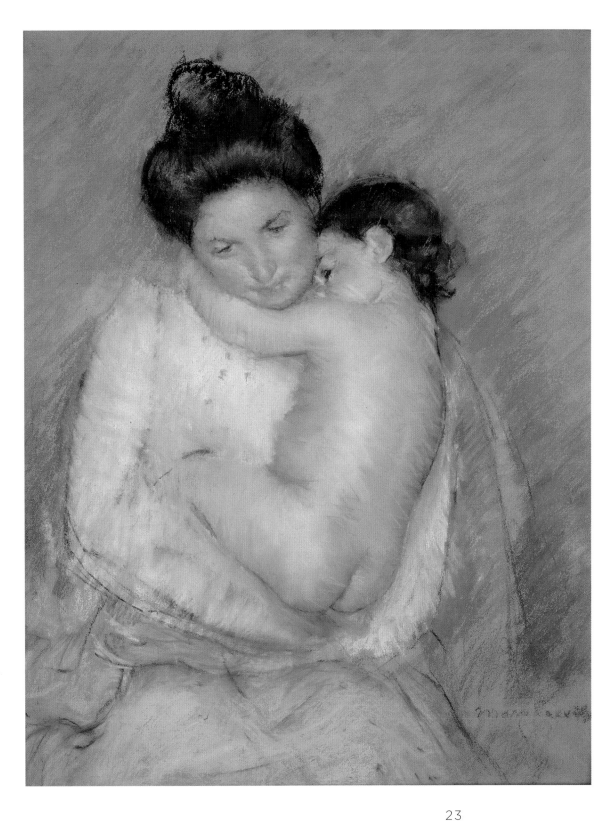

23

MARY CASSATT (1844–1926)

Mother and Child

c. 1900
Pastel on blue-gray wove paper (faded to tan),
mounted on board; 71 x 58.5 cm (27 15/16 in.)
Bequest of Dr. John Jay Ireland, 1968.81
Signed lower right: *Mary Cassatt*

a lonely existence—ahead of her time, ahead of her American compatriots—and her work shows us how radically different their Impressionism was from the work of the original, one and only, true American Impressionist.

Yet Cassatt did make a lasting contribution to Americans' education about contemporary art. The Parisian dealer Ambroise Vollard recalled that Cassatt energetically pushed forward the work of her French Impressionist colleagues: "It was with a sort of frenzy that generous Mary Cassatt laboured for the success of her comrades."[14] A tireless collector as well as a modern working artist, she sought out the very best pictures for herself and her American collecting friends. Those who visited her were treated to a magnificent fan-shaped pastel of ballerinas painted by Degas (1879) hanging on the wall above her favorite armchair, and she owned Degas's famous *Woman Bathing in a Shallow Tub* (1885), both now at the Metropolitan Museum of Art in New York. She owned works by Gustave Courbet, Morisot, and Monet, as well as Manet's *Branch of White Peonies and Pruning Shears* (1864; Musée d'Orsay, Paris). She encouraged her brother Alexander to buy Monet, and she actively pushed sales of her friend Pissarro's work in New York.[15] Above all, Cassatt advised her family and her many collecting friends, Alexander Cassatt in Philadelphia, H. O. and Louisine Havemeyer in New York, Potter and Bertha Honoré Palmer (see fig. 1) in Chicago, Sarah Choate Sears in Boston, Theodate Pope in Connecticut, and many others to buy the works of the Impressionists, and specifically Degas's pastels. Today, pastels from those early collections hang in American museums in all those major cities. Alexander Cassatt, who purchased works by Degas, Monet, Pissarro, Morisot, Renoir, and Whistler under his sister's tutelage, lent his pictures to two important American exhibitions, the 1886 Impressionist exhibition organized by the American Art Association in New York and the 1893 World's Columbian Exposition in Chicago.

At the 1893 World's Fair, Cassatt's own work was present in the form of a fourteen-by-fifty-eight-foot mural, *Modern Woman,* which hung at one end of the Woman's Building. Mrs. Potter Palmer commissioned the mural through Chicago art agent Sara Tyson Hallowell. Palmer would have known Cassatt's work earlier, probably having seen her color prints when they were on view in Paris in 1891.[16] After that date Cassatt worked with Hallowell (who rented a château a few miles from Cassatt's), Palmer, and Art Institute trustees Martin Ryerson and Charles Hutchinson to recommend paintings for the museum's collection. Not content just with the works of her contemporaries, Cassatt kept an eye out for great Old Master pictures, and through her services the Art Institute acquired El Greco's *Assumption of the Virgin* (1577) in 1906.

After the turn of the century, Boston collector Sarah Choate Sears took a Paris apartment a few blocks from Cassatt's, and the two friends attended exhibitions together. Through Cassatt, Sears purchased the work of Manet, Degas, Monet, and Cézanne. Eventually Sears owned over two hundred works of art, many of which she donated to the Museum of Fine Arts in Boston. Sears also supported the work of American Impressionist painters Dennis Miller Bunker, Maurice Prendergast, Edmund Tarbell, and John Singer Sargent.[17] In the end, Mary Cassatt influenced American painters not only through her own work but also through her tireless championing of modern art among American collectors and museums.

14 Ambroise Vollard, *Recollections of a Picture Dealer,* trans. Violet M. MacDonald (Constable, 1936), p. 181.

15 For a discussion of objects owned by Cassatt and those friends she encouraged to buy modern art, see Erica E. Hirshler, "Helping Fine Things across the Atlantic," in Barter 1998, pp. 177–211; and Frances Weitzenhoffer, *The Havemeyers: Impressionism Comes to America* (Harry N. Abrams, 1986).

16 Judith A. Barter, "Mary Cassatt: Themes, Sources and the Modern Woman," in Barter 1998, p. 87.

17 Hirshler (note 15), p. 195.

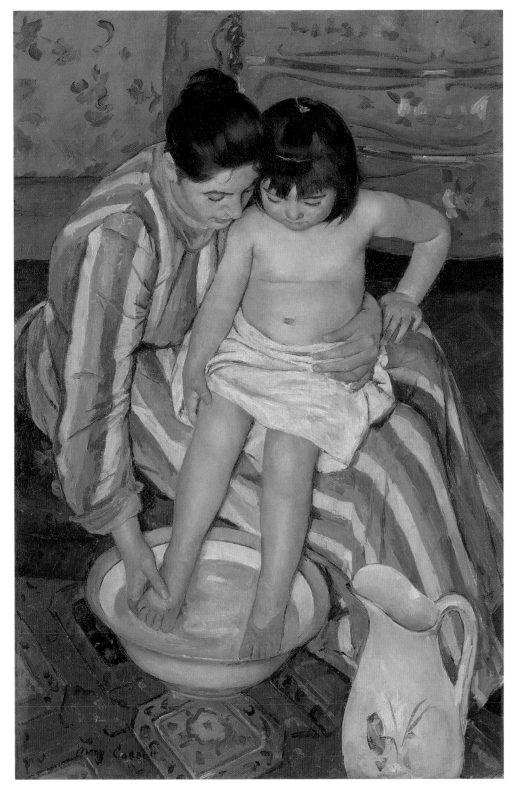

24

MARY CASSATT (1844–1926)

The Child's Bath

1893
Oil on canvas; 100.3 x 66.1 cm (39½ x 26 in.)
Robert A. Waller Fund, 1910.2
Signed lower left: *Mary Cassatt*

25

MARY CASSATT (1844–1926)

The Letter

1890–91
Color drypoint and aquatint, from three plates,
on off-white laid paper; 34.5 x 21.1 cm
(13 ⁵/₈ x 8 5 ¹/₁₆ in.)
Mr. and Mrs. Martin A. Ryerson Collection,
1932.1282
Inscribed lower right: *Imprim[ée] par l'artiste et
Mr. Leroy / Mary Cassatt / (25 épreuves)*

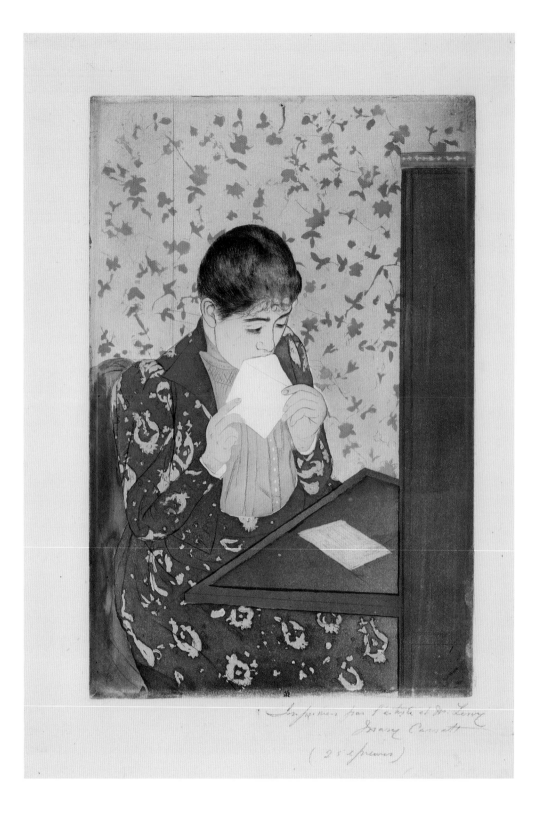

26

MARY CASSATT (1844–1926)

Afternoon Tea Party

1890–91
Color drypoint and aquatint, from three plates,
with brush and gold paint, on ivory laid paper;
34.8 x 27 cm (13 ¹¹/₁₆ x 10 ⁵/₈ in.)
Mr. and Mrs. Martin A. Ryerson Collection,
1932.1285
Signed lower right: *Imprimée par l'artiste et*
M. Leroy / Mary Cassatt / (25 épreuves)

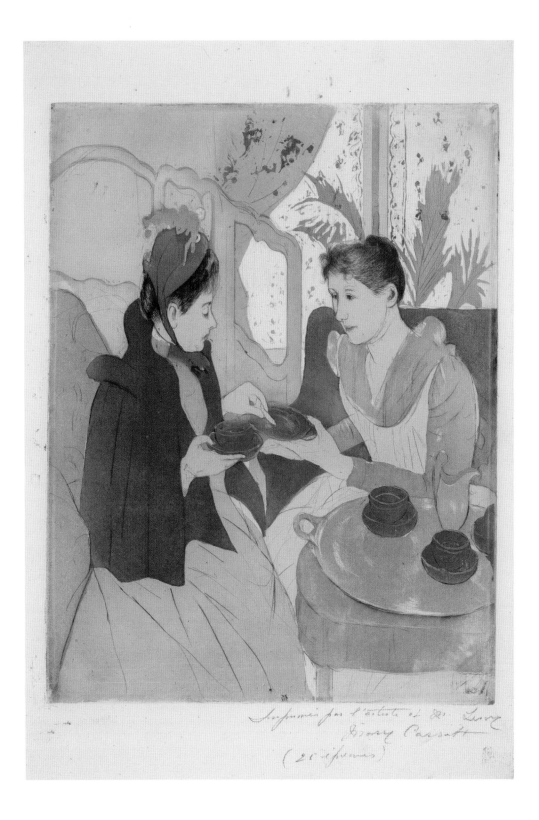

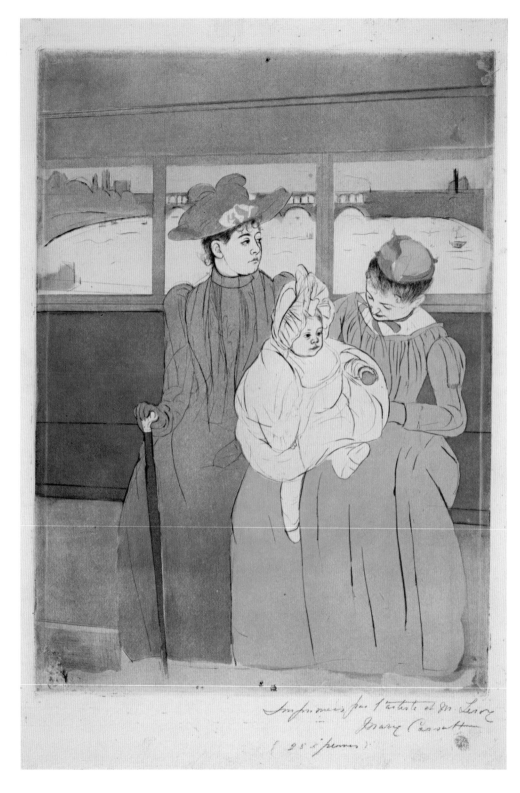

27

MARY CASSATT (1844–1926)

In the Omnibus

1890–91
Color drypoint and aquatint, from three plates, partially printed *à la poupée*, on ivory laid paper; 36.7 x 26.8 cm (14 7/16 x 10 9/16 in.)
Mr. and Mrs. Martin A. Ryerson Collection, 1932.1289
Signed lower right: *Imprimée par l'artiste et M. Leroy / Mary Cassatt / (25 épreuves)*

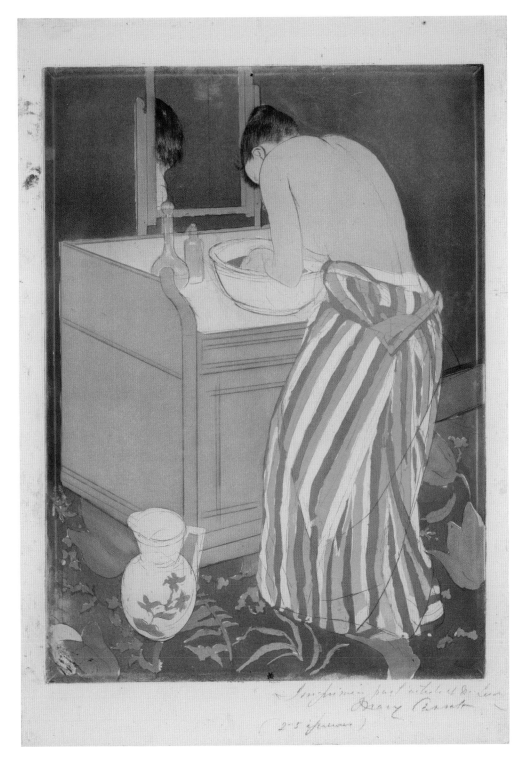

28

MARY CASSATT (1844–1926)

Woman Bathing

1890–91
Color drypoint and aquatint, from three plates,
on off-white laid paper; 36.4 x 26.9 cm (14 5/16 x
10 5/8 in.)
Mr. and Mrs. Martin A. Ryerson Collection,
1932.1281
Signed lower right: *Imprimée par l'artiste et M.
Leroy / Mary Cassatt / (25 épreuves)*

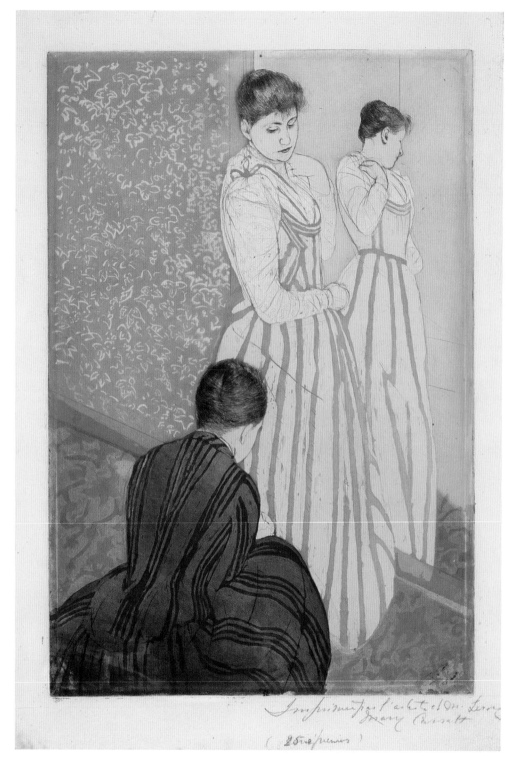

29

MARY CASSATT (1844–1926)

The Fitting

1890–91
Color drypoint and aquatint, from three plates,
on ivory laid paper; 37.7 x 25.6 cm (14 ⅞ x 10 1/16 in.)
Mr. and Mrs. Martin A. Ryerson Collection,
1932.1283
Signed lower right: *Imprimée par l'artiste et
M. Leroy / Mary Cassatt / (25 épreuves)*

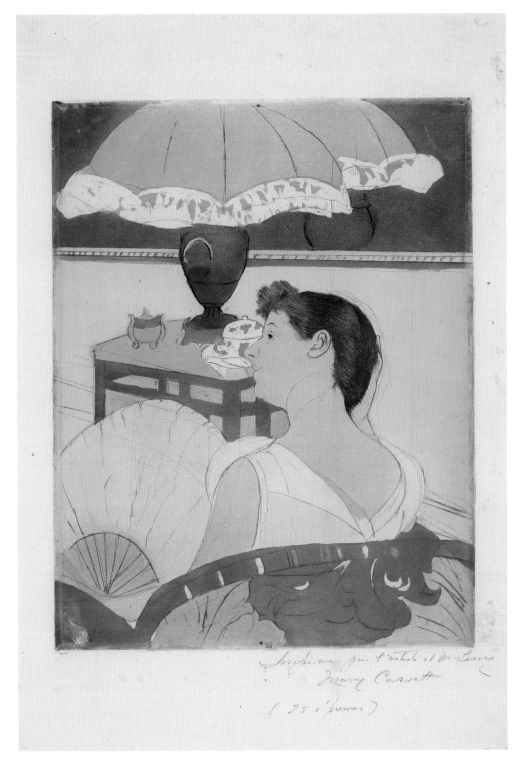

30

MARY CASSATT (1844–1926)

The Lamp

1890–91
Drypoint and aquatint on cream laid paper;
32.3 x 25.2 cm (12 ³/₄ x 9 ¹⁵/₁₆ in.)
Mr. and Mrs. Martin A. Ryerson Collection,
1932.1290
Signed lower right: *Imprimée par l'artiste et
M. Leroy / Mary Cassatt / (25 épreuves)*

ELLEN E. ROBERTS

FOUR

John Singer Sargent: "An Impressionist and an Intransigeant"

THROUGHOUT HIS CAREER, critics defined John Singer Sargent's work in relation to Impressionism. His fellow American expatriate Henry James noted this trend in 1887: "From the time of [Sargent's] first successes at the Salon, he was hailed as a recruit of high value to the camp of the Impressionists, and to-day he is for many people most conveniently pigeon-holed under that head."[1] Despite the "convenience" of this label, critics disagreed about the exact connection between Sargent's art and Impressionism. Some writers concluded that he was an Impressionist; Arthur Baignères, for example, declared in the *Gazette des beaux-arts* in 1883: "M. Sargent shows himself to be an impressionist of the first order."[2] Yet other critics, while still linking his artistic practice to the style, concluded that it was fundamentally different. Paul Mantz in *Le Temps* wrote: "M. Sargent is much more modern than the impressionists."[3] A generation later, Roger Fry, who detested Sargent's work, nevertheless also understood his painting practice by comparing it with that of the Impressionists, writing of the artist's *Carnation, Lily, Lily, Rose* (1887; Tate Britain, London): "This new colour was only a vulgarisation of the new harmonies of the Impressionists; this new twilight effect only an emasculated version of their acceptance of hitherto rejected aspects of nature."[4]

Sargent lived in Paris from 1874 to 1885, years that span almost exactly the era of the eight Impressionist exhibitions. He knew many of the French Impressionists, admired their work, and showed with them at a number of independent exhibition societies in Paris in this period.[5] Yet he never fully embraced any of the various Impressionist styles practiced by his French colleagues. Tellingly, Sargent defined himself as "an impressionist and an intransigeant [*sic*]," simultaneously identifying his affiliation with Impressionism and the independence that made his version of the style fundamentally different from that of its other practitioners.[6] An examination of the Art Institute of Chicago's outstanding collection of Sargent's work reveals his complex relationship with Impressionism, which, in turn, helps to clarify what he was trying to do in his art.

In 1874, the year of the first Impressionist exhibition, Sargent arrived in Paris to begin his formal training as an artist. As was typical of Parisian art students at the time, he enrolled in both the École des beaux-arts and a painting atelier run by the society portraitist Carolus-Duran.[7] At the École, Sargent followed the training regimen that had been instituted by the French academy in the seventeenth century, mastering drawing and anatomy before progressing to painting. Carolus-Duran, however, taught him the opposite approach: to paint without drawing first and with a loaded brush, building up dark and light in emulation of

1 Henry James, "John S. Sargent," *Harper's New Monthly Magazine* 75 (Oct. 1887), p. 684.

2 Arthur Baignères, "Première Exposition de la Société Internationale de Peintres et Sculpteurs," *Gazette des beaux-arts* 27, no. 2 (Feb. 1883), p. 190: "M. Sargent se montre là un impressioniste de premier ordre."

3 Paul Mantz, "Le Salon: VII," *Le Temps,* June 20, 1880, p. 1: "M. Sargent est beaucoup plus moderne que les impressionists."

4 Roger Fry, "J. S. Sargent as Seen at the Royal Academy Exhibition of His Works, 1926, and in the National Gallery," *Transformations: Critical and Speculative Essays on Art* (London: Chatto and Windus, 1926), pp. 125–26.

5 On Sargent's participation in French exhibition societies beyond the Salon, see Simpson 1997, pp. 34–37.

6 John Singer Sargent to Vernon Lee; quoted in Evan Charteris, *John Sargent* (C. Scribner's Sons, 1927), p. 251.

7 On Sargent and Carolus-Duran, see H. Barbara Weinberg, "Sargent and Carolus-Duran," in Simpson 1997, pp. 5–29.

seventeenth-century Dutch and Spanish masters like Frans Hals and Diego Velásquez rather than the Italian Renaissance painters who were admired at the École.[8] Carolus-Duran shared his admiration for these alternative masters and their working method with his friends and fellow painters Gustave Courbet and Édouard Manet. When he taught students like Sargent this painting technique, he gave them a way to appreciate the work of such avant-garde painters. As a result, the influences of Hals, Velásquez, and Manet in Sargent's early pictures are intertwined and difficult to separate.

Sargent admired Manet's work. In 1884, he wrote that the Manet retrospective at the École des beaux-arts was "the most interesting thing in Paris now. . . . It is altogether delightful."[9] He went on to buy two paintings from the artist's studio sale.[10] In 1889, Sargent and his friend Claude Monet spearheaded the effort to buy Manet's 1863 masterpiece *Olympia* for the French national collection.

Sargent's *Rehearsal of the Pasdeloup Orchestra at the Cirque d'Hiver* (pl. 31), executed in the late 1870s, has the dark palette and painterly brushwork typical of Manet's work. Moreover, the subject is one of the modern urban entertainments that were often painted by the Impressionists. Jules Étienne Pasdeloup led his orchestra in *concerts populaires* in Paris that were meant to introduce the broader public to classical music. He held free rehearsals at the Cirque d'Hiver on Sunday afternoons. Sargent was an accomplished pianist and shared with Pasdeloup an appreciation for modern music, including that of composers Gabriel Fauré and Richard Wagner. Sargent's friend and fellow painter William Coffin later recalled how Sargent came to paint Pasdeloup's orchestra:

> I remember how much we used to like to go to the Colonne concerts at the Châtelet, and to those given by Maître Pasdeloup at the Cirque d'Hiver, on Sunday afternoons. . . . Sargent, who dearly loved the music, was struck by the odd picturesqueness of the orchestra at Pasdeloup's, seen in the middle of the amphitheater, the musicians' figures foreshortened from the high point of view on the rising benches, the necks of the bass-viols sticking up above their heads, the white sheets of music illuminated by little lamps on the racks, and the violin-bows moving in unison. While he listened he looked, and one day he took a canvas and painted his impression.[11]

One of two versions Sargent painted, this picture, on long-term loan to the Art Institute from a private collection, has clowns at lower right, an indication of the melding of "high" and popular culture that took place at the Cirque d'Hiver.[12]

Sargent's decision to paint such modern scenes was probably inspired by both Manet's and Edgar Degas's Impressionist works. In pictures like his 1873 *Masked Ball at the Opera* (National Gallery of Art, Washington, D.C.), Manet cropped, flattened, and abstracted the forms of French performers, likely influencing both Sargent's choice and treatment of his subject matter. Sargent also knew Degas's paintings: at the third Impressionist exhibition in 1877, he made a pencil sketch of Degas's *Ballet* (*L'Etoile*) (1877; Worcester Art Museum, Mass.), demonstrating his interest in the French artist's work.[13] Degas's treatment of urban entertainments like the opera and ballet in such works as his *The Orchestra of the Opera* of c. 1870 (fig. 11) probably encouraged Sargent to explore this subject in his Pasdeloup paintings. Furthermore, in both his depictions of Pasdeloup's orchestra, Sargent adopted, as did Manet and Degas, an unusual perspective that serves to flatten and abstract the pictorial space. In Sargent's case, he seems to be looking down from above. However, unlike Manet's or Degas's subjects, Sargent's musicians seem to dissolve into the background: as the orchestra sweeps back into space, the players' forms become so simplified that they almost seem to turn into the notes they are playing. Manet also occasionally included forms that suggest musical notation in his paintings of this time, reflecting contemporary critics' frequent discussion of Impressionism in musical terms.[14] Sargent's evocation of notes on a staff in these paintings is

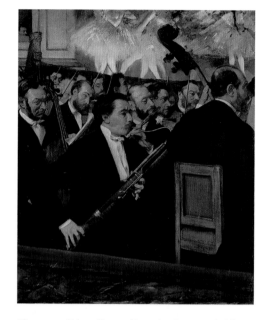

Figure 11. Edgar Degas (French, 1834–1917). *The Orchestra of the Opera*, c. 1870. Oil on canvas; 56.5 x 45 cm (22 ¼ x 17 ¾ in.). Musée d'Orsay, Paris.

8 On the French interest in Spanish painting at this time, see Gary Tinterow, *Manet/Velázquez: The French Taste for Spanish Painting*, exh. cat. (Metropolitan Museum of Art, New York, 2003).

9 Sargent to "Interesting Mad One [Miss Popert]," Jan. 18, 1884, John Singer Sargent Papers, Boston Athenaeum, box 1, folder 18. On Sargent and Manet, see Elaine Kilmurray, "Sargent, Monet . . . and Manet," in *Sargent and Impressionism*, exh. cat. (Adelson Galleries, New York, 2010), n.pag.

10 At the Manet studio sale, held at the Hôtel Drouot in Paris on Feb. 4 and 5, 1884, Sargent bought a portrait of Fanny Claus that was a study for Manet's *Le Balcon* and a watercolor of irises. These paintings are now both in private collections.

11 William A. Coffin, "Sargent and His Painting," *Century Magazine* 52, no. 2 (June 1896), p. 172.

12 The other version of this subject is now in the collection of the Museum of Fine Arts, Boston.

13 Degas's *Ballet* (*L'Etoile*) is now in the collection of the Musée d'Orsay, Paris.

14 Therese Dolan, "Melomanet: Richard Wagner and Music in the Tuileries," paper presented at the session "Music and Other Paradigms for Nineteenth-Century Art, Part I," College Art Association, New York, Feb. 12, 2011.

31

JOHN SINGER SARGENT (1856–1925)

*Rehearsal of the Pasdeloup Orchestra
at the Cirque d'Hiver*

1876/78
Oil on canvas; 93 x 73 cm (36 ⅝ x 28 ¾ in.)
Anonymous loan, 81.1972
Signed lower left: *To G Henschel / John S. Sargent*

more overt than Manet's; in his pictures' abstraction, Sargent conveyed his aural, as well as his visual, experience of Pasdeloup's performances.

After experimenting with this relatively high degree of abstraction, Sargent retreated from it. Like most academically trained American painters at this time, he rarely abandoned the realistic depiction of the human form. Perhaps he also felt that the expressionistic abstraction in his Pasdeloup paintings was only appropriate for a scene involving music. Nevertheless, Sargent continued to explore Impressionist subject matter. His *Venetian Glass Workers* (pl. 32), for example, is one of a number of views of everyday working-class life in Venice that he painted during two lengthy stays there between 1880 and 1882. In the Art Institute's painting, the glass workers are engaged in turning glass tubes into beads. Sargent used broad strokes of paint to suggest, rather than describe literally, the long glass rods. This brushy paint handling, as well as the dark palette, is allied with Manet's exaggerated version of Hals's and Velásquez's method. Sargent's use of this kind of Impressionism in his Venice pictures separates them from other scenes of the city painted at this time. An international array of artists depicted Venice, but they concentrated on its colorful, picturesque aspects, working in the tradition begun by Canaletto and other eighteenth-century view painters. In contrast, Sargent often painted the darkened interiors of Venetian buildings, focusing not on the city's grand old architecture but on its contemporary residents. The American art collector Martin Brimmer, after seeing Sargent in Venice in 1882, wrote that his paintings of the city were "very clever, but a good deal inspired by the desire of finding what no one else has sought here—unpicturesque subjects, absence of color, absence of sunlight. It seems hardly worthwhile to travel so far for these."[15] Sargent's focus on the less obviously attractive, modern aspects of Venetian life, rather than the city's illustrious past, demonstrates his allegiance to Impressionist ideals of capturing everyday modern life.

Early Sargent portraits, like his sketch of *Mrs. Charles Gifford Dyer* (*Mary Anthony*) (pl. 33), have similar dark palettes and brushy paint handling, again linking them to Manet's work.[16] However, they differ in other respects: although Sargent used broad brushwork to paint Dyer's surroundings, he incorporated more detail into her face and hands, demonstrating his adherence to his École training. Dressed in black with a flower next to her, Dyer resembles the sitters of Sargent's favorite seventeenth-century Spanish painters and, by extension, those in Manet's work.

In the ambitious, large-scale paintings he executed in Paris in these years, which were intended to show off his talents at the Paris Salon, Sargent experimented with this same Spanish-influenced Impressionism, with stupendous results. His most obviously Spanish work of this period is the monumental *El Jaleo* of 1882 (Isabella Stewart Gardner Museum, Boston), which depicts a Spanish dance. However, his large-scale portraits *Madame Paul Escudier (Louise Lefevre)* (pl. 34) and *The Daughters of Edward Darley Boit* (Museum of Fine Arts, Boston), both painted the same year as *El Jaleo*, also incorporate the characteristics of Spanish painting that both Sargent and Manet admired. In these pictures, Sargent experimented with placing his portrait sitters in darkened interiors as Velásquez had done in his iconic *Las Meninas* (fig. 12), which Sargent had admired in Madrid. Madame Escudier, wearing a blue silk afternoon dress, stands in her elegantly appointed drawing room, next to a chair covered in impressed velvet and placed on an ornate carpet. On the wall behind her is an Italian mirrored candle sconce set in a carved gilt frame. Yet despite these details, the darkened space is ambiguous. Illuminated only by the light from the windows at right, Madame Escudier's figure is difficult to see. While her arm closest to the window is brilliantly lit, her face, the most important part of a portrait, is in shadow. In such early 1880s paintings, Sargent deliberately undermined the conventions of portraiture, prioritizing dramatic effects of light and dark over a clear depiction of his sitter.

Figure 12. Diego Rodríguez de Silva y Velásquez (Spanish, 1599–1660). *The Family of Philip IV, or Las Meninas*, c. 1656. Oil on canvas, 318 x 276 cm (125 ³⁄₁₆ x 108 ¹¹⁄₁₆ in.). Museo del Prado, Madrid.

15 Martin Brimmer to Sarah Wyman Whitman, Oct. 26, 1882, Martin Brimmer Letters, 1880–96, Archives of American Art, Smithsonian Institution.

16 Dyer and her husband were Sargent's friends and fellow members of the Anglo-American artistic community in Venice in 1880. Sargent inscribed this portrait "To my friend Mrs Dyer John S. Sargent. Venice 1880."

32

JOHN SINGER SARGENT (1856–1925)

Venetian Glass Workers

1880/82
Oil on canvas; 56.5 x 84.5 cm (22¼ x 33¼ in.)
Mr. and Mrs. Martin A. Ryerson Collection,
1933.1217
Signed lower left: *John S. Sargent*

33

JOHN SINGER SARGENT (1856–1925)

Mrs. Charles Gifford Dyer (Mary Anthony)

1880
Oil on canvas; 62.2 x 43.8 cm (24 ½ x 17 ¼ in.)
Friends of American Art Collection, 1915.592
Signed across top: *To my friend, Mrs. Dyer.*
John S. Sargent. Venice. 1880

34

JOHN SINGER SARGENT (1856–1925)

*Madame Paul Escudier
(Louise Lefevre)*

1882
Oil on canvas; 129.5 x 91.4 cm (51 x 36 in.)
Bequest of Brooks McCormick, 2007.391
Signed lower right: *John S. Sargent 1882*

Sargent's undercutting of painting traditions, as well as his use of flashy, dark brushwork and his experimentation with modern, working-class subject matter, allies his early works with those of the Impressionists. Yet unlike Impressionists such as Manet, Sargent wanted to succeed in the traditional academic realm of the Paris Salon, as well as in more radical venues. He deliberately planned his exhibition schedule so that he could succeed in a number of different arenas at once.[17] While he used Impressionist aspects to make his pictures seem more avant-garde and exciting, he also incorporated academic characteristics, carefully rendering his sitter's anatomy in three-dimensional space as he had been taught at the École and as was still valued by the Salon jury. Spatially ambiguous portraits such as that of Madame Escudier are the exception in Sargent's oeuvre, not the rule.

Despite his attempts to please all sides of the art world, in 1884 Sargent went too far. His portrait of *Madame X* (Metropolitan Museum of Art, New York), with her falling gown strap and dominant, sexual stance scandalized the public. The French upper classes, frightened that they, too, would be depicted in such a vulgar manner, refused to commission portraits from Sargent. Seeking to make a living through his art, Sargent found new patrons in England, relocating there permanently in 1885. In Britain, he undertook an entirely different kind of Impressionism.

Faced with a dearth of portrait sitters, Sargent turned to landscape, experimenting extensively for the first time with the Impressionist technique of painting *en plein air* in works such as *Claude Monet Painting by the Edge of a Wood* of c. 1885 (fig. 13). Sargent had met Monet around 1876, and they went on to exhibit together in Paris at the Cercle des arts liberaux in 1881 and the Galerie Georges Petit in 1885. By the late 1880s, they were good friends, and Sargent visited Monet at his home in Giverny on several occasions. There, as recorded in *Claude Monet Painting by the Edge of a Wood*, he observed his friend painting landscapes outdoors. Inspired by Monet's example, Sargent began to experiment with

17 Simpson 1997.

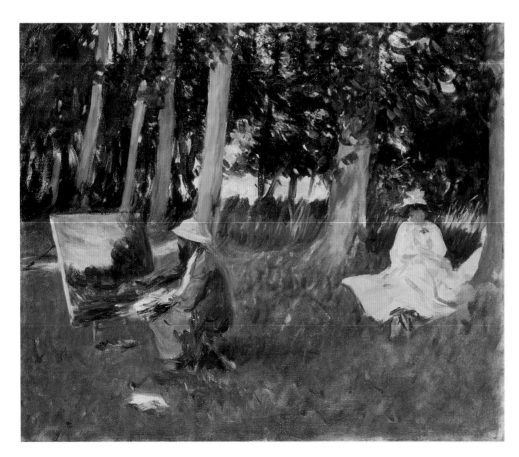

Figure 13. John Singer Sargent (American, 1856–1925). *Claude Monet Painting by the Edge of a Wood,* c. 1885. Oil on canvas; 54 x 64.8 cm (21 ¼ x 25 ½ in.). Tate Britain, London, Presented by Miss Emily Sargent and Mrs. Ormond through the Art Fund 1925.

35

JOHN SINGER SARGENT (1856–1925)

Thistles

1885/89
Oil on canvas; 55.9 x 71.8 cm (22 x 28¼ in.)
Gift of Brooks McCormick, 1996.446

36

JOHN SINGER SARGENT (1856–1925)

Mrs. Charles Deering
(Marion Denison Whipple)

1888
Oil on canvas; 71.1 x 61 cm (28 x 24 in.)
Anonymous loan, 9.2002
Signed across top: *1888 John S. Sargent*

37

JOHN SINGER SARGENT (1856–1925)

Mrs. George Swinton (Elizabeth Ebsworth)

1897
Oil on canvas; 231 x 124 cm (90 ³/₄ x 48 ³/₄ in.)
Wirt D. Walker Collection, 1922.4450
Signed lower left: *John S. Sargent*

plein-air painting, writing that he was going "in for out-of-door things."[18] Monet documented his newly close relationship with Sargent in a letter of October 20, 1885, writing: "This evening I can only write you a few short lines, I had a pile of mail to deal with including an urgent reply to a letter from Sargent making an extraordinary enquiry about the use of yellow and green and asking me if I am coming to London; he needs me to advise him on the pictures he is working on."[19]

The "pictures" Monet referenced were those Sargent had executed in the Worcestershire town of Broadway, in the Cotswolds, an Anglo-American artists' colony he first visited in September 1885.[20] Sargent worked in Worcestershire every year between 1885 and 1889, executing a series of *plein-air* landscapes, including the Art Institute's *Thistles* (pl. 35). As this painting illustrates, in this period Sargent began to adopt Monet's brighter palette, leaving behind Manet's darker, Spanish-influenced hues. He also experimented with Monet's use of painterly brushwork to depict his subjects in a realistic atmosphere, in this case using strokes of white and brown to convey how the thistles looked in light and shadow. While these characteristics of *Thistles* are typical of Sargent's Worcestershire paintings, the picture is more abstract than nearly all of his other works. The mass of thistles fills the composition almost entirely so that the viewer has no sense of three-dimensional space. With the eye arrested at the level of the picture plane by the tangle of plants, the viewer is reminded of the work's reality as paint on canvas, a modernist concern Sargent shared with the Impressionists.

Nevertheless, while he experimented with radical Impressionist treatment in his landscapes, Sargent continued to incorporate it only sparingly into his portraits. In his 1888 portrait *Mrs. Charles Deering (Marion Denison Whipple)* (pl. 36), for instance, he used free paint strokes to suggest the surface of his subject's gown but a tighter, more academic manner to render her face and hands. For his sitters, this combination was ideal, since it made them look simultaneously traditional and modern. Although it was a number of years before Sargent's portrait career recovered from the *Madame X* scandal, by the 1890s the Anglo-American upper classes had concluded that his style memorialized them perfectly for posterity. *Mrs. George Swinton (Elizabeth Ebsworth)* of 1897 (pl. 37) is a magnificent example of Sargent's mature portrait style, combining as it does a careful depiction of the subject's face and hands with a wonderfully free rendering of the highlights on her satin gown. Surrounded by Rococo furnishings, Elizabeth Swinton would immediately have been understood as a member of the upper class, and her portrait seen as part of the English tradition begun by seventeenth- and eighteenth-century artists such as Anthony Van Dyck and Thomas Gainsborough. At the same time, Sargent's selective but exceptional use of Impressionist paint handling would have clearly marked the portrait as modern and cutting edge.

Portraits brought Sargent widespread critical and financial success in the 1890s. However, he never liked painting them. He knew that succeeding with the genre involved careful accommodation of the sitter's desires and therefore a limitation of the artist's creativity. As Sargent grew both increasingly frustrated with this lack of artistic freedom and more financially stable, he began to use the summers to paint landscapes and figure studies around Europe. In these works, he experimented with a looser style than he was able to use in his portraits, further developing his own individual brand of Impressionism.

In these years, Sargent evolved a preferred travel itinerary in which he spent high summer in the Alps and then moved on to Venice and other Mediterranean locales. His *Fountain of Neptune* of 1902 (pl. 38), for example, depicts Bartolomeo Ammanati's Fountain of Neptune (1565–75) in Florence, a work that displays the elongation and exaggeration of form typical of Italian Mannerism. Sargent's view of the fountain eliminates Neptune, concentrating instead on three of the peripheral figures. This unusual perspective enhances the viewer's sense of the work's Mannerist distortion. Furthermore, the figures at center and

18 John Singer Sargent to Henry Marquand, Sept. 1, 1888, Robert Graham Collection of Autograph Letters, Archives of American Art, Smithsonian Institution.

19 Claude Monet to Alice Hoschedé, Oct. 20, 1885; quoted in Daniel Wildenstein, *Claude Monet: Biographie et catalogue raisonné* (La Bibliothèque des Arts, Fondation Wildenstein, 1979), vol. 2, p. 262.

20 On the Broadway artists' colony, see Marc Simpson, "Reconstructing the Golden Age: American Artists in Broadway, Worcestershire, 1885 to 1889" (Ph.D. diss., Yale University, 1993).

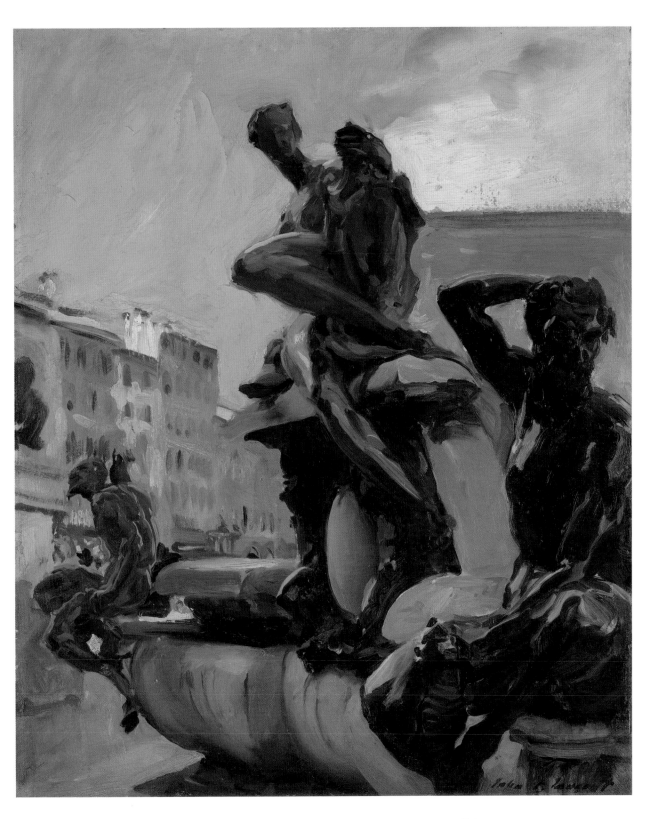

38

JOHN SINGER SARGENT (1856–1925)

Fountain of Neptune

1902
Oil on board; 57.2 x 47.6 cm (22 1/2 x 18 3/4 in.)
Anonymous loan, 313.1996
Signed lower right: *John S. Sargent*

right in Sargent's composition are radically foreshortened, making them hard to read spatially. Instead, the viewer is left with the impression of their contorted movement, seen in shadow against the sunlit Piazza della Signoria beyond. Painted *en plein air*, such works illustrate how Sargent had fully synthesized the Impressionist rendering of the fall of light into his art.

By 1907, Sargent was so occupied with landscapes and subject pictures that he decided to quit painting portraits. When members of the Anglo-American elite wanted to commission a portrait from him after this, he would usually only execute a charcoal drawing, which could be finished in one sitting. He painted fewer than thirty oil portraits in the remaining eighteen years of his career.

A masterpiece of this late period is *The Fountain, Villa Torlonia, Frascati, Italy* of 1907 (pl. 39). In this painting, Sargent depicted his friends, fellow artists, and frequent traveling companions Jane and Wilfred de Glehn surrounded by the gardens of the Villa Torlonia in Frascati, near Rome. Jane de Glehn described sitting for the picture in a letter:

> Sargent is doing a most amusing and killingly funny picture in oils of me perched on a balustrade painting. It is the very "spit" of me. . . . We tried to go on with it this morning but too much rain. . . . I am all in white with a white painting blouse and a pale blue veil around my hat. I look rather like a pierrot, but have rather a worried expression as every painter should have who isn't a perfect fool, says Sargent.[21]

Sargent only rarely painted self-portraits, but he frequently depicted his fellow artists at work. As he did with Jane de Glehn, he often used them as surrogates to express his own painting concerns. Yet if Sargent worried while he was painting *The Fountain,* the finished work shows no sign of his anxiety. Instead, his dazzling painting technique is everywhere in evidence: in the rendering of the sunlight and shade on his sitters' white clothes, the light falling on the architecture, and the spray of the fountain in the background.

Is *The Fountain* an Impressionist painting? As always with Sargent, the answer is equivocal. He executed the work outside, *en plein air*, and focused in it on the fall of light on surfaces, with spectacular results. Yet his light and shadows are not made up of splashes of individual colors, mimicking the way people actually see, as they are in Monet's work, for example. Instead, Sargent depicted light and shade using the same value contrasts—albeit much more freely rendered—that he had learned in his academic training years before. Monet himself identified this characteristic of Sargent's art: "He wasn't an Impressionist, in our sense of the word, he was too much under the influence of Carolus-Duran."[22] As *The Fountain* demonstrates, Sargent synthesized what he had learned from Carolus-Duran with Impressionism to produce a personal style that magnificently suggests how the world looks in light and shadow. His paintings would never be mistaken for Monet's, and yet they succeed equally in achieving the Impressionist goal of evoking what we actually see.

As Sargent became increasingly occupied with *plein-air* landscapes and figure studies in the first decade of the twentieth century, he began to use watercolor more frequently. Although he had worked in the medium since his student days, it was only in this later period that he devoted himself to it, finding that watercolor's rapid execution made it ideal for capturing fleeting light effects. As he painted more in the medium, his method became freer, with few of the pencil outlines that watercolorists traditionally used to block in a composition. As his *Olive Trees, Corfu* of c. 1909 (pl. 40) demonstrates, Sargent typically employed a wide variety of techniques in order to achieve the final picture. In this work, he overlaid layers of watercolor wash with touches of gouache and scraped out paint to suggest the highlights. The subject is a scene on the Greek island of Corfu, where Sargent stayed with a group of friends in 1909. As in the oil *Thistles*, painted over twenty years before, his

21 Jane de Glehn to Lydia Field Emmet, Oct. 6, 1907, Emmet Family Papers, Archives of American Art, Smithsonian Institution.

22 Claude Monet, quoted in Charteris (note 6), p. 130.

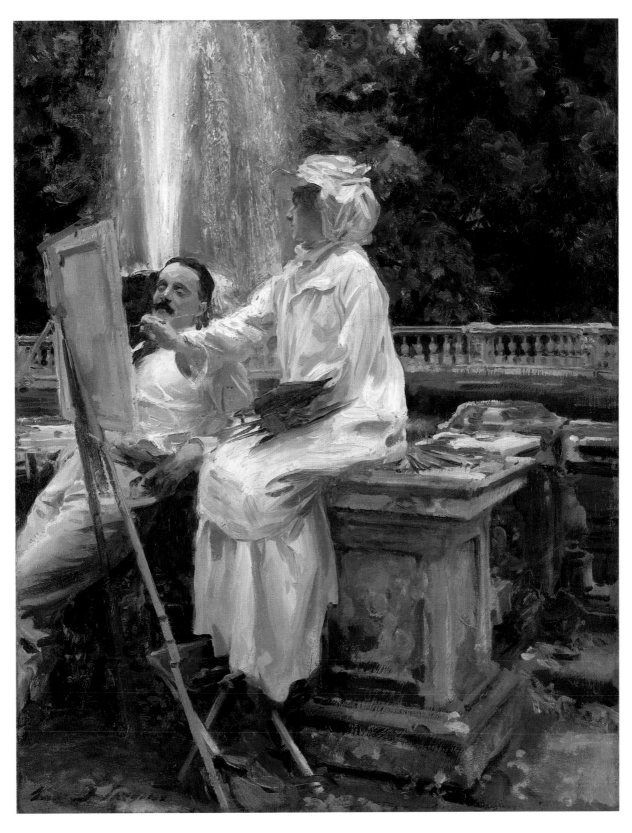

39

JOHN SINGER SARGENT (1856–1925)

The Fountain, Villa Torlonia,
Frascati, Italy

1907
Oil on canvas; 71.4 x 56.5 cm (28⅛ x 22¼ in.)
Friends of American Art Collection, 1914.57
Signed lower left: *John S. Sargent*

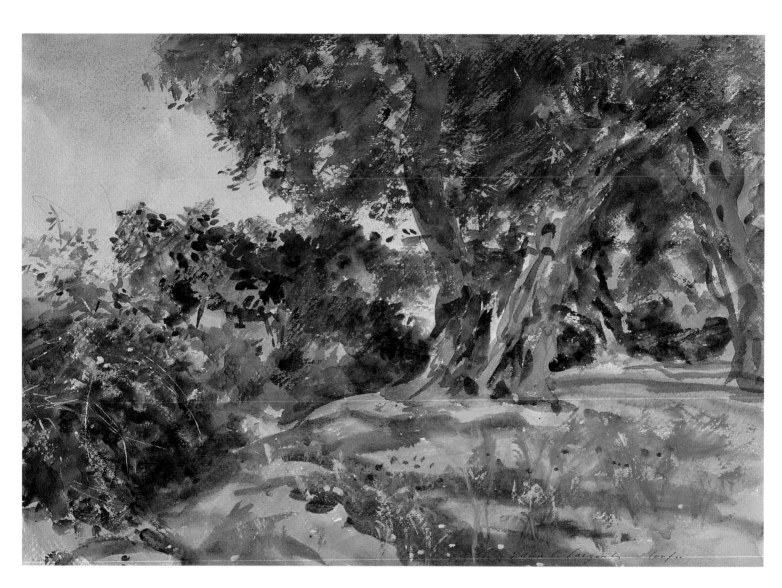

40

JOHN SINGER SARGENT (1856–1925)

Olive Trees, Corfu

c. 1909
Watercolor and gouache, with scraping, over touches of pen and blue ink, on cream wove paper; 35.6 x 50.8 cm (14 x 20 in.)
Olivia Shaler Swan Memorial Collection, 1933.505
Signed lower right: *John S. Sargent - Corfu*

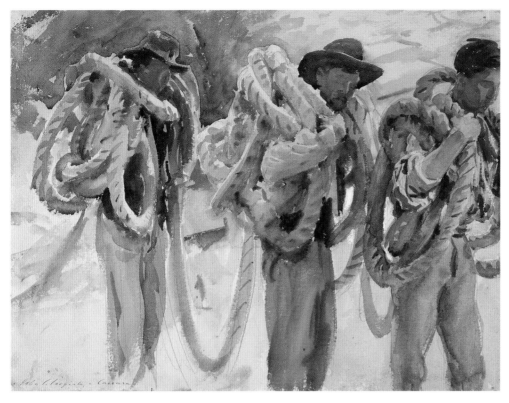

41

JOHN SINGER SARGENT (1856–1925)

Workmen at Carrara

c. 1911
Watercolor, over graphite, heightened with white gouache, on ivory wove paper; 40.3 x 53.4 cm (15 7/8 x 21 in.)
Olivia Shaler Swan Memorial Collection, 1933.507
Signed lower left: *John S. Sargent—Carrara*

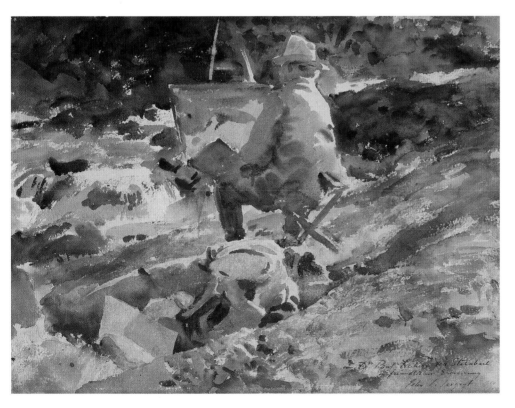

42

JOHN SINGER SARGENT (1856–1925)

An Artist at His Easel

1914
Watercolor, over traces of graphite, on cream wove paper; 40 x 53.4 cm (15 3/4 x 21 in.)
Gift of Charles Deering McCormick, Brooks McCormick, and Roger McCormick, 1962.971
Signed lower right: *an Dr. Paul Freiherr von Sternbach / in freundlicher Erinnerung / John S. Sargent 1914*

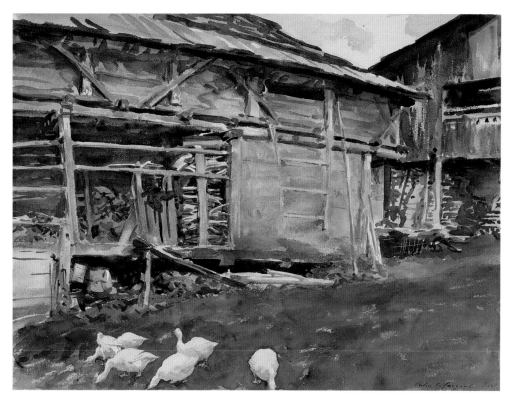

43

JOHN SINGER SARGENT (1856–1925)

Woodsheds—Tyrol

c. 1914
Watercolor, over touches of graphite, on ivory
wove paper; 40 x 53.6 cm (15 ³/₄ x 21 ¹/₈ in.)
Olivia Shaler Swan Memorial Collection, 1933.506
Signed lower right: *John S. Sargent, Tyrol*

expressive use of paint, especially in the foreground, reminds the viewer that the picture is
just that: paint on paper, not a window on the world. Although by this time, Sargent's use
of free brushwork to render the fall of light on surfaces was seen as traditional instead of
avant-garde, such abstract touches ally his late landscapes, just as they do the late works of
his friend Monet, with contemporaneous Fauvist and Expressionist works.

Despite these hints of modernism, however, Sargent's subject matter in these late works
was traditional, the opposite of the contemporary life he had depicted in his earlier Venetian
pictures. In 1911, for instance, he traveled to the marble quarry of Carrara in Italy, drawn
there because of its history as a supplier of raw material for centuries of sculptors, including
Michelangelo, Bernini, and Canova. Sargent's watercolor *Workmen at Carrara* (pl. 41), one of
some eighteen works he painted there, depicts the ancestral quarrying method that had been
used at the site for generations. In this view of three workmen lined up, evenly spaced across
the paper's surface, Sargent emphasized the repetitive, back-breaking nature of this labor.

In the summer of 1914, Sargent's annual sketching expedition to the Alps was extended
when World War I erupted. He found himself in the town of Colfuschg, Austria, without a
passport and in the company of enemy aliens, the English artists Adrian and Marianne
Stokes. Held in Austria until November, Sargent executed an extended series of views of the
Tyrol, including *An Artist at His Easel* (pl. 42) and *Woodsheds—Tyrol* (pl. 43). Although some
of Sargent's works from this period depict Tyrolean graveyards, churches, and crucifixes,
perhaps indicating the artist's unease at the outbreak of war, these two watercolors give no
hint of the fact that the Western world as Sargent knew it was crashing down around him.

Sargent managed to get back to England but had to vary his usual travel itinerary for the
remainder of the war. In 1917, he visited the Villa Vizcaya, James Deering's Renaissance-style
mansion in Miami, Florida. There, he painted his longtime friend Charles Deering (pl. 44),
James's brother and Marion Deering's husband (see pl. 36), whom he had met in 1876.
Although Charles Deering had some ambition to become a painter, he eventually decided to
work in his father's business, Deering Harvester Company, instead. The success of this

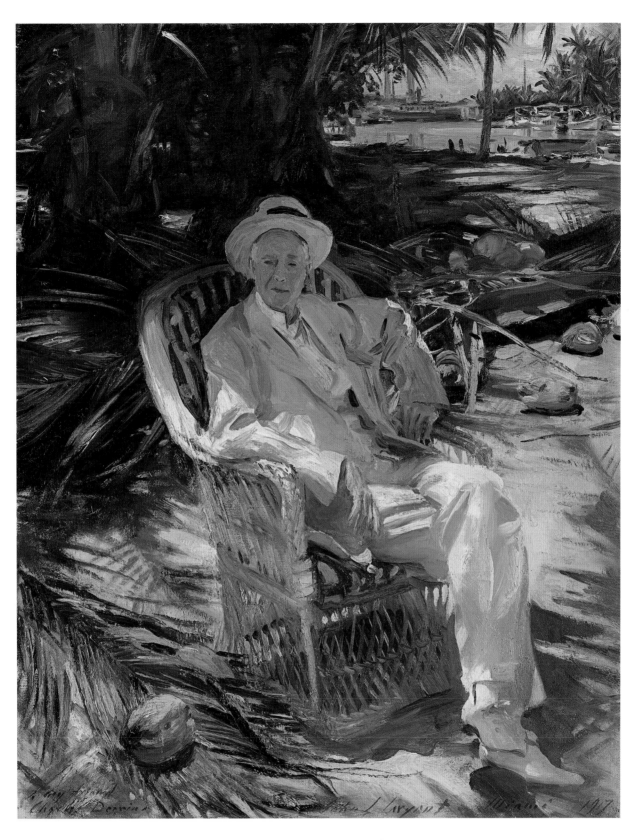

44

JOHN SINGER SARGENT (1856–1925)

Portrait of Charles Deering
1917
Oil on canvas; 72.4 x 53.3 cm (28½ x 21 in.)
Anonymous loan, 8.2002
Signed lower right: *John S. Sargent Miami 1917*

enterprise, later renamed International Harvester, enabled Deering and his brother to become major patrons of the arts and especially of Sargent's work. The Art Institute owes much of its Sargent collection to the generosity of Charles Deering and his family.

In his 1917 portrait of his friend, Sargent depicted him surrounded by south Florida's characteristic landscape, with its palm trees, sand, and gleaming blue ocean. Yet, just as in his views of Italy and England, he focused primarily on capturing how Deering looked as he sat in a chair dappled by sunlight and shade. Perhaps because he was portraying a close friend, this portrait is one of the rare instances when Sargent's Impressionist paint handling takes over not just the landscape but the human form as well, making Deering appear to be a seamless part of his surroundings. Similarly, in a series of watercolors Sargent painted at Vizcaya, including *The Basin, Vizcaya* (pl. 45) and *The Loggia, Vizcaya* (pl. 46), he concentrated on rendering the look of sunlight falling across the Renaissance-style architecture, just as he had done in Europe. Indeed, Sargent's views of James Deering's mansion enhance the viewer's sense of the house as an Old World palace, just as Deering wanted it to be seen.

The Art Institute of Chicago's strong collection of Sargent's work demonstrates that his relationship with Impressionism was never a straightforward one. In his early career, his broad paint handling and dark palette allied his pictures with Manet's strand of the movement, while in his later career, his focus on sunlit landscapes rendered *en plein air* linked his paintings to Monet's work. Yet, like most American Impressionists, Sargent nearly always rendered the human figure with the tighter control he had learned in his academic training. Although he was born in Europe and lived the great majority of his life there, in this sense Sargent remained an American painter throughout his career. Impressionism was for him only one of a number of tools that he could use to capture how the world looked. His personal painting style, combining, as perhaps no other artist did so successfully, academicism with Impressionism, traditionalism with modernism, enabled him to brilliantly achieve this goal.

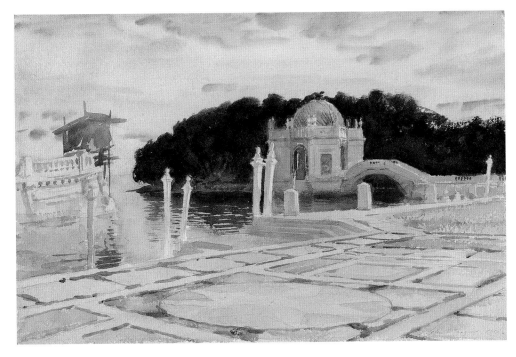

45

JOHN SINGER SARGENT (1856–1925)

The Basin, Vizcaya

1917
Watercolor, over graphite, on paper; 33.7 x 52.1
cm (13¼ x 20½ in.)
Anonymous loan, 309.1996
Signed lower right: *John S. Sargent 1917*

46

JOHN SINGER SARGENT (1856–1925)

The Loggia, Vizcaya

1917
Watercolor, over graphite, on paper; 38.7 x 52.1
cm (15¼ x 20½ in.)
Anonymous loan, 310.1996
Signed lower left: *John S. Sargent 1917*

FIVE

Other Americans Abroad: The Lure of Paris

LIKE MOTHS TO A FLAME, American artists flocked to Paris, the center of the art world in the nineteenth century. Some arrived having already exhibited successfully, such as Childe Hassam (pls. 48–49), while others came with less skill, yet all were open to the experience of absorbing what the city had to offer the artist, through museums, galleries, and acquaintances with fellow painters.

Many of the Americans enrolled in the Académie Julian, a school comprising several ateliers and offering classes in drawing, painting, and sculpture.[1] Founded by Rodolphe Julian in 1868, the academy offered a viable alternative to the École des beaux-arts in its acceptance of female and non-French students, and lack of a rigorous—or indeed any—entrance examination. However, the Académie Julian was hardly radical in its teaching philosophies; professors advocated an academic training, usually centered on the human figure. Instructors, who included Adolphe-William Bouguereau and Jules Lefebvre, were noncontroversial.

For artists who wished to exhibit at the prestigious Salon, conservative practices were necessary to appeal to the traditional juries, and figurative paintings were an obvious way to do this. Cecilia Beaux (pl. 62) showed her French-titled *Les derniers jours d'enfance* (translated as *The Last Days of Infancy*) (Pennsylvania Academy of the Fine Arts) in 1887, and Walter Gay (pl. 51) exhibited *The Blessing (La Bénédicité)* (Musée de Picardie, Amiens) in 1879. The former depicts a mother holding her young son on her lap and the latter a pious elderly woman before her humble repast; both paintings are in muted tones and both were well received at the time.

At the same time, the latter part of the nineteenth century was a revolutionary era for artists in Paris. In 1863 the Salon des Refusés displayed works by Édouard Manet and Camille Pissarro, the French Impressionists exhibited from 1874 to 1886, and the Salon des Indépendants held its first show in 1884. American artists would have seen some of these exhibitions and could have met some of their French counterparts as well. Indeed, the rate at which the artists' colony in Giverny thrived after Claude Monet moved there in 1883 is testament to the influence of the Impressionists on other artists.

Yet the Americans did not follow a prescribed journey. Some, like Theodore Robinson (pl. 47), spent many extended periods in Giverny, working with Monet. Others, such as Thomas Wilmer Dewing (pl. 69), studied at the Académie Julian but then returned home, making their careers in America. Walter Gay made his permanent home in France, although apart from the artists' colony at Giverny, while Frank Benson (pl. 63) never returned overseas after his first visit. The allure of France encompassed the Americans, but each responded individually to the call.

1 Little research has been done on the Académie Julian, but an excellent resource is Catherine Fehrer, *Julian Academy, Paris 1868-1939,* exh. cat. (New York: Shepherd Gallery, 1989).

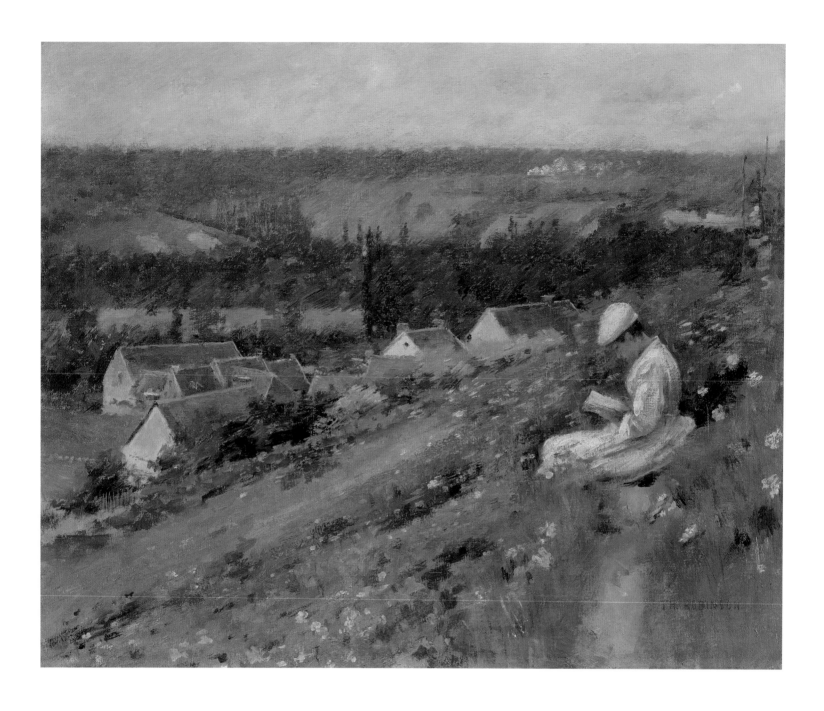

47

THEODORE ROBINSON (1852–1896)

The Valley of Arconville

c. 1887
Oil on canvas; 45.8 x 55.7 cm (18 x 21⁷/₈ in.)
Friends of American Art Collection, 1941.11
Signed lower right: *TH. ROBINSON*

Theodore Robinson was one of the first American painters to embrace Impressionism. Born in Irasburg, Vermont, he took his first art classes at the Chicago Academy of Design, and then attended the National Academy of Design and the Art Students' League in New York. In 1876, he moved to Paris, where he studied at the École des beaux-arts and with Carolus-Duran and Jean-Léon Gérôme. Synthesizing this academic training with his admiration for Winslow Homer (see pls. 1–9) and French Barbizon painter Jean-François Millet, Robinson evolved a style that focused on capturing effects of light while still rendering solid form.

In 1887, he began to spend extended periods in the small town of Giverny, northwest of Paris, where he was one of the first Americans to work alongside French Impressionist Claude Monet. The two became close friends, and Robinson incorporated Monet's strokes of pure color to suggest transitory effects of light into his landscapes of the French countryside. In *The Valley of Arconville*, which depicts an area southeast of Paris, Robinson's rough paint handling and focus on the hill's diagonal slope create a sense of movement that contrasts with the stillness of Marie, a close friend and frequent model, who sits at right. Robinson painted a number of these panoramic views across valleys, perhaps in emulation of Monet's series paintings.

At this stage, Impressionism was still controversial in America. In 1887, a writer for the *Art Amateur* reported: "Quite an American colony has gathered . . . at [Giverny] . . . the home of Claude Monet, including . . . W. L. Metcalf [see pl. 67] . . . and Theodore Robinson of New York. A few pictures just received from these young men show that they have all got the blue-green color of Monet's impressionism and 'got it bad.'"[1] By the time of the Society of American Artists exhibition in 1889, however, where Robinson became one of the first Americans to show a group of Impressionist paintings—including *The Valley of Arconville*—an *Art Amateur* critic declared:

> Robinson is one of those who have really gained a good deal by study of impressionistic methods. Of his seven contributions, there is none which does not show a solid advance beyond his work of previous years, and none that does not belong distinctly to the new school. The narrowing of his aim in this case, as in so many others, has been the saving of the artist.[2]

Robinson's exhibitions and teaching of *plein-air* painting helped to facilitate the dissemination of Impressionism in America. (EER)

1 Greta, "Boston Art and Artists," *Art Amateur* 17, no. 5 (Oct. 1887), p. 93.

2 "The Society of American Artists," *Art Amateur* 21, no. 2 (July 1889), p. 28.

CHILDE HASSAM (1859–1935)

48

Saint-Cloud

1889
Watercolor on paper; 18 x 27.5 cm (sight) (7 1/8 x
10 13/16 in.)
Bequest of Marion E. Merrill, 1978.481
Signed lower left: *Childe Hassam St. Cloud 1889*

49

View of a Southern French City

1910
Oil on board; 65.1 x 52 cm (25 5/8 x 20 5/8 in.)
Anonymous loan, 79.1972
Signed lower left: *Childe Hassam 1910*

Childe Hassam was perhaps the most nomadic of the group of artists known as the American Impressionists; he painted various locations along the New England coast (see pl. 57), as well as many sites in Europe. Arriving in Paris in 1886 with the intention of staying for three years, Hassam immediately enrolled at the Académie Julian and began making the acquaintance of other artists, both American and French. He had an advantage in that he had previously exhibited successfully in Boston and other places and was thus somewhat of an established artist. During the summer of 1889, the artist traveled to areas outside of Paris and then later to England, all the while painting watercolors, a medium with which he was very familiar and comfortable. *Saint-Cloud* would have been done during this period. The small size of the watercolor indicates that this was a travel-related composition, one of many completed that summer.

Located outside of Paris, the town of Saint-Cloud contains a large park overlooking the Seine, which is undoubtedly where Hassam painted this image. In this compact watercolor the artist depicts visitors strolling through the gardens on what appears to be a hot summer day, as evidenced by the parasols held by the women bringing up the rear.

A young girl apart from the crowd is the main figural focus. Her light blue dress contrasts with the dark greenery around her, and she holds several rosy blossoms. To achieve the effect of thick foliage Hassam has layered many different hues of transparent green washes, with a break in the far background providing the only sense of sunlight; nonetheless, the overall effect is one of airy freshness.

Hassam and his wife made another trip overseas in 1910. As during his earlier voyages, he embarked on an ambitious schedule of painting, going from London to the Netherlands, then through France and Spain, all within a period of four months. *View of a Southern French City* was likely painted sometime in late summer or early fall of that year. The precise location is not known, but the pastel hues evoke the light and colors of the Mediterranean. The composition is similar to that of a painting done on Bastille Day in Paris, *July Fourteenth, Rue Daunou, 1910* (Metropolitan Museum of Art, New York), in which the artist captured, from a hotel window, the celebratory mood of throngs of Parisians as

they congregate in the street, with colorful flags, the majority of them French, flying from nearby buildings. *View of a Southern French City* was likewise painted from a high viewpoint and shows a crowd of people; here, the bustling activity is located in the village square, where an open-air market is taking place. Unlike the contemplative mood that characterizes *Saint-Cloud,* the canvas here is lively and full of movement. The brightly colored flickers of paint used to render the figures in the center provide a contrast to the paler and more broadly brushed buildings and landscape. Given the long shadows, it is either morning or late afternoon that is portrayed, and the shade of the taller buildings falls onto the majority of the figures, sharply separating them from the sun-soaked structures just yards away. The artist was noted for his urban and rural landscapes, and elements of both are present here, with an expansive countryside spreading beyond the crowds and architecture in the foreground. Hassam would travel to France again, but this was his last ambitious working European trip. (DM)

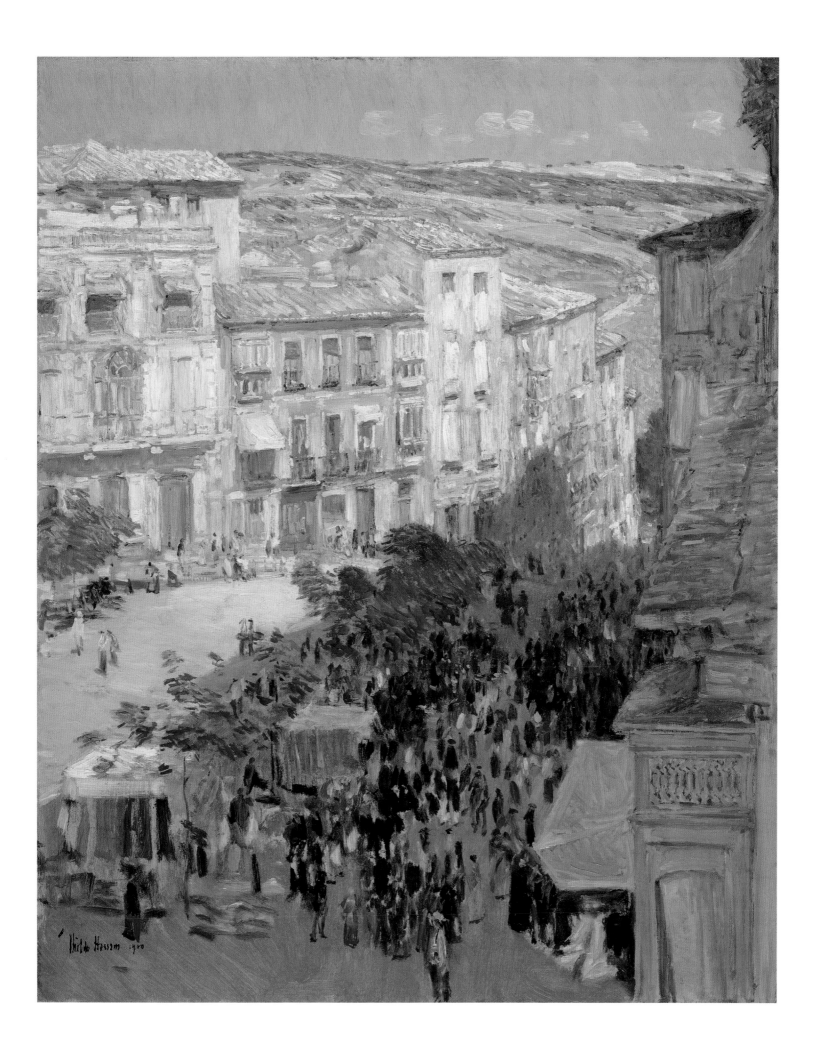

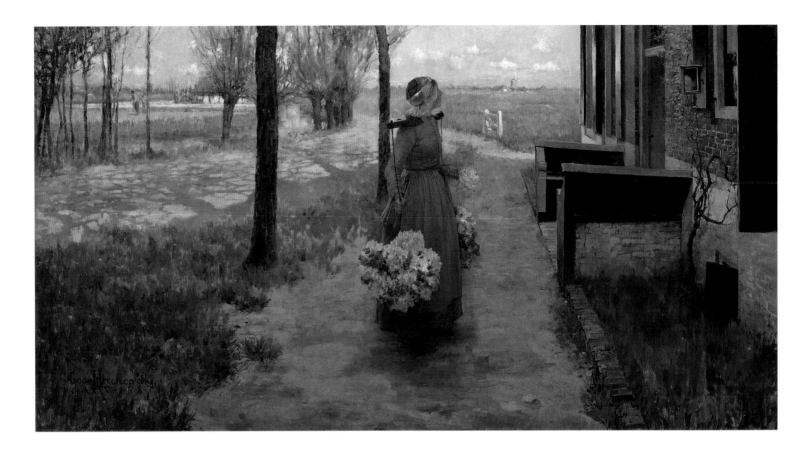

50

GEORGE HITCHCOCK (1850–1913)

Flower Girl in Holland

1887
Oil on canvas; 79.1 x 147.3 cm (31⅛ x 58 in.)
Potter Palmer Collection, 1888.169
Signed lower left: *Geo. Hitchcock op. XXXV 1-8-8-7*

Following in his father's footsteps, George Hitchcock graduated from Harvard Law School and then began a legal practice in Chicago. While there he viewed an exhibition of watercolors and was inspired to begin painting himself. He traveled to Paris to study at the Académie Julian, where the emphasis was on drawing. Wanting to learn more about color, Hitchcock left Paris after a year and went to Holland. There he was influenced first by such artists as Anton Mauve and Hendrik Willem Mesdag of the Hague School, whose landscapes are characterized by grays, olive greens, and other subdued tones. This is evident in his

1887 painting *The Annunciation* (Art Institute of Chicago), which features a palette of cool blues, greens, browns, and shades of gray. However, his success at the Paris Salon with another 1887 painting, *Tulip Culture* (*La culture des tulipes*) (private collection), was instrumental in turning his color scheme toward brighter and more richly hued works, often with flowers as their theme, such as *Flower Girl in Holland*, painted the same year. It is also possible that Hitchcock saw and was influenced by Claude Monet's paintings of tulip fields when they were exhibited in Paris in 1886.

Flower Girl in Holland depicts a young girl with a yoke over her shoulders at the ends of which two buckets overflow with vibrant blossoms; holding a smaller bunch in her hand she hesitates and turns expectantly toward a door she has just passed. Hitchcock wrote a series of articles entitled "The Picturesque Quality of Holland," which was published in *Scribner's Magazine*, and in one

he described this very girl: "A fresh complexioned girl, with large balls of many-colored flowers," who "is often seen in the spring turning an honest penny in a beautiful way."[1] Having settled in the coastal area of Egmond in northern Holland in the early 1880s, Hitchcock greatly admired the Dutch people and their customs.

This regard for the people and ways of the Egmond community led the artist to depict them in a romantic and idealized manner. His subjects appear to reject modern technology in favor of a simple life. *Flower Girl in Holland* shows the slow pace of such an existence—the old-fashioned dress of the young woman and of the two figures in the background, the winding dirt path, the ambling stream, and the windmill in the distance give no hint of the contemporary world. (DM)

1 George Hitchcock, "The Picturesque Quality of Holland—Figures and Costumes," *Scribner's Magazine* 10, no. 5 (Nov. 1891), p. 627.

51

WALTER GAY (1856–1937)

The Commode

1905/12
Oil on canvas; 66 x 54.6 cm (26 x 21½ in.)
Friends of American Art Collection, 1914.357
Signed lower right: *Walter Gay*

Walter Gay and his wife, Matilda, were both
American-born, but they made their lives in
France. Immediately after their marriage in
1899, they lived in an apartment in Paris,
then for several years rented residences at
different locations outside the city. The
Gays first leased Château du Bréau, located
southeast of Paris, in 1905; in 1908 they were
able to purchase the property, which they
kept for the rest of their lives.

The Gays' life in France did not include
many other American expatriate painters or
indeed any of the French Impressionists.
Given Matilda's wealth and their somewhat
conservative artistic views, they were more
comfortable socializing with members of the
French elite. They were also close to the
American writers Edith Wharton and
Henry James and counted French artists
such as Paul Helleu and Gay's former
instructor, Léon Bonnat, as part of their
circle. It was only after the move to Le Bréau
that Walter Gay found his artistic calling in
the painting of interiors like *The Commode*.

The Commode depicts one of the salons
in the Gays' château. As in many of the
artist's interiors, the addition of a mirror and
a door leading to another room serves to
open up the space of the painting. The
symmetrical placement of the two chairs and
the objects atop the commode reflects a sense
of order and a lifestyle of luxury, while the
open door indicates a recent presence, as if
someone has just left the room. The Gays
looked to the past when furnishing their
homes, as is evidenced here in the Louis XV
commode. They also often moved furniture

from house to house, and the titular piece
is present in other paintings, albeit in
different locations and with different
articles on its surface.

Despite artistic shifts during his lifetime,
Gay continued to paint these realistic
interior scenes, both of his own residences
and commissions. Yet while conservative in
nature, the effects of sunlight and opening
of space looked toward modernism, and his
works were positively received, both
critically and financially. (DM)

52

HERMANN DUDLEY MURPHY (1867–1945)

Henry Ossawa Tanner

1896
Oil on canvas; 73 x 50.2 cm (28 ¾ x 19 ¾ in.)
Friends of American Art Collection, 1924.37
Signed lower left, with colophon; inscribed on
verso: *Hermann Dudley Murphy. / 18* [colophon]
*96 / Portrait of / Henry Ossawa Tanner / Salon of
the / Champs de Mars 1896*

Born in Marblehead, Massachusetts,
Hermann Dudley Murphy took his first art
classes at the School of the Museum of Fine
Arts in Boston and then worked in that city
as an illustrator. In 1891, he moved to Paris,
where he studied at the Académie Julian and
the École des beaux-arts. At the Académie,
he met fellow American painting student
Henry Ossawa Tanner. The two became
close friends and roomed together on the
boulevard Saint-Jacques. Despite their
academic art training, both Murphy and
Tanner were deeply influenced by the work
of James McNeill Whistler (see pls. 10–18),
whom they likely knew in Paris in these
years. In his portrait of Tanner, Murphy
emulated Whistler's distinctive thinly
applied paint and reduced palette of grays
and greens. Murphy's colophon signature,
carefully placed at left to create a Japanesque
sense of asymmetrical balance, is also
reminiscent of Whistler's practice.

This portrait was greatly admired in its
time and was shown widely. In 1896 alone, it
was accepted into the annual exhibitions at
the Paris Salon, the Art Institute of Chicago,
and the Pennsylvania Academy of the Fine
Arts in Philadelphia, and it went on to win a
silver medal at the 1904 Louisiana Purchase
Exposition in St. Louis. Part of the portrait's
attraction was its sitter, who was becoming a
well-known painter, especially of religious
subjects. A writer in the *Chicago Times-Herald*
declared in 1900, for example: "In this portrait
[Tanner's] artistic personality lives, with his
highly arched brows, his thin but well-
modeled head, the thoughtful eyes, gazing
into those of the observer, the whole melting
intangibly into the soft grayish background."[1]

Murphy returned to the United States in
1897, where he specialized in landscape and
floral still life, but Tanner chose to remain in

France for the rest of his career; as an
African American, he encountered less
discrimination there. Offering this painting
to the Art Institute in 1923, Murphy noted:
"As the Art Institute was the first museum
in the U.S. to buy one of Tanner's pictures—
as well as one of my own—it seems quite
fitting that it should belong to the Institute if

the Committee care to have it."[2] The next
year, the Friends of American Art purchased
the work for the museum. (EER)

1 "Art: Exhibitions of the Week," *Chicago Times-Herald*,
January 7, 1900, p. 7.

2 Hermann Dudley Murphy to Robert Harshe, Nov. 19,
1923, Robert Harshe Papers, Ryerson and Burnham
Libraries, Art Institute of Chicago.

53

FREDERICK W. MACMONNIES (1863–1937)

Self-Portrait

1898/1906
Oil on canvas; 54.6 x 45.7 cm (21½ x 18 in.)
Restricted gift of Mrs. Harold T. Martin, 1980.202

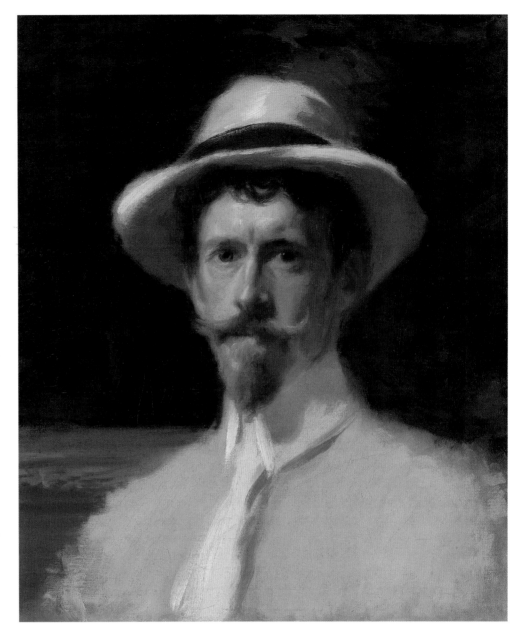

A neighbor of Claude Monet at Giverny, Frederick MacMonnies was part of a group of expatriate American artists who drew inspiration from their proximity to the well-known French Impressionist. Yet unlike his slightly earlier compatriots Theodore Robinson (see pl. 47) and Willard Metcalf (see pl. 67), MacMonnies did not depict the landscape surrounding his home, an old priory in France, but when painting concentrated on portraits or figures in situ.

MacMonnies abruptly gave up a successful career as a sculptor in the Beaux-Arts tradition to take up painting. An apprentice of Augustus Saint-Gaudens, he worked in a similar style, creating many commissioned public monuments. Most of these were for locations in the United States, so MacMonnies was a frequent traveler. While financially successful, the stress of these projects took a toll on his health. After a particularly harrowing episode over difficulties installing two large pieces, *Army* and *Navy,* on the *Soldiers and Sailors' Memorial Arch* in Brooklyn, Macmonnies took a break from sculpting. While this incident happened in 1900, it is likely he began painting around 1898 and continued in earnest for about eight years. However, his lack of commercial success in painting ultimately forced his return to sculpture.

At least eight self-portraits are known, and although none are signed or dated, they likely originate from this period. The artist was known for customarily wearing pink, as he is depicted in the Art Institute's portrait. Unlike several of his other self-portraits, in which he is shown holding a palette and brush, he is not identified as an artist in this painting. Looking more like a gentleman of leisure, he wears a hat, as if he were ready to depart to attend a casual gathering. MacMonnies was very social and was known to be a ladies' man, and here he exudes an easy confidence. The broken brushwork in the shirt and bold lighting on the face and hat show the painting's affinity with Impressionism. (DM)

54

EVERETT SHINN (1876–1953)

The Tired City (Early Morning, Paris)

1901
Pastel on paper; 53.3 x 73.7 cm (21 x 29 in.)
Watson F. Blair Purchase Prize, 1939.181
Signed lower right: *Everett Shinn 1901*

An extraordinarily versatile man, Everett Shinn was not just a talented painter but also a cinema art director, an illustrator, an interior decorator, a playwright, and a set designer. Fascinated by the theater, Shinn remains most famous for his brilliant representations of theatrical life, including *The Hippodrome, London* of 1902 (pl. 85). He was renowned for his participation in The Eight, a rebellious group of artists who broke from the restrictive selection policies of the National Academy of Design to hold their own exhibition in 1908. That display, however, only solidified his already substantial reputation as an innovative and dynamic artist. His early recognition derived largely from a group of striking pastels—among them *The Tired City*—that Shinn created between 1899 and 1901. *The Tired City*, a sober view of Paris at dawn, reveals his modern compositional techniques, masterful use of pastel, and interest in portraying the less fortunate members of society.

Shinn began his career as a newspaper illustrator in Philadelphia in 1893, an experience that shaped his later development as an artist by training him to work quickly from brief observations. He simultaneously enrolled at the Pennsylvania Academy of the Fine Arts, seeking to hone his skills as a draftsman. During this time, he met fellow illustrators William Glackens (see pl. 86), George Luks, and John Sloan; together they formed a circle around the influential artist Robert Henri, who encouraged them to paint the urban scene around them. In 1897, Shinn, the youngest of this group, relocated to New York, where he continued to work as an illustrator. He made his successful debut as a pastel painter at a solo exhibition in 1900, showing scenes of New York to great acclaim.

Later that year, Shinn spent six months in Paris and London, a period during which he frequently sketched his impressions of these metropolises. Over the next few years, Paris became the subject of a number of Shinn's pastels. Unlike his pastels of New York's public spaces, which prominently feature that city's bustling activity, his images of the French capital generally portray empty streets and quiet moments. In *The Tired City*, Shinn dedicated the foreground to a bare expanse of snow and the background to a row of shuttered and silent buildings. To the left, a rag picker encounters a starving cat, which arches its back in warning. The rag picker was a favorite subject of Shinn's, and in this pastel the man appears hunched over from the weight of his large sack, an image of hardship that evokes sympathy for his weary desperation.

Pastel was an ideal vehicle of expression for Shinn, as the use of its crayons enabled him to work rapidly, befitting his background as an illustrator. Previously considered a lesser form of artistic production, pastel had seen a resurgence of interest among artists, including James McNeill Whistler (see pl. 14). By the turn of the twentieth century, it was well established as a medium worthy of artistic respect. However, in contrast to the delicate, elegant pastels of Whistler and other American practitioners, Shinn's works are notably vigorous. In *The Tired City*, he roughly delineated the figure of the man and the trash heap behind him, and the details of the houses are similarly sketchy. Shinn then densely applied white and blue pastel to suggest the thick, shadowy snow. His working method was unusual and involved applying pastel to paper soaked in water. The damp pastel would dry to a hard finish, fixing the colors of the image with an intensity not usually associated with the medium's normally soft appearance. Critics admired such effects, with one author declaring in *Everybody's Magazine* in 1904: "Mr. Shinn has developed a free, fluent manner which is wholly his own, and the results achieved are genuinely artistic as well as genuinely novel."[1] Shinn's work in pastel so firmly established his reputation that this same critic could boldly proclaim, "Everett Shinn has arrived." (SEK)

1 "Everett Shinn Has Arrived," *Everybody's Magazine* 10, no. 5 (May 1904), p. 720.

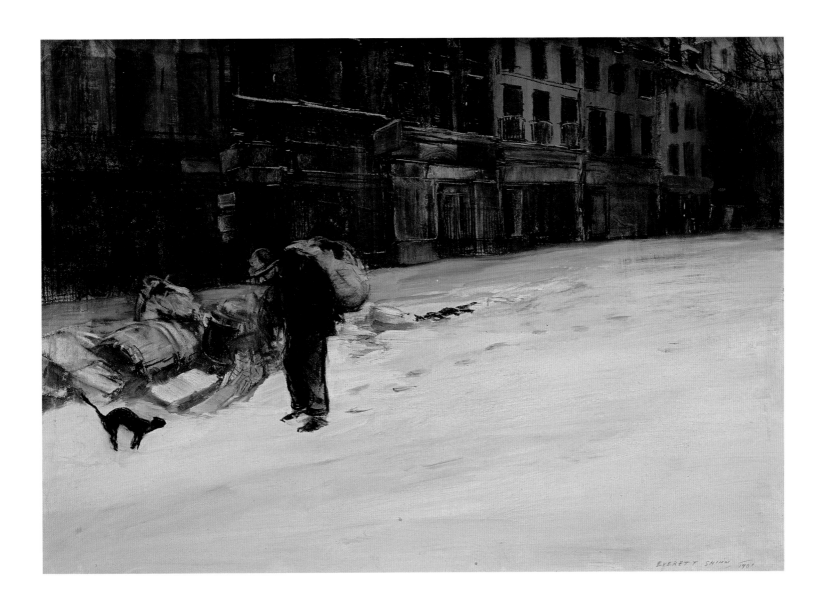

SARAH E. KELLY

SIX

"Local in Its Subject": American Impressionists and the Countryside

IN 1891, THE ARTIST JOHN TWACHTMAN wrote to his colleague J. Alden Weir, "I feel more and more contented with the isolation of country life. To be isolated is a fine thing and we are then nearer to nature. I can see how necessary it is to live always in the country—at all seasons of the year."[1] A year prior, Twachtman had purchased a farm in Greenwich, Connecticut, and had begun to live and paint there year-round. He found inspiration and refreshment in the countryside, and he registered the constantly changing appearance of his land in numerous paintings (see pls. 58 and 59). Although not all American Impressionists were as passionate about rural living as Twachtman, the countryside was a significant source of inspiration for many Gilded Age artists, who ventured out of the urban environment in search of picturesque settings and appealing effects of light and shadow. Although the city played a significant role in the careers and art of the American Impressionists, views of nature were far more prevalent, signaling the importance of the countryside as a place of artistic exploration and personal relaxation.[2]

In painting the countryside American Impressionists were following the lead of their French counterparts; indeed several of them, most notably Theodore Robinson (see pl. 47), worked directly with Claude Monet in Giverny. Although Monet and other French artists frequently painted country scenes, their landscapes were balanced by their fondness for modern, urban subjects, which often featured dancers, prostitutes, and other disreputable figures. In contrast, landscape became the preferred genre for American artists because it allowed for formal experimentation without being too radical in subject matter. Many American artists studied in France, where they assimilated Impressionist techniques of paint handling, then returned to the United States to paint their own country. In this endeavor, they were encouraged by the words of author Hamlin Garland, who had visited Chicago's 1893 World's Columbian Exposition and found the Impressionist paintings on view to be thrilling. He wrote an impassioned defense of the movement—only then becoming more popular in the United States—in which he acknowledged the significance of the countryside to American painters. The Impressionist, Garland declared, "takes fresh, vital themes, mainly out-of-door scenes. He aims always at freshness and vigor."[3] The countryside offered artists myriad opportunities to capture the liveliness of the natural world, enabling them to paint their personal responses to nature.

Garland also approved of Impressionist painters because of the specificity of their landscape subjects. Praising American painters for their focus on familiar surroundings, Garland declared, "Art, to be vital, must be local in its subject."[4] Impressionist painters

1 John H. Twachtman, letter to J. Alden Weir, postmarked Dec. 16, 1891; quoted in *The Life and Letters of J. Alden Weir*, ed. Dorothy Weir Young (Yale University Press, 1960), pp. 189–90.

2 An excellent discussion of Impressionism and the countryside, to which this essay is indebted, is the chapter "The Country," in Weinberg, Bolger, and Curry 1994, pp. 50-133.

3 Hamlin Garland, *Crumbling Idols: Twelve Essays on Art Dealing Chiefly with Literature, Painting, and the Drama*, John Harvard Library (1894; repr., Belknap Press of Harvard University Press, 1960), p. 105.

4 Ibid., p. 104.

celebrated the American landscape, but they did not gravitate toward the sublime vistas preferred by earlier American artists such as Thomas Cole or Frederic Edwin Church. Instead, Impressionist painters depicted familiar settings: backyards, local woods, and settled coastlines. Unlike the French Impressionists, they frequently eschewed signs of modernity in favor of peaceful, calm depictions of pastoral scenery that struck viewers as being quintessentially American. The bucolic imagery of Daniel Garber in Pennsylvania and Wilson Irvine in Connecticut (see pls. 68 and 73), for example, included scenic elements that were considered characteristic of their regions. In the case of Irvine, the stone walls he depicted also signaled an era long since passed, giving his works overtones of nostalgia. American artists revisited their subjects numerous times, painting scenes that they lived with on a daily basis. Edward Redfield, for example, repeatedly portrayed the land around his Bucks County, Pennsylvania, home (see pl. 66), using swift, slashing brushwork to broadly depict the changing seasons and different atmospheric conditions. Instead of revising his work, he would finish a painting in one day, venturing forth the next day to essay a different composition.

Redfield, like Twachtman, considered himself a country-dweller, drawn there by the solitude and the proximity of nature. Such artists painted year-round and often preferred winter scenes. They were intrigued by the challenge of depicting snowy landscapes, which required cool palettes of blue and lavender. The winter season was also a time of limited tourism, when they could connect more personally with the desolate countryside. Many other artists, however, lived in the city during the winter and made yearly visits to the country during their favorite seasons, attracted to the bright, clear light of summer or the rich colors of fall. Such trips enabled them to escape the city and its clamorous urbanization. Modern city living was seen by many as being unhealthy and enervating, while the country offered fresh air and a relaxed lifestyle. Artists were thus part of a larger societal trend toward escapism. Childe Hassam, for instance, regularly summered on the isolated Isles of Shoals, located ten miles off the coast of New Hampshire (see pl. 57). The islands boasted a comfortable climate, glorious views, and lush vegetation and were popular with tourists seeking a rest cure. Hassam frequented Appledore House, a resort hotel run by the poet Celia Thaxter, which attracted Boston's artistic and literary set.[5]

Although artists sought a respite from the city, the allure of pleasant company like that offered by Thaxter remained compelling. Countless painters were thus drawn into the country by the growing popularity of artists' colonies. In addition to being situated in the country or in suburban resort towns, with numerous picturesque subjects close at hand, these colonies offered their residents camaraderie through interaction with like-minded colleagues. They also undoubtedly fulfilled artists' romantic notions of living a bohemian lifestyle. Many northeastern towns hosted gatherings of artists during the summer, including Old Lyme and Cos Cob, Connecticut; Cornish, New Hampshire; Provincetown, Massachusetts; and Woodstock, New York. One of the most famous colonies formed around the key figure of William Merritt Chase (see pls. 60 and 61).[6] His Shinnecock Hills Summer Art School attracted those who wanted to learn Impressionist techniques from one of the style's early masters. In contrast to other, more rural locales, Chase's school was located on the eastern end of Long Island, a short trip from New York City. Indeed, the growing ease of train travel facilitated movement around the suburban and rural areas of the Northeast, as artists could quickly relocate from New York and Boston to their preferred summer homes. But artists' colonies were not limited to the East, as artists also gathered in western regions, including Brown County, Indiana; Taos, New Mexico; and Laguna Beach, California.

Ultimately, the American Impressionists' preference for rural subject matter endowed their paintings with a sense of idealized nostalgia. By seeking out picturesque villages and

5 For more on Hassam's time on the Isles of Shoals, see Curry 1990.

6 A good resource on Chase and Shinnecock is Atkinson and Cikovsky 1987.

isolated regions, artists characterized the American landscape as a premodern place. Figures are rare in these works, and if pictured, tend to be engaged in genteel amusements (see pls. 62 and 63). The refined, relaxed lifestyle depicted in Impressionist pictures appealed as well to the collectors of these works, many of whom were wealthy city-dwellers similarly invested in a romanticized view of the American countryside. The Gilded Age was a time of transition: industrialization was rapidly transforming the habits of labor, creating a distinction between work and play and generating new demand for leisure activities. The spread of industry also increased the pace of life in the city and threatened the natural serenity of the country. Although American Impressionists favored direct observation, their paintings of the country-side are not simple records of bucolic views. Instead, their idyllic imagery defined the national landscape as a place of beautiful refuge, a shelter from the many changes confronting American society at the turn of the century.

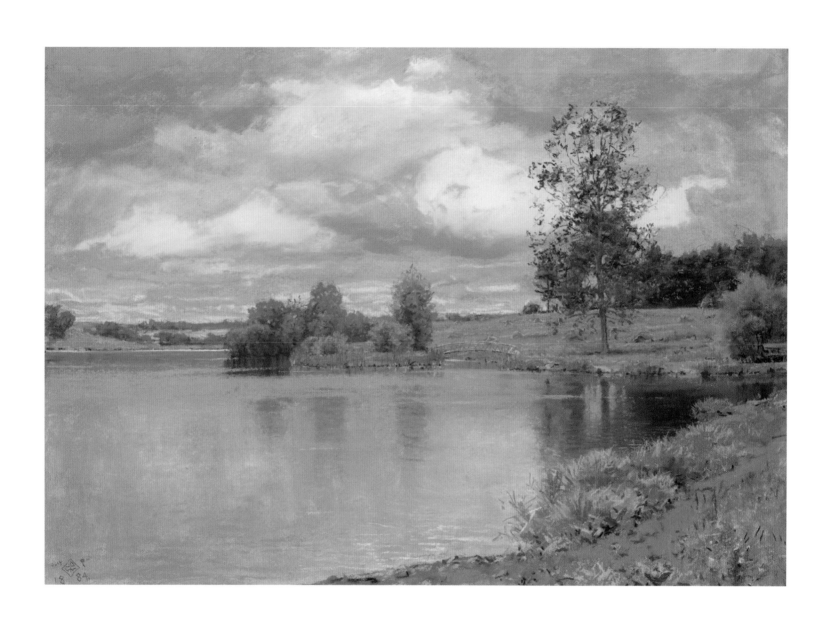

55

WALTER LAUNT PALMER (1854–1932)

Lake at Appledale

1884
Pastel on tan wove paper; 38.7 x 54.6 cm
(15 1/4 x 21 1/2 in.)
Restricted gift of Mrs. Herbert Vance; Print and
Drawing Fund, 2003.65
Signed lower left: *July 9 / WLP
[monogram] / 1884*

Although acclaimed for his oil paintings of frozen winter landscapes, which reveal his sensitivity to the appearance of light and shadow on snow, Walter Launt Palmer exhibited his mastery of the pastel medium in the exquisite summertime landscape *Lake at Appledale*. His use of pastel was a significant and innovative choice at the time. Eighteenth-century American artists, most notably John Singleton Copley, had used pastel for the purposes of portraiture, but by the first decades of the nineteenth century it was considered a minor medium. However, interest in pastel revived in the 1870s; key proponents included the American expatriate James McNeill Whistler (see pl. 14), as well as the French Impressionists, who displayed pastels in their first exhibition in 1874. Palmer, who was in Paris studying with Carolus-Duran at this time, could have seen firsthand the pastels of Edgar Degas or Claude Monet. A small group of American artists began using pastel more seriously in the 1880s, forming the Society of Painters in Pastel in 1882. Their exhibitions, although few in number, contributed to the resurgence of pastel as an important artistic medium in the United States.

Lake at Appledale records a view of the idyllic setting of the Palmer family farm south of Albany, New York, on July 9, 1884, the date on the work suggesting the immediacy of the artist's response to nature. As a medium more akin to drawing than to painting, pastel offers artists a means of responding to the observed world with greater freshness of handling and spontaneity of gesture. Palmer's light, flickering strokes of pastel are apparent in the verdant grasses and foliage, giving the composition a lively, dappled feel. Furthermore, the dramatic sky and surface of the lake superbly display his skill at capturing the quickly changing appearance of the summer day. Darker and lighter storm clouds, enhanced by his deployment of the tan paper as an integral part of the design, encroach upon a patch of brilliant blue sky. Palmer also gently applied delicately modulated tones of pastel to indicate the subtle shimmer of the surface of the lake. The pastel is at once full of detail and a testament to Palmer's ability to express the fleeting effects of nature. (SEK)

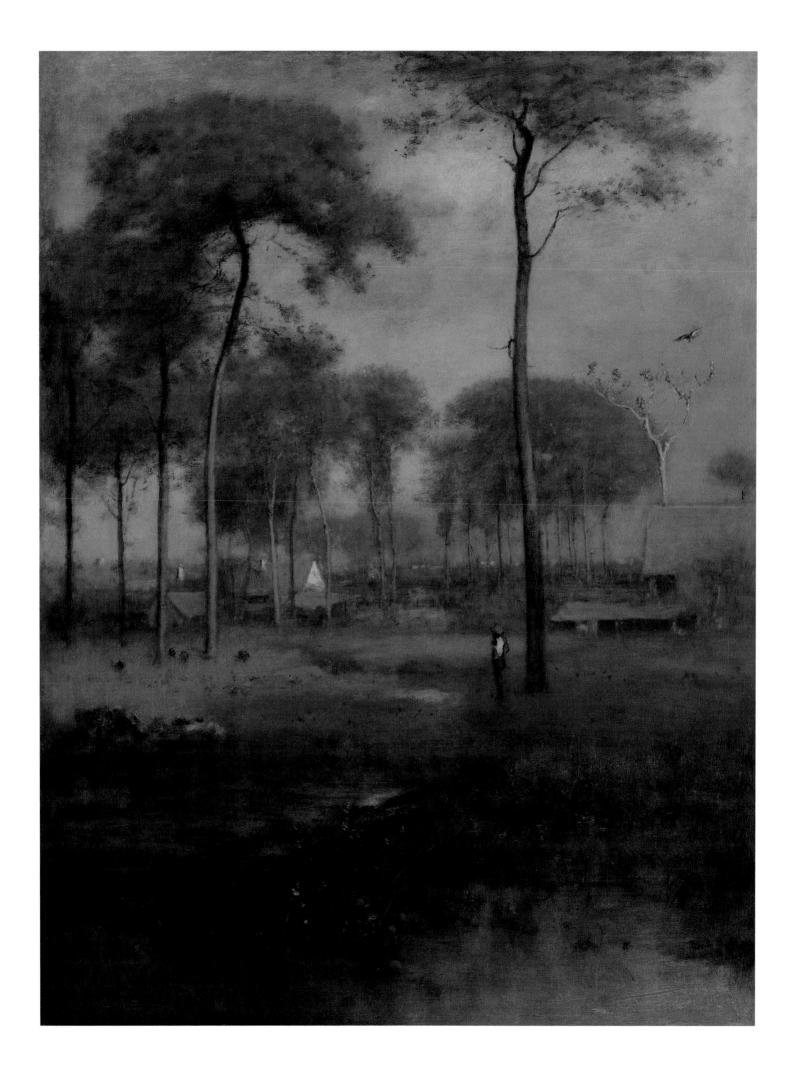

GEORGE INNESS (1825–1894)

Early Morning, Tarpon Springs

1892
Oil on canvas; 107.2 x 82.2 cm (42 1/8 x 32 3/8 in.)
Edward B. Butler Collection, 1911.32
Signed lower left: *G. Inness 1892*

Near the end of his life, George Inness painted several works depicting the area around Florida's Tarpon Springs, where he spent time periodically, recovering from various ailments. Each painting captures the area at a different time of day or night, thus evoking the light of that particular moment. While this process can be seen as adhering to Impressionist standards, Inness himself viewed his work as decidedly un-Impressionist.

The fifth of thirteen children, Inness was born on a farm in Newburgh, New York. The family moved to New York City while he was an infant and later settled more permanently in Newark, New Jersey. Inness's childhood schooling was somewhat erratic due to his poor health (he may have suffered from epilepsy), and while he did study with individual artists and take classes at the National Academy of Design, he was largely self-taught. Early influences were two American landscape painters, Thomas Cole and Asher B. Durand; Inness spoke of his desire to combine elements of the work of both artists in his own paintings. He exhibited and sold some of his early landscape works, and in 1851, shortly after marrying, he traveled with his wife to Europe for the first time, residing and working in Florence and later in Rome. After a brief stay in New York, he returned overseas, this time to Paris, where he gained exposure to the artists of the Barbizon School.

The Barbizon School artists, in particular Jean-Baptiste-Camille Corot and Théodore Rousseau, greatly influenced Inness at this time, while the French Impressionists had the opposite effect. Inness spoke of the movement as a "passing fad" and maintained that the artistic process and subject matter of these French, and later American, artists, were in opposition to his methods.[1] At first glance, a connection between Inness and the Impressionists seems obvious—both are working with the effects of light; both are using broken and other altered brushwork; both are painting the landscape. However, while Inness spent a great deal of time outdoors sketching, he did not turn his sketches into finished paintings, nor did he ever adopt the *en plein air* approach, with its emphasis on the immediate capture of a scene, instead creating his compositions in the studio, often repainting them many times. Indeed, he rejected the entire idea of working directly from nature, saying later in his life that by concentrating solely on the physical scene before them, the Impressionists lost any sense of spirituality in their art. As Inness progressed through his artistic career, it was this spirituality that became paramount in his work, as evidenced by his extensive writings on the subject.

Raised a Methodist and later a member of the Baptist Church, in 1868, at the age of forty-three, Inness was baptized in the Swedenborgian faith, which was based on the writings of the Swedish scientist and visionary Emanuel Swedenborg. Some of the tenets of Swedenborgianism, including the ideas that objects in the natural world are symbols of those in the spiritual world and that shapes have their own inherent psychological properties, allowed Inness to merge his interest in metaphysics and theology with his artistic output, using landscape as a vehicle.

Early Morning, Tarpon Springs displays the pale pink and blue colors associated with sunrise. Dwarfed amid the towering trees, a figure stands at nearly the center of the composition, surveying the houses in the distance. The blot of strong crimson on the figure makes him a focal point, and yet he appears to be part of the landscape, the color of his pants mirroring the tree trunks, his shirt, the sky, and his red hat, the sun. The painting is well ordered, with the bridge crossing the marsh leading into the scene, and the trees following a linear path into the distance. The houses in the landscape are overpowered by the natural forms surrounding them. The air is heavy with humidity, rendering the lone bird as if frozen in flight. Inness has used his characteristic thin washes of paint to achieve the painterly effects.

In 1911, Edward B. Butler, a Chicago businessman, amateur artist, and Art Institute trustee, purchased eighteen landscapes by Inness and presented them to the museum as a gift. One of the most important donations to the Art Institute at the time, creating as it did one of the most significant collections of Inness's works, it was well received and publicized. (DM)

1 For more on Inness's views on Impressionism, see Bell 2006, pp. 91–93, 130–33.

57

CHILDE HASSAM (1859–1935)

The Little Pond, Appledore

1890
Oil on canvas; 40.6 x 55.8 cm (16 x 22 in.)
Through prior acquisition of the Friends of
American Art and the Walter H. Schulze Memorial
collections, 1986.421
Signed lower right: *Childe Hassam 1890*

In *The Little Pond, Appledore*, painted on one of the Isles of Shoals, off the coast of New Hampshire, Childe Hassam has captured the light, water, and especially, the gardens of Celia Thaxter, all of which contributed to the island's appeal for members of the artists' colony that congregated there.

Hassam first visited Appledore probably around 1883, although he had met Thaxter a few years earlier. A poet, Celia Thaxter had a summer home on the island, where she grew up. Hoping to draw vacationers to the remote location, her father had opened Appledore House, a large hotel, in 1847. Thaxter helped her family operate the resort, advertised as a place to relax and rejuvenate, even after her marriage and the subsequent birth of three children. Through her husband, Levi, a Harvard graduate and member of a prominent family, she became acquainted with literary circles in the Boston area and began writing poetry herself, publishing her first work in 1862. By the time she met Hassam, she was hosting artists, writers, and musicians at her home on Appledore. Many artists made return visits, but it is Hassam, because of his enormous output of work based on the island's landscape, whose name is most closely associated with Appledore.

Beyond her well-received salons, Thaxter was also known for her gardens. Over fifty varieties of flowers were planted in her rectangular plot, although the plants were allowed to overlap, creating a lush, rambling scene. The purpose of the garden was to provide blooms to fill the large number of vases in Thaxter's parlor, but rather than depicting the cut flowers, Hassam was inspired to paint them directly outdoors. His many paintings of a colorful, blossom-filled landscape belie the fact that Appledore is actually a very rocky island; indeed, the abundance of Thaxter's garden was sometimes met with amazement by visitors.

The Little Pond, Appledore depicts a spot behind the hotel, yet there is no sense of there being any inhabitants in the area, save for a very small sailboat on the far horizon. The color here is somewhat subdued when compared to other Hassam images of Thaxter's garden, such as the oil painting *Poppies on the Isle of Shoals* (1890; Brooklyn Museum) or the watercolor *The Garden in Its Glory* (1892; Smithsonian American Art Museum, Smithsonian Institution, Washington, D.C.), which overflow with vibrancy. *The Little Pond, Appledore* exudes a sense of tranquility. The flowers in the foreground are likely scarlet pimpernel and white yarrow; they are dense and interspersed with wild grasses, evoking Thaxter's relaxed way of gardening. The titular pond is calm and radiates warmth, and the sea in the far background also emits a sense of peacefulness. Hassam used a great deal of white pigment, and the entire canvas is suffused with bright light, reflecting off the pale and warm greens, blues, and pinks of the flowers.

Hassam painted this piece the first summer after his return from an extended trip to Europe (see pls. 48–49), where he would undoubtedly have seen works by Claude Monet. While comparisons between the two artists can easily be made, Hassam dismissed suggestions that his work was influenced by the French artist. His brushstrokes here show the beginnings of what would later be a much freer, and wider, mark (see pl. 82), and while they are more deliberately placed than those of the later paintings, and the artist is using a smaller brush, the brokenness typical of the Impressionists is still evident.

Celia Thaxter died in 1894, and although Hassam continued to travel to Appledore most summers, it had become a different experience. The gardens abandoned, the artist now concentrated on depicting the rocky coastline and sea. In 1914, the Appledore House, Thaxter's home, and other cottages were destroyed by fire and never rebuilt, marking the end of the era. (DM)

JOHN HENRY TWACHTMAN (1853–1902)

58

Icebound

c. 1890
Oil on canvas; 64.2 x 76.6 cm (25¼ x 30⅛ in.)
Friends of American Art Collection, 1917.200
Signed lower right : *J. H. Twachtman*

59

The White Bridge

after 1895
Oil on canvas; 75 x 75 cm (29½ x 29½ in.)
Mr. and Mrs. Martin A. Ryerson Collection,
1937.1042
Signed lower left: *J. H. Twachtman*

Born in Cincinnati, John Henry Twachtman
took his first formal art classes with Frank
Duveneck at that city's Ohio Mechanics
Institute in 1874–75. In 1875, he went with
Duveneck to Munich, where he enrolled in
the Königliche Akademie and mastered the
school's characteristic style of broad paint
handling, with heavy impasto and a dark
palette. He soon grew frustrated with the
Akademie's lack of emphasis on draftsman-
ship, and in 1883 enrolled in the Académie
Julian in Paris to remedy this deficiency.

Despite this academic training, while in Paris Twachtman became increasingly inspired by the work of American expatriate painter James McNeill Whistler (see pls. 10–18), producing Tonalist landscapes that were more abstracted, thinly painted, and lighter hued than his earlier works. Back in the United States in 1885, Twachtman began to experiment with Impressionism, under the influence of fellow American painter Theodore Robinson (see pl. 47), whom he had met in Paris. Combining Tonalism and Impressionism, Twachtman evolved a distinctive style that appears in the Art Institute of Chicago's paintings *Icebound* and *The White Bridge*.

Both these pictures represent scenes around Twachtman's home in Greenwich, Connecticut, where the artist purchased seventeen acres of land in 1890. He spent the last decade of his life painting there *en plein air*, seeking to capture the look of the landscape as the seasons changed. *Icebound* is one of many works Twachtman created in winter. Like many Impressionists, he enjoyed the challenge of working outside in that season and was convinced that snow and ice made the landscape more pictur-esque. He wrote in 1891: "We must have snow and lots of it. Never is nature more lovely than when it is snowing. Everything is so quiet and . . . all nature is hushed to silence."[1] *Icebound* is typical of Twachtman's depictions of winter in its coupling of simplified form and palette with a nearly square format, which together transform what could have been a harsh scene of difficult climatic conditions into a beautifully harmonious composition. The artist's use of a high horizon line and scattered notes of orange in the otherwise white and blue color scheme derive from the admiration he shared with many Impressionists for Japanese art and enhance the viewer's sense of the work's decorative quality.

In contrast to *Icebound*, in which Twachtman's thick, encrusted paint suggests hardened ice and snow, in *The White Bridge* his feathery strokes evoke the first delicate leaves of spring. This later painting depicts the bridge the artist constructed over Horseneck Brook on his property around

1895. Here, again, the square format, high horizon line, and carefully balanced compo-sition serve to abstract the forms of nature, while Twachtman's free brushwork and stretches of unprimed canvas further remind the viewer that the work is, fundamentally, paint on canvas. At the same time, the artist's sketchy paint handling evokes the fleeting moment when the bridge is partially, but not completely, blocked by the trees' new growth. Unlike the stillness of *Icebound*, *The White Bridge* conveys spring's sense of life and reawakening.

Critics celebrated Twachtman's effective combination of expressive Impressionism with a decorative abstraction. When one of his winter scenes was exhibited at the Art Institute in 1889, a writer in the *Chicago Herald Tribune* declared: "Mr. Twachtman's contribution . . . is of a nearly square format well-suited to the scene of a frozen brook in

winter. Impressionism has brought forth these soft lavenders and blues, and this loving adulation of the icy winter air."[2] Impressionist paintings of such idealized rural landscapes were particularly popular among the increasing numbers of Americans who were living in cities at the turn of the century. Faced with the gritty reality of daily life in the rapidly industrializing urban landscape of places like New York and Chicago, city-dwellers found a therapeutic escape and solace in Twachtman's harmoni-ous scenes of the natural world. (EER)

1 John Henry Twachtman to J. Alden Weir, December 16, 1891; published in *The Life and Letters of J. Alden Weir,* ed. Dorothy Weir Young (Yale University Press, 1960), p. 190.

2 *Chicago Herald Tribune,* May 30 or 31, 1889, p. 6.

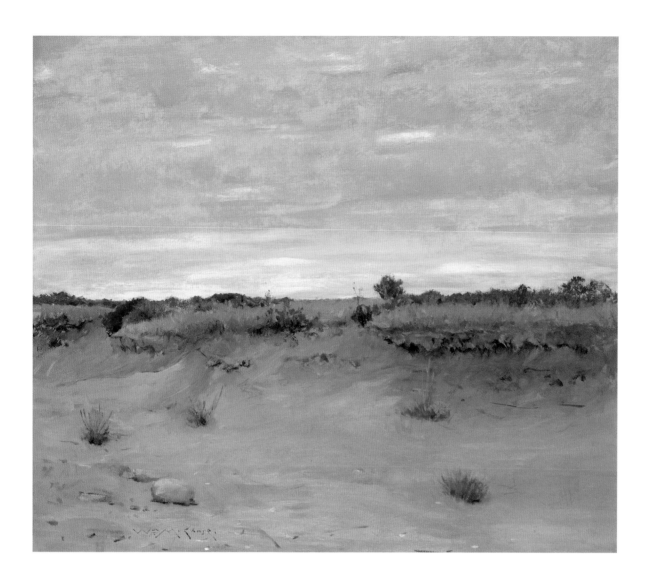

60

WILLIAM MERRITT CHASE (1849–1916)

Wind-Swept Sands

1894
Oil on canvas; 87 x 101.5 cm (34 1/4 x 39 3/4 in.)
Restricted gift of Mrs. Eric Oldberg in honor of
Milo M. Naeve; Friends of American Art and R. H.
Love Galleries Funds; Walter Aitken Endowment;
through prior acquisitions of the Charles H. and
Mary F. S. Worcester Collection, 1991.249
Signed lower left: *Wm M. Chase.*

In addition to his career as a painter, William Merritt Chase was an influential art teacher. He taught first at the Art Students' League in New York, beginning in 1878, and then at the Brooklyn Art Association, the Chase School of Art in New York (now Parsons The New School for Design), and the Pennsylvania Academy of the Fine Arts in Philadelphia. In 1891, Chase helped to found the Shinnecock Summer School of Art in the Shinnecock Hills of eastern Long Island, near Southampton, New York. This institution became the first important summer art school in the United States, and Chase taught there for twelve years, instructing students in the Impressionist method of painting *en plein air*. In this period, Chase also created a series of Impressionist views of the Shinnecock landscape, capturing it from different perspectives and under varying atmospheric conditions. One such work is the Art Institute's 1894 picture *Wind-Swept Sands*.

Although many of Chase's Shinnecock landscapes include his wife and children, *Wind-Swept Sands* is devoid of human presence, depicting only a line of dunes against a cloud-filled sky. The painting's emptiness, coupled with Chase's decision to portray the dunes straight on, functions to flatten the pictorial space, abstracting the subject matter. This characteristic is further heightened by the nearly square format, which makes the work seem more decorative and less like a window on the world. Chase's empty landscapes demonstrate his synthesis of Impressionist goals with those of American expatriate painter James McNeill Whistler, who had been using such flattened pictorial space and simplified subject matter since the 1860s in his quest to create art for art's sake (see pls. 10–18). Chase had met Whistler in London in 1885 and was an ardent admirer of the older painter's work. In pictures like *Wind-Swept Sands*, Chase effectively incorporated Whistler's Aestheticism and the Impressionist interest in capturing a moment in time to create works that combine realism and abstraction. The tension in Chase's Shinnecock landscapes between these two apparently opposing goals makes them some of his most intriguing works. (EER)

61

WILLIAM MERRITT CHASE (1849–1916)

North River Shad

c. 1910
Oil on canvas; 73.7 x 94 cm (29 x 37 in.)
Friends of American Art Collection, 1914.56
Signed lower left: *Wm. M. Chase*

North River Shad is one of a series of still lifes featuring dead fish that William Merritt Chase painted in the last decade of his career. As he explained, "I enjoy painting fishes: in the infinite variety of these creatures, the subtle and exquisitely colored tones of the flesh fresh from the water, the way their surfaces reflect the light, I take the greatest pleasure."[1] A consummate marketer of his own work, Chase used these fish pictures to showcase his technical skill, often painting them in front of an audience so that the viewers could marvel at his ability to capture the fishes' scintillating surface surrounded by contrasting textures.

Chase's dark palette and flashy brush-work in these pictures, which is so different from his earlier light-filled Impressionist style (see, for example, pl. 76), recalls contemporaneous Ashcan School paintings, which led early twentieth-century viewers to see these works as modern and cutting edge. However, while these paintings may allude obliquely to contemporary issues, such as the effects of industrialization on the fisherman's traditional way of life, they do not contain the more overt social commentary that is often present in Ashcan School works. Moreover, Chase's fish pictures clearly reference the Old Master still-life tradition, particularly as practiced by the eighteenth-century French painter Jean-Baptiste-Siméon Chardin. Like Chardin, Chase did not try to fool the eye into believing that his subjects were real, as trompe l'oeil still-life painters did, but instead depicted an arrangement of objects receding into atmospheric light and shade.

Chase's relating of his fish paintings to both the Old Master tradition and contemporary American art made them appealing to a wide range of critics and patrons. Nearly every major American museum purchased one of these pictures in the early twentieth century. By 1915, Chase declared, perhaps with a hint of regret: "It may be that I am remembered as a painter of fish."[2] (EER)

1 W. H. Fox, "Chase on Still Life," *Brooklyn Museum Quarterly* 1, no. 4 (Jan. 1915), p. 199.

2 Ibid., p. 198.

62

CECILIA BEAUX (1855–1942)

Dorothea and Francesca

1898
Oil on canvas; 203.5 x 116.8 cm (80⅛ x 46 in.)
A. A. Munger Collection, 1921.109
Signed lower left: *Cecilia Beaux*

Cecilia Beaux was part of a rarified circle of successful late nineteenth-century portrait painters whose clientele were primarily members of the upper class. After meeting them in Paris in 1896, Beaux enjoyed a lifelong friendship with *Century* magazine editor and poet Richard Watson Gilder, his artist wife Helena de Kay Gilder, and their children. Two of the Gilder daughters are depicted here; Dorothea, the eldest, was one of Beaux's favorite models.

Leaders of an artistic, literary, and musical circle in New York City, the Gilders counted Augustus Saint-Gaudens, John La Farge, and Stanford White among their friends. In addition to their New York residence, the Gilders had a country home, a farm called Four Brooks in Tyringham, Massachusetts, where this painting was produced.

This full-length portrait is innovative in its portrayal of spontaneous movement. As would befit young daughters of an artistic family, the girls are dancing, with Dorothea carefully guiding her younger sister. While she leads her sister in a dance step, she can also be said to be introducing her to the period of adolescence, through which she herself has nearly passed. The graciousness of the family's lifestyle is apparent in the girls' portrayal, not only in the lavish fabric of their dresses, which are spotlessly clean, but in the dance itself, emphasizing the luxury and availability of leisure time.

The girls look down, rather than at the viewer, concentrating on their dance steps. That the movement is not static is emphasized by Dorothea's hair, which moves in front of her face in a blur. The fluid brushstrokes and use of subtle color accurately convey motion and also give the appearance of a swiftly executed canvas, but in fact Beaux worked diligently on the picture for over two months.

While Beaux wrote of her admiration for the Impressionist work of Claude Monet, she indicated no wish to follow him. Nevertheless, the sweeping brushstrokes and unusual composition of this work indicate a modern tendency, one that Beaux would continue to develop in her portraits. (DM)

63

FRANK WESTON BENSON (1862–1951)

Rainy Day

1906
Oil on canvas; 63.5 x 76.2 cm (25 x 30 in.)
Friends of American Art Collection, 1910.314
Signed lower right: *F. W. Benson, 1906*

Like many of his American contemporaries, Frank Benson spent time in Paris in his youth, studying at the Académie Julian. However, after returning to his native soil he never again ventured overseas, choosing instead to work and draw his artistic inspiration from his homes and surroundings in Boston and Salem, Massachusetts, and North Haven, Maine.

After studying at the School of the Museum of Fine Arts in Boston, Benson left for Paris in 1883, intending to study for two years or until his money ran out. True to his plan, he returned to Salem in 1885 and opened a studio, hoping for portrait commissions. While these were slow in coming, he painted portraits of his new wife and other family members; he also joined the faculty of the School of the Museum of Fine Arts, a position he held for twenty-four years. There he met fellow faculty member Edmund Tarbell; the two formed a close friendship and are now considered part of the Boston School of painting, which is perhaps best known for interior scenes with female figures. Later, the two artists would be part of the group known as The Ten American Painters, which also included Thomas Wilmer Dewing (see pl. 69), Childe Hassam (see pls. 48–49, 57, and 82), and John Twachtman (see pls. 58–59).

While Benson did not call himself an Impressionist, he did concentrate on the effects of light in his works, and his paintings of his children outdoors at his summer home in Maine are full of dappled sunlight shining through trees and onto the figures. *Rainy Day,* in contrast, shows an interior scene, a rarity among Benson's Maine pictures. Here, his daughter Elizabeth curls up in a rattan chair with a book, but her gaze is directed toward a glowing fire. Pictures on the mantel and the Chinese urn on the table allude to a refined sensibility, but the rest of the room is comfortably uncluttered and informal, as would befit a summer residence. The light diffusing the room is dull and colorless, typical of a stormy day.

Although he adapted his style and medium over the years to suit his own taste and interests, moving from portraiture to more impressionistic figures in landscape to prints and drawings of wildlife and game, Benson's work remained consistently popular, and he was a critical and financial success during his lifetime. (DM)

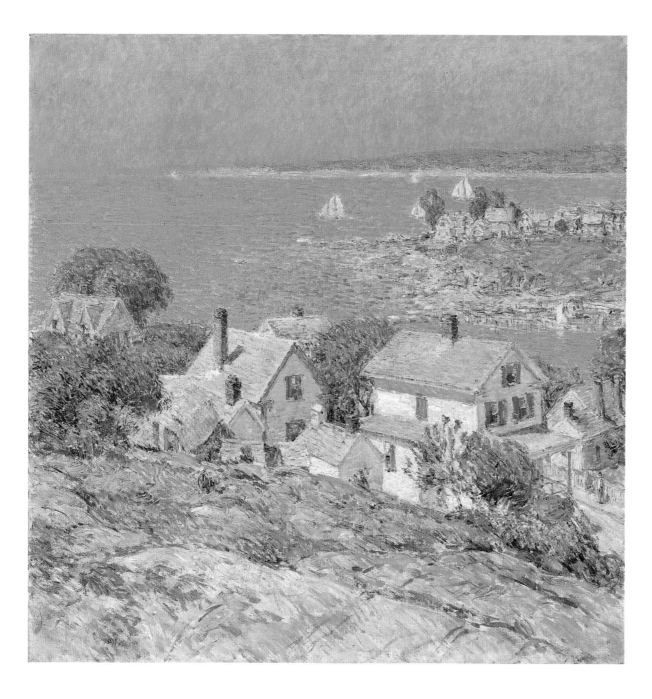

CHILDE HASSAM (1859–1935)

64

New England Headlands

1899
Oil on canvas; 68.9 x 68.9 cm (27 ⅛ x 27 ⅛ in.)
Walter H. Schulze Memorial Collection, 1930.349
Signed lower left: *Childe Hassam 1899*

65

Bailey's Beach, Newport, R.I.

1901
Oil on canvas; 61 x 66 cm (24 x 26 in.)
Walter H. Schulze Memorial Collection, 1936.243
Signed lower left: *Childe Hassam 1901*

Although *New England Headlands* and *Bailey's Beach, Newport, R.I.* both depict summer scenes of leisure at seaside towns, the two settings, Gloucester, Massachusetts, as illustrated in the first work, and Newport, Rhode Island, were very different in character.

Starting in 1890, Childe Hassam began a pattern of travel and painting, spending summers in various New England locales, beginning with Appledore, one of the Isles of Shoals (see pl. 57). Later venues included the artists' colony of Gloucester as well as those of Old Lyme and Cos Cob, Connecticut; he apparently visited Newport for any significant length of time only once. While the views he painted obviously changed with the

variation in location, the underlying themes are the sea, sunlight, and leisure time. In *New England Headlands* the subject is a section of East Gloucester. Hassam noted on the reverse of the painting that the promontory on the right is Rocky Neck and also stated:

This picture was painted in Gloucester Massachusetts in July 1899—This part of the town (really East Gloucester) then had many examples of the small New England frame houses painted white with green blinds which are seen in the foreground . . . the point of land in the distance is Norman's Woe celebrated in the poem by Longfellow.

The poem in question is Henry Wadsworth Longfellow's "The Wreck of the Hesperus,"

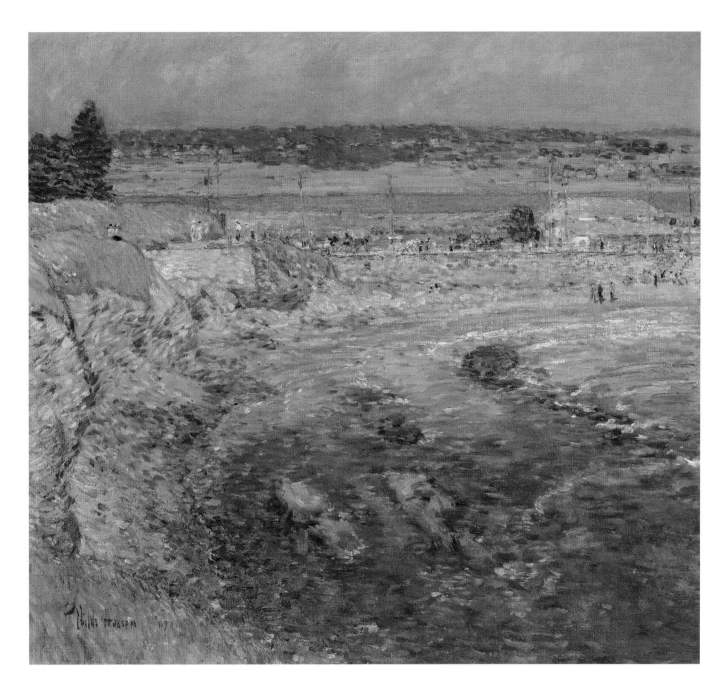

first published in 1842. A chilling tale of a tragic shipwreck off Norman's Woe during a fierce storm, the poem's setting is nothing like the pastoral scene portrayed here by Hassam. The artist's use of broken brushwork and his interest in describing the quaint New England architecture, the green shrubbery leading to the brilliant turquoise sea with sailboats in the distance, and the bright sun shining overhead are perfectly in keeping with Impressionist tenets.

Hassam revisited Gloucester many times, and he returned to this particular area the same year to paint at least one other, nearly identical, composition. As noted above, he did not frequent Newport, perhaps because of the character of the locale. By the time *Bailey's Beach* was painted in 1901, Newport had become the summer resort of choice for such wealthy American families as the Vanderbilts and the Astors, who built enormous mansions, which they dubbed as "cottages," along the seashore. Despite the artist's success, this type of wealth was out of his reach, and unlike Gloucester and Hassam's other favorite summer sites, Newport did not support an artists' colony, making it even less inviting to creative individuals.

Bailey's Beach was private and exclusive, purposely located in a secluded area. In the painting wealthy beachgoers walk along the sand and the promenade leading to the shore, with their residential area situated in the background. Unlike *New England Headlands,* where the viewpoint puts the artist right at the edge of the scene, Hassam here is a distant observer, reinforcing the fact that he, and the viewer, are not invited to this privileged setting. Both paintings feature a sun-drenched scene, but *Bailey's Beach* shows a richer and more vibrant palette. The addition of shades of brown, green, and navy to the turquoise waters indicates a rougher surf than that seen in *New England Headlands*. (DM)

66

EDWARD WILLIS REDFIELD (1869–1965)

Centre Bridge

1904
Oil on canvas; 91.4 x 127 cm (36 x 50 in.)
W. Moses Willner Fund, 1905.152
Signed lower right: *EW Redfield*

In 1963, Edward Redfield recalled his early approach to painting: "When I first began to work, most of the artists were busy in studios working with models, draped artistically. What I wanted to do was to go outdoors and capture the look of a scene, whether it was a barn or a bridge, as it looked on a certain day. So I trained myself to set down what I saw all in one day, working sometimes eight hours or more."[1] Redfield, a leading member of a group of Impressionists located in Bucks County, Pennsylvania, most frequently painted the landscape around his hand-built home in the river town of Center Bridge. The rural village offered Redfield a retreat from urban living, a quiet locale where he and his family could experience a simpler lifestyle in close harmony with nature. His intimate familiarity with this land, and his commitment to recording its ever-changing appearance, is apparent in *Centre Bridge*, a wintry portrayal of the hillside above the town overlooking the Delaware River.[2]

Redfield later informed the Art Institute that he painted *Centre Bridge* in January 1904, and the dead brown grass, bare trees, and patchy snow convey the barrenness of the season. As his 1963 recollection suggests, Redfield was dedicated to quickly rendering his direct observations of the landscape, working outside without recourse to sketches or preliminary drawings. Instead, he created each painting in one sitting, completing entire compositions—many of which were quite large—over the course of one day. The rapidity of his paint application enabled him to capture the momentary appearance of the land, especially the transient effects of light on melting snow. To represent shadows modulated by the uneven terrain, Redfield blended small amounts of pink, purple, and blue pigment into the white paint, varying the appearance of the snow to suggest the play of light. He did not, however, unthinkingly transcribe his immediate perceptions of the land but studied his chosen subjects at length before applying paint to canvas, a practice begun during his student years at the Pennsylvania Academy of the Fine Arts in Philadelphia. Despite the painting's look of immediacy, Redfield carefully composed the picture to emphasize the sweeping hillside and dramatic panoramic view of the valley. The high vantage point and deep diagonal perspective also suggest that Redfield employed Japanese techniques of composition, which he could have learned directly from wood-block prints, or indirectly, though his admiration of the paintings of Claude Monet.

Redfield's brushwork in *Centre Bridge* is quite broad; he slashed on thick strokes of pigment to denote the snow and surrounding terrain. To depict the feathery dry grasses of the bleak hillside, which irregularly protrude through the patches of snow, he more lightly brushed varying shades of brown on top of the underlying layers of snow, only barely suggesting their forms. Redfield was a close friend of Robert Henri, whom he had met at the Academy, and both artists swiftly and thickly applied paint to create lively, textured surfaces. Redfield's working method thus merged techniques derived from Impressionism, including *plein-air* painting and an interest in the play of light and shadow, with the dynamic realism associated with Henri and his followers in the first decades of the twentieth century. Although these realist painters frequently depicted unsentimental urban scenes or created vivid, unflinching portraits, Redfield instead focused on the portrayal of his rural Pennsylvania region. His paintings reveal his unwavering commitment to capturing the specifics of place and time, in a locale with which he was intimately familiar. The flair of his technique and local flavor of his subject matter brought Redfield enormous critical and popular acclaim as the creator of art that seemed to reflect a distinctly American character: fresh, vigorous, and rough-hewn. (SEK)

1 Barbara Pollack, "A Visit with Edward W. Redfield," *Sunday Bulletin Magazine* (Philadelphia), Aug. 4, 1963, p. 9.

2 When Redfield first exhibited the painting at the Art Institute in 1905, he named it *Centre Bridge* in accordance with the spelling of the town's name at that time. The town's name has since been changed to Center Bridge.

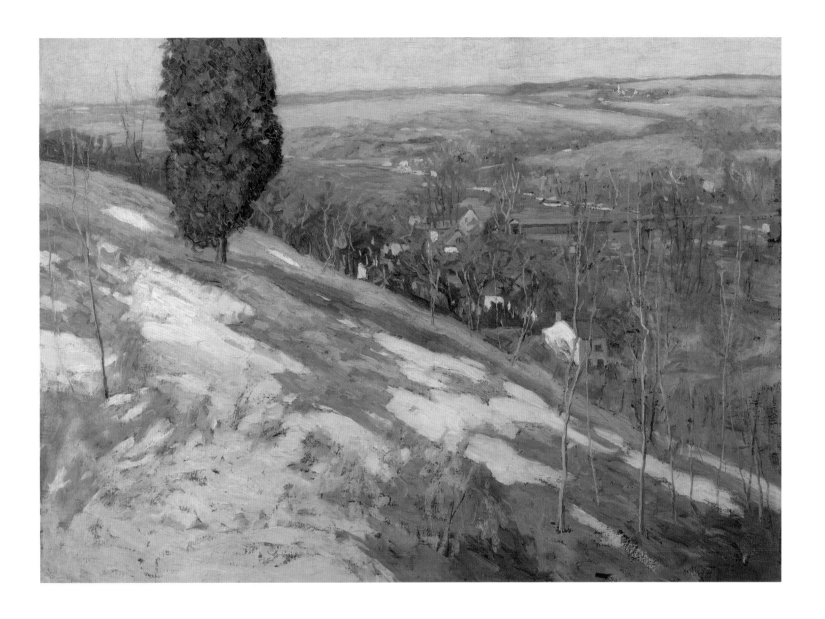

67

WILLARD LEROY METCALF (1858–1925)

Icebound

1909
Oil on canvas; 73.7 x 66.4 cm (29 x 26 ⅛ in.)
Walter H. Schulze Memorial Collection, 1910.311
Signed lower left: *W. L. Metcalf 1909*

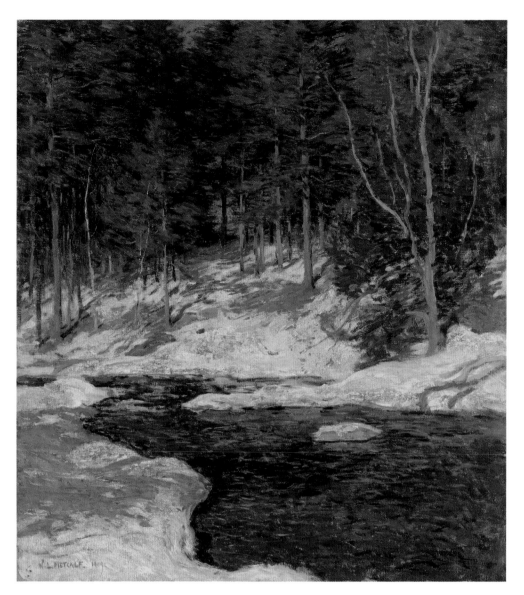

Born in Lowell, Massachusetts, Willard Leroy Metcalf began his career as an engraver and illustrator in Boston. After taking art classes at several schools there, in 1883 he went to France, where he studied at the Académie Julian in Paris and worked alongside Impressionist Claude Monet in Giverny. Back in America in 1888, Metcalf moved to New York, where he increasingly dedicated himself to painting Impressionist landscapes. In 1897, Metcalf and other American Impressionists, including William Merritt Chase (see pls. 60–61 and 76), Thomas Dewing (see pl. 69), Childe Hassam (see pls. 48–49, 57, and 82), and John Twachtman (see pls. 58–59), formed a group called The Ten American Painters. Exhibiting in opposition to the exclusive policies of the Society of American Artists, the group's members championed Impressionism in the United States.

Although Metcalf maintained his chief residence in New York, he created most of his mature paintings outside the city, first in the artists' colony of Old Lyme, Connecticut, and then, beginning in 1909, in the Cornish hills of New Hampshire and Vermont, where he painted *Icebound*. Like Old Lyme, this area had been an artistic center for a generation. Metcalf grew to prefer the region to Old Lyme because it was more rural and had longer winters. Like other Impressionists, Metcalf was fascinated by the challenge of capturing the many colors of snow as seen in sunlight and shade. Despite the difficulties of working *en plein air* in winter, he returned to this subject repeatedly. In *Icebound*, one of several versions of this scene that likely depicts Blow-Me-Down Brook, Metcalf evoked the brilliantly clear light of a winter day, demonstrating his continuing dedication to the Impressionists' goal of capturing a particular moment in time. When Metcalf exhibited *Icebound* at the Montross Gallery in New York in January 1910, the *New York Herald* declared that it "reveals the poetry of the winter."[1] (EER)

1 "Idylls of Outdoor Life and Portraits Exhibited," *New York Herald*, Jan. 4, 1910, p. 12.

68

DANIEL GARBER (1880–1958)

Hills of Byram

1909
Oil on canvas; 106.7 x 118.1 cm (42 x 46 ½ in.)
Walter H. Schulze Memorial Collection, 1910.309
Signed lower left: *Daniel Garber*

Daniel Garber was one of the leading artists of the New Hope group of painters working in Bucks County, Pennsylvania. Like Edward Redfield (see pl. 66), Garber preferred to paint the countryside around his rural home on the Delaware River, finding ample inspiration in nature's myriad forms. *Hills of Byram* is one of Garber's earliest successes, described by the Chicago editor and critic Harriet Monroe as striking a "fresh and strong and musical note."[1] Garber later declared this painting to be the beginning of his career as it won an award at the

Carnegie Institute before being acquired by the Art Institute of Chicago.

Garber painted *Hills of Byram* in March 1909 from a high vantage point in Point Pleasant, Pennsylvania, from which he overlooked the river and the distant quarry at Byram, New Jersey. Bare trees, dead grasses, and the pale sky evoke a crisp spring day. Using the light palette of blue and blond tones he then preferred, the artist freely painted the landscape with a flickering yet controlled touch. This is most evident in the sky, where he deliberately juxtaposed short brushstrokes of pink, white, and blue to convey the cool quality of light. Although his fluid brushwork suggests affinities between his work and Impressionism, Garber did not consider himself an Impressionist as the term is now commonly understood. He prized form and structure—reveling in the irregular, gnarled figures of the trees, for

instance—and carefully planned his compositions to best convey the beauty of the terrain. He also worked on his paintings at length, spending months observing the land in different conditions and making drawings and other studies before embarking upon the final picture in the studio. Through such means, Garber developed a style that appealed to critics and the public alike because it appeared graceful, elegant, and, owing to his deft assimilation of French techniques, forward-thinking without being too radical. Above all, because of his focus on Bucks County, his art seemed distinctly American to his audiences. Although Garber would later be categorized as a regional painter, during his lifetime his dedication to painting the local and familiar brought him acclaim as a truly national landscape artist. (SEK)

1 Harriet Monroe, "Fine Exhibit of Small Bronzes Attracts Art Lovers," *Chicago Tribune*, Apr. 2, 1911, p. B7.

69

THOMAS WILMER DEWING (1851–1938)

Lady in Green and Gray

1911
Oil on canvas; 61.3 x 50.8 cm (24 ⅛ x 20 in.)
Friends of American Art Collection, 1911.5
Signed lower right: *TW Dewing*

While Thomas W. Dewing spent time in England and France, studying at the Académie Julian in Paris as a young man, he did not fall under the spell of the expatriate life, preferring to spend his career painting in New York City among his fellow Americans.

Shortly after returning from his studies in Paris in 1877, the artist took a teaching position at the newly formed School of the Museum of Fine Arts in his hometown of Boston, but by 1880 he had moved to New York, where he met his future wife, artist and writer Maria Richards Oakey. She was part of the artistic and literary circle of Richard Watson Gilder and his wife Helena de Kay Gilder, and after her marriage to Dewing she collaborated with her husband on some of his early works. Dewing's introduction to the Gilder circle through his wife and her participation in the American Aesthetic Movement influenced his artistic output. The couple worked together on paintings, including *Hymen* (1886; Cincinnati Art Museum), a wedding gift to the prominent architect Stanford White, for which Maria painted the background foliage and Thomas completed the foreground figure; both signed this work.

White was instrumental in getting commissions for the artist to adorn the houses he designed, and he also created many elaborate frames for Dewing's paintings, thus increasing their aesthetic value. The American Aesthetic Movement emphasized making art a part of daily life by surrounding oneself with beautiful and tasteful objects. Central to the emotional life and health of its owner, the setting of the home could be controlled with refined furnishings and decoration that promoted harmony and beauty, thus eliminating the roughness and vulgarity of everyday life.

Dewing was one of the founding members of the group known as The Ten American Painters, or simply The Ten, which was organized in 1897 out of frustration at the conservative exhibition practices of the National Academy of Design and the Society of American Artists. The theme of a woman in an interior was a popular one among the group (see, for example, Frank Benson, *Rainy Day*, pl. 63) and indeed preoccupied Dewing for much of his career.

The model for *Lady in Green and Gray* was Gertrude McNeill, an actress who posed for the artist from 1911 to 1917. She perches elegantly, if awkwardly, on a Windsor chair, the kind of seat featured many times in Dewing's work. The chair's long, austere spindles echo her slender arms and elongated neck, and its flat, smooth surfaces match the planes of her cheekbones. McNeil's body is nearly obscured by her heavy dress, which

the artist created using many layers of thin washes. Like the Impressionists, he did not use varnish, emphasizing the surface. Dewing focused not on the corporeal reality of his figures but instead sought to capture the essence of ideal female beauty as it was understood at the time: his figures are elegant, intelligent, refined, and untouched by anything in the outside world. The very atmosphere of *Lady in Green and Gray* seems to be airless as well as timeless, a place where nothing is hurried and the quietly seated figure, her empty hands resting on her lap, has nothing to do.

This painting is one of a group of monotone works with similar titles, among them *Lady in Gold* (by 1912; Brooklyn Museum) and *Green and Gold* (c. 1916/17; Metropolitan Museum of Art, New York). Dewing's exploration of a single color palette, often referred to as Tonalism, can arguably be traced to the influence of James McNeill Whistler (pls. 10–18); indeed, the two artists worked together periodically while Dewing was in London for a short time in 1894/95. In *Lady in Green and Gray* Dewing's intention was to explore the theme of harmony through color, and the carefully controlled brushwork of the muted green and gray hues contrasts with the sparingly placed underlying rosy tones that give life to the figure. (DM)

70

GEORGE GARDNER SYMONS (1861–1930)

The Winter Sun

c. 1909
Oil on canvas; 120 x 181.6 cm (47¼ x 71½ in.)
Friends of American Art Collection, 1910.313
Signed lower right: *Gardner Symons*

When Gardner Symons painted *The Winter Sun*, his career was flourishing, with critics in the United States and England commending him for his crisp paintings of snowy landscapes. Symons, the son of German immigrants, was born in Chicago and appears to have begun his artistic education at the School of the Art Institute. He also studied in Paris, London, and Munich in the 1890s, before joining the St. Ives artists' colony in Cornwall, England, where he adopted a *plein-air* technique. He led a peripatetic life, traveling extensively at

home and abroad to paint. He exhibited frequently at the Royal Academy and the Royal Society of British Artists in London, but his first triumph occurred when he won the Carnegie Prize at New York's National Academy of Design in 1909. By this time he was maintaining studios in New York, Chicago, Laguna Beach, California, and Colrain, Massachusetts, the last of which is likely the location of *The Winter Sun*.

Symons enjoyed the challenge of painting wintry landscapes, which he largely completed outside rather than in the studio. In *The Winter Sun*, Symons employed shades of icy blue and subtle lavender to capture the play of light and shadow on the reflective snow, while the ice-laden river appears dark in contrast. Brisk brushwork is evident throughout the composition, aligning his work with contemporaries such as Edward Redfield (see pl. 66) and Walter Elmer

Schofield (see pl. 72), who likewise combined direct observation, a high-keyed palette, and a strong technique in their paintings. Essayist Marie Louise Handley wrote about Symons, "You might call him a realist, for he is one: vigorous, direct, clear-cut; or an impressionist, for light and air are put into his canvases to stay."[1] His approach had a painterly expressiveness aligned with cosmopolitan trends, yet its forceful breadth was seen as particularly national in character. Symons's works thus found great favor among American audiences, and numerous museums acquired his paintings. The Friends of American Art acquired *The Winter Sun* for the Art Institute in 1910, after it was exhibited in London, New York, and Chicago. (SEK)

1 Marie Louise Handley, "Gardner Symons—Optimist," *Outlook* 105 (Dec. 27, 1913), p. 881.

71

GUY CARLETON WIGGINS (1883–1962)

Snow-Crowned Hills

c. 1920/37
Oil on canvas; 84.5 x 100.3 cm (33¼ x 39½ in.)
Walter H. Schulze Memorial Collection, 1924.918
Signed lower right: *Guy Wiggins*

Devoted to the depiction of both rural and urban landscape, Guy Carleton Wiggins embraced Impressionism through his contact with artists such as William Merritt Chase (see pls. 60–61 and 76) and Childe Hassam (see pls. 48–49, 57, and 82), and he became well known for winter scenes. Wiggins spent time in England as a young man, traveling and painting the landscape there, but his schooling was confined to art lessons from his father and classes at the National Academy of Design in New York.

Wiggins was one of a second generation of artists to claim membership in the artists' colony of Old Lyme, Connecticut; his father, Carleton Wiggins, belonged to the first. The early group was led by Henry Ward Ranger (see pl. 87), who declared the area an American Barbizon in 1899.[1] However, with the arrival of Hassam in 1903, Impressionism became the reigning style. While there were a number of summer schools in the region, the unofficial artists' center was the large estate of Florence Griswold (now the Florence Griswold Museum), which had been transformed into a boarding house, *en plein air* studio, and social hub. Wiggins likely first arrived in Old Lyme around the same time as Hassam, and he spent years traveling between New York City and the colony, painting at both locations, before making Connecticut his more permanent home in 1920.

Painted in Old Lyme, *Snow-Crowned Hills* depicts a cold, barren winter landscape. Clouds hang heavily in the air, warning of a future snowfall; the tall, spindly young trees in the foreground have shed their leaves, revealing the expansive mountain range in the background. While there is no direct source of light, the cold grays, blues, and violets give a sense of late afternoon. Wiggins has contrasted those colors with the warm golds and reds of the berries and spare foliage in the foreground. Although the broken brushstrokes of the composition clearly derive their inspiration from the Impressionists, the unspoiled, uninhabited wintry landscape portrayed is uniquely American. (DM)

1 See Spencer, Anderson, and Larkin 1980, pp. 114–21.

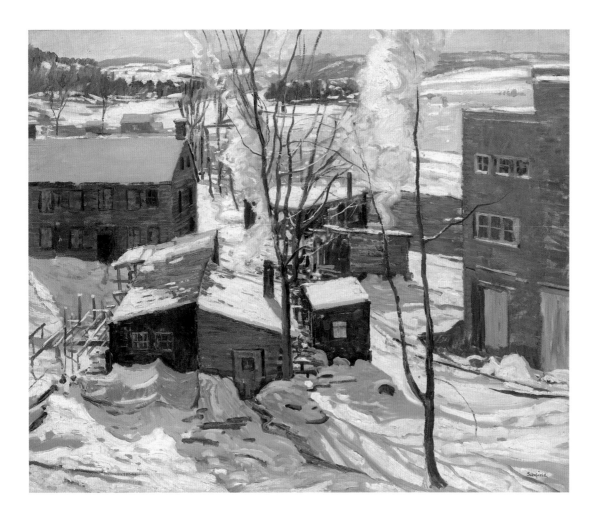

72

WALTER ELMER SCHOFIELD (1867–1944)

The Powerhouse, Falls Village, Connecticut

c. 1914
Oil on canvas; 101.6 x 124.5 cm (40 x 49 in.)
Walter H. Schulze Memorial Collection, 1924.915
Signed lower right: *Schofield*

Although he lived much of his life abroad, Walter Elmer Schofield was a leading figure in the Pennsylvania Impressionist group. He grew up in Philadelphia and studied at the city's Pennsylvania Academy of the Fine Arts for three years beginning in 1889. He then moved to Paris and enrolled in the Académie Julian, working there for an additional three years. In 1895, he returned to the United States to work in his family's textile business but soon gave this up so that he could paint full time. His early landscapes, rendered with a Tonalist simplification of form and subtlety of palette, brought him much success. He showed these works

nationally and internationally, including at the American painting annuals at the Art Institute of Chicago, where he exhibited for the first of many times in 1900.

In 1903, Schofield and his British wife moved to the village of St. Ives in Cornwall, England, and he began to adopt a more broadly painted Impressionist style rendered *en plein air*. This shift was likely inspired both by Schofield's friendship with his fellow Pennsylvania Impressionist Edward Willis Redfield (see pl. 66) and by his connections to the British Impressionists then working in St. Ives. From this time forward, Schofield maintained his residence abroad but continued to work and exhibit extensively in the United States, spending an average of six months a year here.

It was on one of these trips back to his native country that he created *The Powerhouse, Falls Village, Connecticut*. Schofield frequently painted such winter scenes; like many Impressionists, he was fascinated by the challenge of rendering

snow and its many hues in sunlight and shade. He also welcomed the difficulties of painting outdoors in winter. As his friend C. Lewis Hind wrote, Schofield was "rarely able to resist the vigorous delight of painting winter in his native land. There he is working at this moment, perhaps in zero weather, with rain and falling snow and tugging winds, enjoying it immensely."[1]

While the painting's winter setting was typical for Schofield, the industrial subject matter was not. In the early nineteenth century, Falls Village had been a center for iron production, but by the time Schofield painted these industrial buildings, the village's iron industry was in serious decline, supplanted by the greater natural resources that had been found farther west. Schofield's painting of these snow-blanketed structures seems to suggest the renewed peace and quiet in the postindustrial town. (EER)

1 C. Lewis Hind, "An American Landscape Painter: W. Elmer Schofield," *International Studio* 48 (1913), p. 286.

73

WILSON HENRY IRVINE (1869–1936)

Autumn

c. 1914
Oil on canvas; 81.3 x 101.6 cm (32 x 40 in.)
Friends of American Art Collection, 1915.558
Signed lower right: *IRVINE*

Wilson Henry Irvine first made his artistic reputation in Chicago—he spent his student years at the School of the Art Institute and had a successful career in the city as both a fine and commercial artist. He actively participated in exhibitions at the Art Institute between 1900 and 1939 and was a member of several local private organizations, including the Cliff Dwellers Club and the Palette and Chisel Club. However, although he maintained lasting connections to Chicago, he moved permanently to Connecticut in 1918, having commenced yearly visits to the artists' colony at Old Lyme as early as 1914. It was presumably during one early visit to Connecticut that Irvine painted *Autumn*, one of his finest representations of that season.

Autumn is typical of Irvine's Impressionist technique at the time, in which he employed loose, broken brushwork to apply vibrant shades of green, pink, orange, and yellow. Irvine was fascinated by the challenge of representing light at different times of the day or year, and here the lively texture of the paint surface enhances the appearance of the dappled, sun-drenched hillside. Although the painting's exact location— a rocky pasture crossed by meandering stone walls—is unknown, the composition unmistakably evokes the bucolic feel of the Connecticut landscape.

For many Impressionist artists, New England towns held great appeal as a source of comfort and nostalgia. The artists' colony in Old Lyme had been founded by Henry Ward Ranger (see pl. 87) before becoming popular with Childe Hassam (see pls. 48–49, 57, and 82), Willard Metcalf (see pl. 67), and other American Impressionists. They valued the town because of its picturesque architecture, its peace and quiet, and its pastoral character, with few signs of modernity to intrude upon their compositions. *Autumn* evokes an unchanging landscape, in which the rural traditions of American settlers— from the hand-built walls and fences to the irregular piles of cornstalks—resonate as reminders of the nation's past. Although Irvine was born in Illinois, his paintings of the New England landscape nevertheless helped define the region as quintessentially American at a time when the nation was undergoing tremendous change. (SEK)

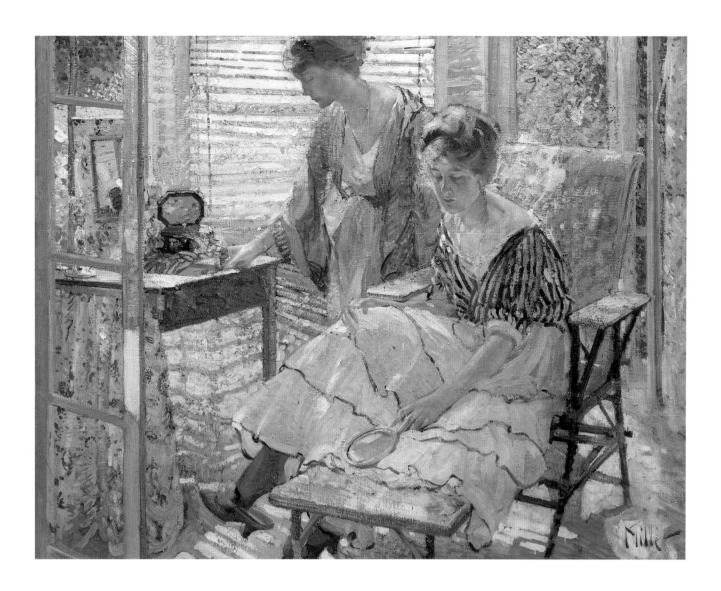

74

RICHARD E. MILLER (1875–1943)

Sunlight

c. 1913
Oil on canvas; 114.3 x 146.1 cm (45 x 57½ in.)
Friends of American Art Collection, 1915.557
Signed lower right: *Miller*

Born and raised in St. Louis, Richard Miller first traveled to Paris in 1899, where he studied at the Académie Julian. Like many of his American contemporaries, Miller spent time in Giverny, site of Claude Monet's country home. He taught there and exhibited, with Frederick Frieseke, among others, as part of the Giverny Group in New York in 1910. His many influences included Mary Cassatt (pls. 19–30), Edgar Degas, and Édouard Vuillard, although his paintings were often seen as academic and relatively conservative.

Around 1913, Miller began painting scenes of women outdoors or in sunlit interiors in a less academic way. One of this group is *Sunlight,* depicting two young women on a sun-filled porch. Legs crossed, with a slipper dangling elegantly off her arched foot, the seated model looks down and reaches for a hand mirror. Her companion likewise does not engage the viewer but, also with eyes downcast, focuses on an item on the small dressing table next to her. The motif of elegant drapery appears throughout the composition, from one woman's full and flowing skirt, to the other's loose, kimono-type robe, to the fabric adorning the table.

The sunlight filling the room is diffused evenly over the models, objects, and windows, creating a variety of decorative patterns. The long lines of the window blinds and the stripes on the seated model's dress; the flowers depicted on the fabric and echoed

out-of-doors; the cool shades of blue alternating with warmer yellows and oranges, all contribute to give the work a decorative sensibility. Such conscious patterning is also present in the works of a group of French artists known as the Nabis, which included Vuillard and Pierre Bonnard, who saw the function of painting as primarily to create *décorations.* In his interest in painting as nonnarrative and his technical experiments with thickly applied color over thin layers of pigment Miller is not dissimilar to Vuillard. In *Sunlight,* the two models are not portrayed as individuals but as part of the decorative whole, in which the emphasis is on beauty for its own sake. Miller used many of the same objects in painting after painting; for example, the elegantly framed mirror and box on the table appear in at least three other works, and the ruffled skirt in no fewer than seven paintings. (DM)

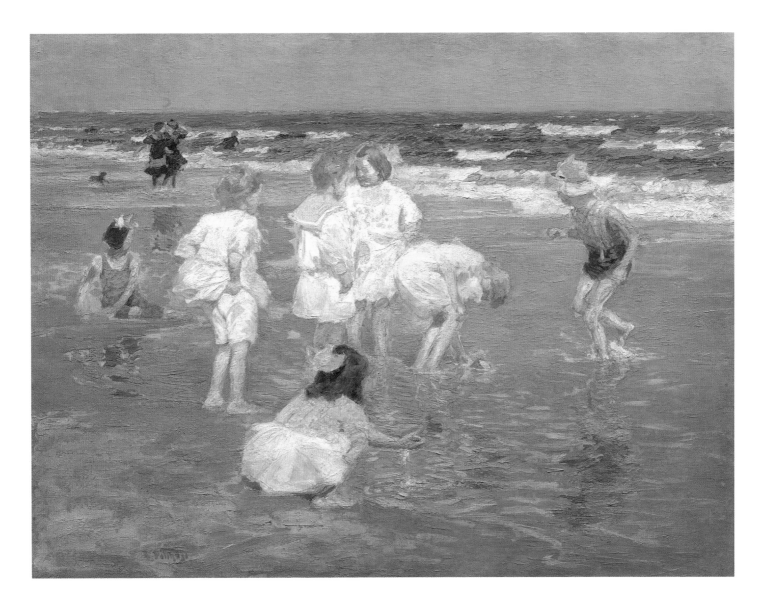

75

EDWARD HENRY POTTHAST (1857–1927)

A Holiday

c. 1915
Oil on canvas; 76.4 x 101.8 cm (30 ⅛ x 40 ⅛ in.)
Friends of American Art Collection, 1915.560
Signed lower left: *E. Potthast*

A Holiday depicts one of the beach scenes for which Edward Henry Potthast was best known. Capturing a quintessentially Impressionist scene—a sun-dappled land-scape with women and children enjoying leisure time—Potthast also utilized the movement's technique of thickly applied paint, broken brushwork, and the use of brilliant colors.

Potthast never married and left no diaries, thus making the details of his life somewhat elusive. Born and raised in Cincinnati, early in his career he worked as a lithographer and took evening art classes. His first trip to Europe in 1882–85 took him to Antwerp and then to Munich, following the example of other Cincinnati artists such as John Twachtman (see pls. 58–59); his work during and just after this period shows the influence of the latter school in its dark, somber colors. In 1887, he returned to Europe, where he met the American Impressionist Robert Vonnoh in France and was introduced to the work of the French Impressionists. Several years later Potthast came home to the United States, and in 1894 exhibited a painting, *Dutch Interior,* that was subsequently purchased for the Cincinnati Art Museum. Emboldened by this financial and critical success, he was prompted to move to New York City, where he could establish himself fully as an artist. There, he joined several artist societies and painted in various styles, his well-known beach scenes emerging around 1910. It is possible that these were inspired by a popular 1909 exhibition in New York of the works of Joaquín Sorolla y Bastida, a Spanish artist whose oeuvre included numerous seaside scenes of his native Valencia.

In *A Holiday* a group of children converse and frolic at the water's edge. The bright overhead light indicates that it is midday, the white-capped waves, billowing clothing, and, in the background, a woman holding on to her hat evoke the wind. There is nothing threatening about the wind or the waves; indeed, Potthast's paintings were both praised and criticized for presenting nothing other than a pleasant, innocent, and optimistic view. (DM)

SEVEN

"Landscape in and about the City": American Impressionists and Urban Subjects

IN THE 1880s, the first group of Americans to experiment with Impressionism did so while working alongside Claude Monet at Giverny in the French countryside. Perhaps because of this early focus on landscape, these painters continued to depict rural subjects after they returned to the United States. In this choice, they differed from their French colleagues, who had first used Impressionism in the 1860s and 1870s to portray the new leisure activities enjoyed in Paris by the growing bourgeoisie. Most American Impressionists only turned to such urban subject matter after 1900, when the style had been broadly accepted by critics and patrons in the United States.

An early innovator in this area was William Merritt Chase, who painted Impressionist renderings of parks and wharves in Brooklyn and Manhattan in the late 1880s. Chase detailed his appreciation of urban subjects in a conversation with *Art Amateur* critic A. E. Ives in 1891, declaring: "If you want to know of good places to sketch in the vicinity of New York . . . I think I could easier tell you where they are not than where they are. The good places are everywhere." Ives went on to explain, "In his remarks about New York as a sketching ground Mr. Chase speaks with the authority of one who has had experience, as it is generally conceded he was the first metropolitan artist to appreciate the hitherto almost untouched field of landscape in and about the city."[1] Chase's pictures of New York, such as *A City Park* (pl. 76), explore the same sort of urban middle-class leisure activities favored by the French Impressionists in the 1860s and 1870s. Like the French artists, Chase frequently featured women in his city paintings, illustrating the new, more active and public, role they were assuming in the modern age.

Chase's paintings of urban subjects were widely praised. A writer in the *Chicago Tribune* reported in 1889:

> Mr. Chase is always eager to explore new fields of beauty. Of late he has omitted his usual summer trips to Europe and sought inspiration in the neighborhood of his own home. The result is a series of richly colored studies of Brooklyn parks and docks, pictures gay, and joyous, and brilliant as a June festival, giving us the splendor of flowers, the brightness of sunshine on grass and walks, the vivacity of crowds in gala colors—scenes of richly colored life and pleasure. . . . Straightway we have a joyous little masterpiece.[2]

Such critics helped to publicize Chase's city scenes, and their appreciation of his paintings encouraged other artists to use Impressionism to explore urban subject matter.

1 A. E. Ives, "Suburban Sketching Grounds: I. Talks with Mr. W. M. Chase, Mr. Edward Moran, Mr. William Sartain and Mr. Leonard Ochtman," *Art Amateur* 25, no. 4 (Sept. 1891), p. 80.

2 "Mr. Chase's Pictures," *Chicago Tribune*, Sept. 15, 1889, p. 31.

In their urban scenes the American Impressionists, like their French counterparts, focused on the new spaces of the modern city. Parks, first painted by Chase, continued to be popular subjects. Maurice Prendergast portrayed the crowds who visited these sites in order to experience nature in the city (see his watercolors *The Terrace Bridge, Central Park* of 1901, pl. 80, and *New York City, 86th Street and East River* of c. 1900–03, pl. 81). William Glackens explored another popular location for middle-class urban leisure, the café, in his painting *At Mouquin's* of 1905 (pl. 86). Childe Hassam depicted a characteristic modern space—the street—in his oil *New York Street* of 1902 (pl. 82), placing the newly mobile modern woman front and center. The painter Elizabeth Sparhawk-Jones, who was just such a modern woman, used Impressionism to suggest the busy atmosphere of another new urban space, the department store, in her *Shoe Shop* of c. 1911 (pl. 78).

Other painters employed Impressionism, and the related style known as Tonalism, to depict the modern city from afar. Henry Ward Ranger, for example, painted *Brooklyn Bridge* in 1899 (pl. 87), celebrating the triumph of modern engineering represented by this structure, which was the world's first steel-wire suspension bridge. Jonas Lie, in his *Afterglow* of c. 1913 (pl. 89), portrayed the skyscrapers and waterfront of lower Manhattan, evoking the city's burgeoning power and energy through the gleaming electric lights shining everywhere. Alson Skinner Clark ascended the State Street Bridge lookout in Chicago in order to depict the bold modern form of the bridge's iron span in his painting *The Coffee House* of 1905–06 (pl. 90). Such Impressionist and Tonalist urban views, like James McNeill Whistler's earlier renditions of London (see pl. 13, *Nocturne: Blue and Gold—Southampton Water* of 1872), idealized the city's industrial landscape, celebrating its new, uniquely modern, beauty.

Yet at this same time, another group of painters, centered around the artist Robert Henri, used free Impressionist brushwork to portray the human costs of the modern industrial age. A number of these artists had begun as illustrators, and they often brought a more critical journalist's perspective to their city views. In his pastel *The Tired City (Early Morning, Paris)* of 1901 (pl. 54), for example, Everett Shinn depicted a rag picker, whose slumped position in front of a trash heap embodies the darker side of the modern city's vibrant industrial growth. These paintings of the urban lower classes were also in the tradition of French Impressionism, but instead of the sunlit scenes of Claude Monet, they looked to the prostitutes and drug addicts depicted by Edgar Degas in works such as his 1876 painting *The Absinthe Drinker* (Musée d'Orsay, Paris). Henri, Shinn, and their friends formed the group The Eight and exhibited their scenes of the urban lower classes' plight in 1908 at the MacBeth Galleries in New York. Their stark realism offended critics, who dismissed them as "the Ashcan School."[3]

Thus, as in France, the distinction between American Impressionism and Realism is difficult to define.[4] In addition to Realist views like *The Tired City,* Shinn painted scenes of middle-class urban entertainments, such as the circus in his 1902 picture *The Hippodrome, London* (pl. 85), that are squarely in the Impressionist tradition. Likewise, George Bellows is often associated with the Ashcan School because of paintings like *The Cliff Dwellers* (1913; Los Angeles County Museum of Art), which depicts the crowded conditions of lower-class urban life. Yet Bellows also painted middle-class urban leisure activities; he featured ice skating in his 1914 painting *Love of Winter* (pl. 83), for example. The American Impressionists' different ways of depicting the city demonstrate the simultaneous excitement and desolation inherent in this quintessential modern place.

3 On the Ashcan School, see Zurier, Snyder, and Mecklenburg 1995.

4 For more on the relation between these two modes of painting in the United States, see Weinberg, Bolger, and Curry 1994.

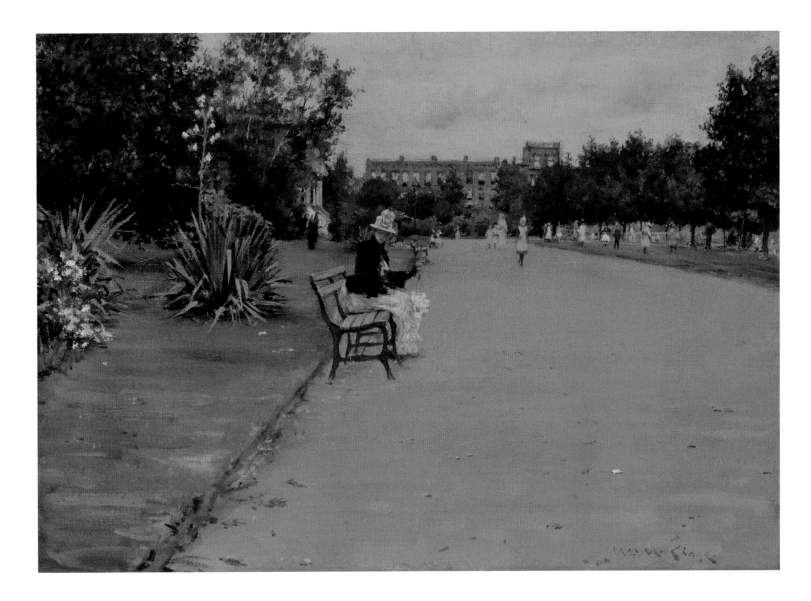

76

WILLIAM MERRITT CHASE (1849-1916)

A City Park

c. 1887
Oil on canvas; 34.6 x 49.9 cm (13 ⁵/₈ x 19 ⁵/₈ in.)
Bequest of Dr. John J. Ireland, 1968.88
Signed lower right: *Wm M. Chase*

Born in Williamsburg, Indiana, William Merritt Chase studied art at the Königliche Akademie in Munich from 1872 to 1877. There, he learned the school's characteristic freely brushed, dark, realist style of painting, which emulated seventeenth-century Dutch and Spanish masters such as Frans Hals and Diego Velásquez. On a return visit to Europe in 1881, Chase encountered the work of the French Impressionists, and he gradually began to adopt their goal of capturing the effects of light and atmosphere

en plein air. In a September 1891 article in the *Art Amateur*, Chase described his new painting method, declaring: "When I have found the spot I like, I set up my easel, and paint the picture on the spot. I think that is the only way rightly to interpret nature. I don't believe in making pencil sketches, and then painting your landscape in your studio. You must be right out under the sky."[1]

In works of the late 1880s, including *A City Park*, Chase became one of the first painters to use this Impressionist technique to portray the American city. Likely depicting Tompkins Park in Brooklyn, the Art Institute's painting is one of a number of views of that city's parks that Chase created after he moved there in 1886. In these works, he experimented with the Impressionists' use of striking compositional viewpoints to depict scenes of urban leisure. These pictures

simultaneously present nature contained by the city and the urban landscape softened by the natural world. In *A City Park*, the woman at center looks up, suggesting that the painting represents a specific moment in time and drawing the viewer into the pictorial space. Chase's strong one-point perspective leads the eye through the park to the modern brownstones beyond. At the same time, the high horizon line and large, empty path dominating the composition flatten the pictorial space, halting the viewer's progress and allowing the park to serve the viewer as it did Chase and his fellow Brooklynites: as an open respite from the press of the city surrounding it. (EER)

1 A. E. Ives, "Suburban Sketching Grounds," *Art Amateur* 25, no. 4 (Sept. 1891), p. 80.

77

CHARLES COURTNEY CURRAN
(1861–1942)

An Alcove in the Art Students' League

1888
Oil on canvas; 21.6 x 29.2 cm (8½ x 11½ in.)
Bequest of Kate L. Brewster, 1950.1514
Signed lower left: *Chas. C. Curran '88*

Born in Hartford, Kentucky, Charles Courtney Curran grew up in Sandusky, Ohio, and first studied art at the Cincinnati School of Design in 1880. Between 1881 and 1883, he began classes in New York at the National Academy of Design and the Art Students' League. Founded in 1875, the League was a progressive alternative to the older National Academy and a center for avant-garde styles, including Impressionism. Nevertheless, instruction there was still grounded in the French academic method,

with students drawing plaster casts of classical sculptures before they rendered subjects from life or painted with oil.

In *An Alcove in the Art Students' League*, Curran depicted one of these antique drawing classes, creating an intriguing contrast between the timeless classical statues in the foreground and the contemporary art students behind them. The two women facing into the alcove may be sitting for the exam required before a student was allowed to move into life classes. This assessment involved rendering more complex casts, such as that of Michelangelo's *Night,* which appears at left. Unlike life classes, which were segregated by gender, antique classes were integrated; as Curran's painting demonstrates, increasing numbers of women studied art in these years.

Curran had great success with pictures like this one in the 1880s, exhibiting and

selling them widely. He sold this work the year he painted it to leading Chicago art patron James Ellsworth, who immediately lent it to the Art Institute's *First Annual Exhibition of American Oil Paintings*. Reviewing that show, a writer in the *Chicago Journal* noted: "Curran has a clever little picture giving a view through a brick arch at the Art Students' League, the light from above striking on the casts, easels and drawing-boards in very effective contrast to the brick."[1] As this critic observed, Curran's early works demonstrate his ability to render light effects, an interest he would further develop between 1888 and 1891 in Paris, where he embraced the light-filled Impressionist style he would use for the rest of his career. (EER)

1 "The Art Exhibition," *Chicago Journal*, May 26, 1888. Scrapbooks, Art Institute of Chicago, 1965, 25, vols. 1–6 (1869–97), reel 1.

78

ELIZABETH SPARHAWK-JONES
(1885–1968)

Shoe Shop

c. 1911
Oil on canvas; 99.1 x 79.4 cm (39 x 33¼ in.)
William Owen and Erna Sawyer Goodman
Collection, 1939.393
Signed lower right: *Elizabeth Sparhawk-Jones*

Born in Baltimore, Elizabeth Sparhawk-Jones grew up in that city and in her family's native Philadelphia. She studied art at the Pennsylvania Academy of the Fine Arts in Philadelphia from 1902 to 1909, working there with Thomas Anshutz and Cecilia Beaux (see pl. 62), as well as with William Merritt Chase (pls. 60, 61, and 76), who gave weekly critiques at the Academy in those years. In this period, Sparhawk-Jones also spent significant time in Paris, where she took classes at the Académie de la Grande Chaumière. In her first mature paintings, including *Shoe Shop*, Sparhawk-Jones synthesized elements derived from all these sources, using Chase's Impressionistic brilliant color and broad brushwork to depict Realist subject matter that was more characteristic of the work of Anshutz and Ashcan School painters such as Robert Henri and John Sloan. In *Shoe Shop*, she focused on the interactions between women customers and shop workers, creating an active composition that, coupled with her brushy paint handling, conveys the energy of a new urban space, the department store.

Sparhawk-Jones exhibited her canvases in major shows throughout the United States, including the annual exhibitions at the Art Institute of Chicago, where she displayed *Shoe Shop* in 1911. Her paintings won important prizes and were praised by critics; in 1912, a writer in the *New York Times* described *Shoe Shop* and Sparhawk-Jones's related painting *Shop Girls* as "two gay shop interiors painted with spontaneous gusto by Elisabeth [*sic*] Sparhawk-Jones—the breeziest of protestants against sentimentality in paint."[1] That year, the Friends of American Art purchased *Shop Girls* for the Art Institute of Chicago.

Poised on the brink of a significant artistic career, Sparhawk-Jones suffered a nervous breakdown and stopped painting entirely for twelve years. When she began to work again in the mid-1920s, she discarded Impressionism and Realism in favor of more imaginative and symbolic subject matter. She first exhibited her new paintings in the Art Institute's annual show in 1926, where she won the Kohnstamm Prize, the first of many successes she would achieve in this second phase of her career. (EER)

1 "Philadelphia Exhibition: Pennsylvania Academy Shows Interesting Paintings of Many Schools," *New York Times*, Feb. 4, 1912, p. 12.

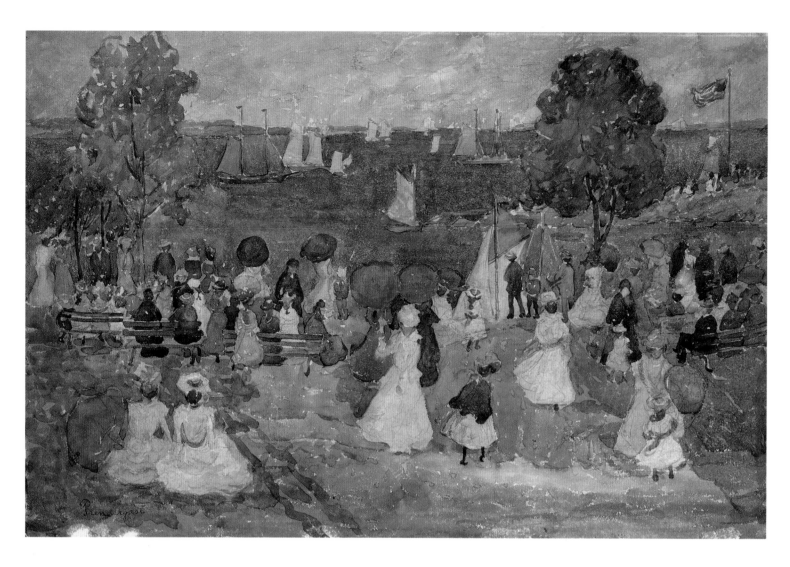

MAURICE BRAZIL PRENDERGAST
(1858–1924)

79

Yacht Race

c. 1896–97
Watercolor, over graphite, on ivory wove paper;
35.4 x 53 cm (13 ¹⁵⁄₁₆ x 20 ⅞ in.)
Watson F. Blair Purchase Prize Fund, 1932.175
Signed lower left: *Prendergast*

80

The Terrace Bridge, Central Park

1901
Watercolor, over graphite, on ivory wove paper;
38.8 x 56.9 cm (15 ⁵⁄₁₆ x 22 ⁷⁄₁₆ in.)
Olivia Shaler Swan Memorial Collection, 1939.431
Signed lower right: *Maurice B. Prendergast / The
Terrace Bridge Central Park / 1901 New York*

81

*New York City, 86th Street and East
River*

c. 1900–03
Watercolor, with touches of pastel, over graphite,
on ivory wove paper; 35.4 x 50.8 cm (13 ¹⁵⁄₁₆ x 20 in.)
Gift of Kate L. Brewster, 1948.558R
Signed lower left: *Prendergast*

Maurice Prendergast's bright, cheerful
watercolors of Boston and New York
established his reputation at the turn of the
twentieth century as a unique and original
painter. Although contemporary critics
primarily applauded his deft mastery of
the difficult medium of watercolor, they
found his preferred subject matter—women
and children in public spaces, partaking in
a variety of leisure activities—equally
compelling. These modern motifs link his
work to that of the French Impressionists,
who likewise chronicled new forms of
public interaction, while his sparkling color
reveals his debt to the Nabis, a group of

Post-Impressionist painters working in Paris
in the 1890s.

Born in St. John's, Newfoundland,
Prendergast was raised in Boston following
his family's move to the United States when
he was ten. He received no formal artistic
training until he traveled to Paris in 1891.
He spent three years studying at the
Académies Julian and Colarossi and devel-
oped a style influenced by the Nabis, as well
as Art Nouveau, Japanese prints, and the
works of James McNeill Whistler (see pls.
10–18). Upon his return to Boston in 1894,
he began painting watercolors of Boston life.
Prendergast probably painted *Yacht Race* in
Salem, a resort town north of Boston made
fashionable by the increasing ease of trans-
portation. The site appears to be Salem
Willows, a popular amusement park and
beach, which the artist would depict again in
Salem Willows (1904; Terra Foundation for
American Art, Chicago). Choosing an
elevated vantage point, Prendergast por-
trayed a small crowd of spectators, primarily

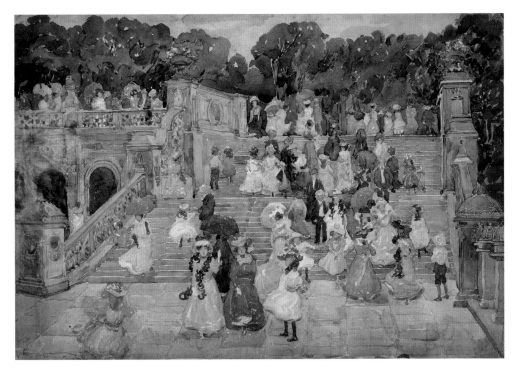

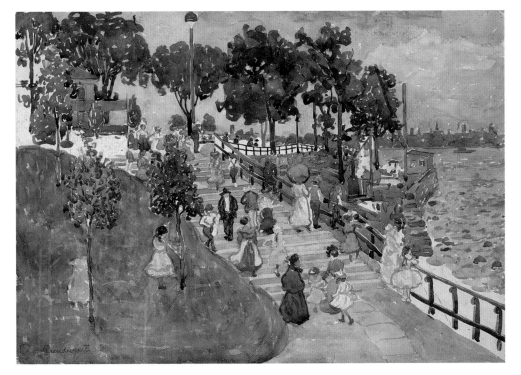

including its ornately carved balustrades. The steps are filled with clusters of upper-class women and children; many of the women delicately lift their skirts as they promenade with parasols. Prendergast paid close attention to the fashions of the day, indicating distinctive hats, sashes, and other accessories with a fluid hand. Relatively few men can be seen, which is typical of Prendergast's scenes of urban leisure. Men would have been at work during the week, seeking to provide for their families. Central Park thus offered women a socially accept-able location for strolling in the fresh air as they observed and interacted with each other. Such park settings therefore became an important part of the spectacle of the city, as engrossing as the theater or other urban entertainments.

Prendergast depicted Manhattan's parklike riverfront in *New York City, 86th Street and East River*, capturing another setting in which urban residents could pass their leisure hours. At the time, 86th Street was the heart of the city's Yorkville neighbor-hood, the home of hundreds of European immigrants, primarily middle-class Germans, who established bakeries, breweries, and other businesses in the area. In contrast to the predominantly well-dressed women of *The Terrace Bridge*, in this watercolor there appears to be a mixture of classes. Several women are outfitted in simpler styles, with fewer fashionable details on display, while a nanny clad in dark clothes accompanies a mother and her two children. Prendergast rendered the watercolor with broad strokes, freely outlining the figures in blue and rapidly brushing on color to indicate the grass, trees, and water.

Following a return trip to France in 1907, Prendergast increasingly adopted a more radical Post-Impressionist aesthetic. In 1908, his works were the most avant-garde of those displayed at the exhibition of The Eight (see pl. 86), and in 1913, he showed at the momentous International Exhibition of Modern Art, also known as the Armory Show. However, even prior to his embrace of modernism, Prendergast's vivacious water-colors of modern life firmly identified him as one of the most progressive American painters of the time. (SEK)

women, all turned toward the water to observe the race. He loosely rendered the figures in pencil overlaid by transparent watercolor, giving the scene a vitality and freshness that is further enhanced by bold spots of color.

In 1898, Prendergast traveled to Italy, supported by the wealthy Boston patron Sarah Choate Sears (see the introduction, pp. 13–14). During his eighteen-month stay, he became particularly enthralled with the

architecture of Venice and painted numer-ous watercolors that reflect his fascination with the urban environment. Upon his return to the United States, he brought a similar sensibility to works such as *The Terrace Bridge, Central Park*. Here he focused on one of the grand staircases of the Bethesda Terrace in New York's Central Park, which he portrayed from the vantage point of the upper terrace. He carefully depicted the bridge's structural elements,

82

CHILDE HASSAM (1859–1935)

New York Street

1902
Oil on canvas; 59.7 x 49.5 cm (23 ½ x 19 ½ in.)
Bequest of Edna H. Lowenstein, 1980.289
Signed lower left: *Childe Hassam 1902*

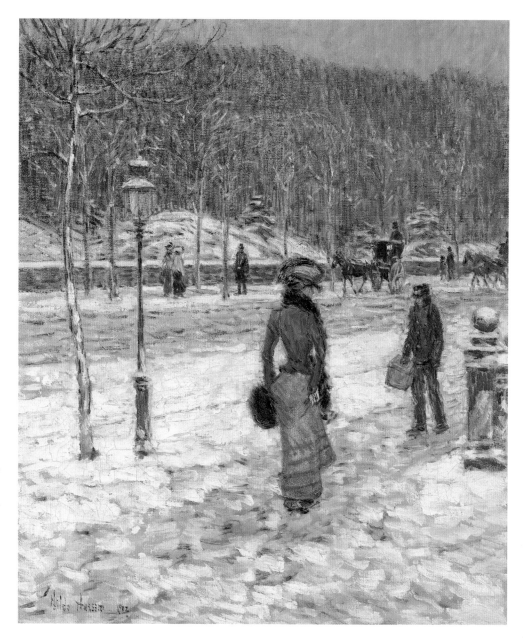

A depiction of Fifth Avenue with Central Park on the left, *New York Street* was one of several paintings by Childe Hassam done around 1902 that feature a female figure making her way through the snowy city. By this time Hassam had twice traveled and studied in Europe—enrolling, like many of his contemporaries, at the Académie Julian in Paris—and his artistic output included both urban and rural landscapes, portraying scenes abroad and at home. Typically summering in various artists' colonies in New England, such as those in Gloucester and on Appledore Island (see pls. 57 and 64), Hassam often returned to New York City by the end of each year; it is possible that *New York Street* was completed during November or December of 1902.

New York Street casts the city neither as a vibrant modern site nor as a gritty urban space; the trees of Central Park appear on one side of the avenue and no architecture is visible. The fresh snow covers all that might be unsightly, and it has not yet become muddied by pedestrians, horses, or carriages. Hassam's earlier paintings of New York in the winter often depict the city from a higher vantage point and with a greater panorama, but here the viewpoint is situated at nearly street level. The brightly colored hat of the woman in the foreground draws the eye toward her as she attempts to maneuver elegantly through the slush; other bundled figures make their way through the snow and ice. The sky overhead gives off a cold light that is captured in Hassam's broken brushstrokes; the pale grays, greens, blues, and white are offset by the bright yellow and red-orange of the hat and dress. The brushwork, the urban setting, and the wintry scene position Hassam firmly within the sphere of American Impressionism. (DM)

SUGGESTIONS FOR FURTHER READING

GENERAL SOURCES

Adler, Kathleen, Erica E. Hirshler, and H. Barbara Weinberg. 2006. *Americans in Paris, 1860–1900*. Exh. cat. National Gallery, London.

Anderson, Jeffrey W., with contributions by the staffs of the Florence Griswold Museum and the Guild Hall of East Hampton. 1989. *En Plein Air: The Art Colonies at East Hampton and Old Lyme, 1880–1930*. Exh. cat. Florence Griswold Museum, Old Lyme, Conn., and Guild Hall of East Hampton, Conn.

Barter, Judith A., Kimberly Rhodes, and Seth A. Thayer, with contributions by Andrew J. Walker. 1998. *American Arts at the Art Institute of Chicago: From Colonial Times to World War I*. Art Institute of Chicago/Hudson Hills Press.

Brettell, Richard R. 2000. *Impression: Painting Quickly in France, 1860–1890*. Exh. cat. Sterling and Francine Clark Art Institute, Williamstown, Mass./Yale University Press.

Burns, Sarah. 1996. *Inventing the Modern Artist: Art and Culture in Gilded Age America*. Yale University Press.

Davis, Richard Harding, and Charles Dana Gibson. 1895. *About Paris*. Harper.

Folk, Thomas. 1997. *The Pennsylvania Impressionists*. Fairleigh Dickinson University Press.

Gerdts, William H. 1984. *American Impressionism*. Abbeville Press.

———. 1993. *Monet's Giverny: An Impressionist Colony*. Abbeville Press.

———. 1994. *Impressionist New York*. Abbeville Press.

Hirshler, Erica E., and MaryAnne Stevens. 2005. *Impressionism Abroad: Boston and French Painting*. Exh. cat. Royal Academy of Arts, London.

Hosley, William. 1990. *The Japan Idea: Art and Life in Victorian America*. Exh. cat. Wadsworth Atheneum, Hartford, Conn.

Larkin, Susan G. 2001. *The Cos Cob Art Colony: Impressionists on the Connecticut Shore*. Exh. cat. National Academy of Design, New York/Yale University Press.

Peters, Lisa N. 1997. *Visions of Home: American Impressionist Images of Suburban Leisure and Country Comfort*. Exh. cat. Trout Gallery, Dickinson College, Carlisle, Pa.

Peterson, Brian H., ed. 2002. *Pennsylvania Impressionism*. University of Pennsylvania Press.

Solon, Deborah Epstein. 1999. *Colonies of American Impressionism: Cos Cob, Old Lyme, Shinnecock, and Laguna Beach*. Exh. cat. Laguna Art Museum, Laguna Beach, Calif.

Spencer, Harold, Jeffrey W. Anderson, and Susan G. Larkin. 1980. *Connecticut and American Impressionism*. Exh. cat. William Benton Museum of Art, University of Connecticut.

Weinberg, H. Barbara, Doreen Bolger, and David Park Curry. 1994. *American Impressionism and Realism: The Painting of Modern Life, 1885–1915*. Exh. cat. Metropolitan Museum of Art, New York.

Weitzenhoffer, Frances. 1986. *The Havemeyers: Impressionism Comes to America*. Harry N. Abrams.

Zurier, Rebecca. 2006. *Picturing the City: Urban Vision and the Ashcan School*. University of California Press.

Zurier, Rebecca, Robert W. Snyder, and Virginia M. Mecklenburg. 1995. *Metropolitan Lives: The Ashcan Artists and Their New York*. Exh. cat. National Museum of American Art, Washington, D.C./W. W. Norton and Company.

SOURCES ON THE ARTISTS

BEAL

Kraushaar Galleries, New York. 1993. *Gifford Beal, Picture-Maker*. Exh. cat. Kraushaar Galleries, New York.

BEAUX

Beaux, Cecilia. 1930. *Background with Figures*. Houghton Mifflin Company.

Liebold, Cheryl, Sarah Burns, Patrick Connors, Barbara Katus, Nancy Mowll Mathews, Tara Leigh Tappert, Jeannette M. Toohey, and Sylvia Yount. 2000. "Cecilia Beaux: Philadelphia Artist." *Pennsylvania Magazine of History and Biography* (July).

Yount, Sylvia, Kevin Sharp, Nina Auerbach, and Mark Bockrath. 2007. *Cecilia Beaux: American Figure Painter*. Exh. cat. High Museum of Art, Atlanta/University of California Press.

BELLOWS

Quick, Michael, Jane Meyers, Marianne Doezema, and Franklin Kelly, with an introduction by John Wilmerding. 1992. *The Paintings of George Bellows*. Exh. cat. Edited by Nancy Stevens. Amon Carter Museum, Fort Worth, Tex.

Setford, David F., and John Wilmerding. 1997. *George Bellows: Love of Winter*. Exh. cat. Norton Museum of Art, West Palm Beach, Fla.

BENSON

Bedford, Faith. 1994. *Frank W. Benson: American Impressionist*. Rizzoli.

Bedford, Faith, Laurene Buckley, Dean T. Lahikainen, and Jane M. Winchell. 2000. *The Art of Frank W. Benson, American Impressionist*. Exh. cat. Peabody Essex Museum, Salem, Mass.

CASSATT

Barter, Judith A., ed. 1998. *Mary Cassatt, Modern Woman*. Exh. cat. Art Institute of Chicago.

Breeskin, Adelyn Dohme. 1970. *Mary Cassatt: A Catalogue Raisonné of the Oils, Pastels, Watercolors, and Drawings*. Smithsonian Institution Press.

Mathews, Nancy Mowll, ed. 1984. *Cassatt and Her Circle: Selected Letters*. Abbeville Press.

Mathews, Nancy Mowll, and Barbara Stern Shapiro. 1989. *Mary Cassatt: The Color Prints*. Exh. cat. Williams College Museum of Art, Williamstown, Mass./Harry N. Abrams.

CHASE

Atkinson, D. Scott, and Nicolai Cikovsky, Jr. 1987. *William Merritt Chase: Summers at Shinnecock 1891–1902*. Exh. cat. National Gallery of Art, Washington, D.C.

Gallati, Barbara Dayer. 1999. *William Merritt Chase: Modern American Landscapes, 1886–1890*. Exh. cat. Brooklyn Museum of Art/Harry N. Abrams.

Pisano, Ronald G. 2006. *William Merritt Chase: The Complete Catalogue of Known and Documented Work by William Merritt Chase, 1849–1916*. Yale University Press.

CLARK

Solon, Deborah Epstein. 2005. *An American Impressionist: The Art and Life of Alson Skinner Clark*. Exh. cat. Pasadena Museum of California Art/Hudson Hills Press.

Stern, Jean. 1983. *Alson S. Clark*. Petersen Publishing Co.

CURRAN

Cook, Clarence 1895. "A Representative American Artist." *Monthly Illustrator* 11 (November), pp. 289–92.

Saint-Gaudens, Homer. 1906. "Charles Courtney Curran." *The Critic* 48 (January), pp. 38–39.

Silver, Kenneth. 1974. "*At the Sculpture Exhibition* by Charles Curran." *Yale University Art Gallery Bulletin* 35, no. 1 (Summer), pp. 20–25.

DEWING

Hobbs, Susan. 1996. *The Art of Thomas Wilmer Dewing: Beauty Reconfigured*. Exh. cat. Brooklyn Museum of Art/Smithsonian Institution Press.

McCarthy, Maura. 1999. "Maria Oakey Dewing: The Beautiful Ideal." M.A. thesis, School of the Art Institute of Chicago.

GARBER

Humphries, Lance Lee. 2006. *Daniel Garber: Catalogue Raisonné*. 2 vols. Hollis Taggart Galleries, New York.

———. 2007. *Daniel Garber: Romantic Realist*. Exh. cat. Pennsylvania Academy of the Fine Arts, Philadelphia/James A. Michener Art Museum, Doylestown, Pa.

GAY

Reynolds, Gary A. 1980. *Walter Gay: A Retrospective*. Exh. cat. Grey Art Gallery, New York University.

Rieder, William. 2000. *A Charmed Couple: The Art and Life of Walter and Matilda Gay*. Harry N. Abrams.

GLACKENS

Gerdts, William H. 1996. *William Glackens*. Abbeville Press.

Glackens, Ira. 1957. *William Glackens and The Eight: The Artists Who Freed American Art*. Horizon Press.

HASSAM

Curry, David Park. 1990. *Childe Hassam: An Island Garden Revisited*. Exh. cat. Denver Art Museum/W. W. Norton.

Weinberg, H. Barbara, et al. *Childe Hassam, American Impressionist*. Exh. cat. Metropolitan Museum of Art, New York.

HITCHCOCK

Stott, Annette, Holly Koons McCullough, Nina Lübbren Emke Raassen-Kruimel, and Kim Saget. 2009. *Dutch Utopia: American Artists in Holland*. Exh. cat. Telfair Museum of Art, Savannah, Ga.

Van den Berg, Peter, J. H. 2008. *De uitdaging van het licht: George Hitchcock (1850–1913)*. Bahlmond.

HOMER

Cikovsky, Nicolai, Jr., and Franklin Kelly. 1995. *Winslow Homer*. Exh. cat. National Gallery of Art, Washington, D.C.

Conrads, Margaret C. 2001. *Winslow Homer and the Critics: Forging a National Art in the 1870s*. Exh. cat. Nelson-Atkins Museum of Art, Kansas City/Princeton University Press.

Goodrich, Lloyd. 1944. *Winslow Homer*. Whitney Museum of American Art, New York/MacMillan Company.

———. 2005–08. *Record of Works by Winslow Homer*. Edited and expanded by Abigail Booth Gerdts. Vols. 1–3. Spanierman Gallery, New York.

Griffin, Randall C. 2006. *Winslow Homer: An American Vision*. Phaidon.

Tedeschi, Martha. 2008. *Watercolors by Winslow Homer: The Color of Light*. Exh. cat. Art Institute of Chicago/Yale University Press.

INNESS

Bell, Adrienne Baxter. 2003. *George Inness and the Visionary Landscape*. Exh. cat. National Academy of Design, New York.

Bell, Adrienne Baxter, ed. 2006. *George Inness: Writings and Reflections on Art and Philosophy*. George Braziller.

DeLue, Rachel Ziady. 2004. *George Inness and the Science of Landscape*. University of Chicago Press.

Quick, Michael. 2006. *George Inness: A Catalogue Raisonné*. Rutgers University Press.

IRVINE

Gordon, Cheryl Cibulka. 1990. *Explorations of an American Impressionist: The Art of Wilson Irvine, 1869–1936*. Exh. cat. Adams Davidson Galleries, Washington, D.C.

Spencer, Harold. 1998. *Wilson Henry Irvine and the Poetry of Light*. Exh. cat. Florence Griswold Museum, Old Lyme, Conn.

LIE

Gerdts, William H., and Carol Lowrey. 2005. *Jonas Lie (1880–1940)*. Exh. cat. Spanierman Gallery, New York.

MACMONNIES

Smart, Mary. 1996. *A Flight with Fame: The Art and Life of Frederick MacMonnies*. Sound View Press.

METCALF

De Veer, Elizabeth, and Richard J. Boyle. 1987. *Sunlight and Shadow: The Life and Art of Willard L. Metcalf*. Abbeville Press.

MacAdam, Barbara J. 1999. *Winter's Promise: Willard Metcalf in Cornish, New Hampshire, 1909–1920*. Exh. cat. Hood Museum of Art, Dartmouth College.

MILLER

Kane, Mary Louise. 1997. *A Bright Oasis: The Paintings of Richard E. Miller*. Exh. cat. Jordan–Volpe Gallery, New York.

MURPHY

Coles, William A. 1982. *Hermann Dudley Murphy (1867–1945):"Realism Married to Idealism Most Exquisitely."* Exh. cat. Graham Gallery, New York.

Graham Gallery, New York. 1985. *Hermann Dudley Murphy, 1867–1945: Boston Painter at Home and Abroad*. Exh. cat.

Morrell, Dora H. 1899. "Hermann Dudley Murphy." *Brush and Pencil* 5, no. 2 (November), pp. 49–57.

PALMER

Mann, Maybelle, and Alvin Lloyd Mann. 1984. *Walter Launt Palmer, Poetic Reality*. Schiffer Publishing.

POTTHAST

Wilson, John. 1998. *Edward Henry Potthast: American Impressionist*. Exh. cat. Gerald Peters Gallery, New York.

PRENDERGAST

Carol Clark, Nancy Mowll Mathews, and Gwendolyn Owens. 1990. *Maurice Brazil Prendergast, Charles Prendergast: A Catalogue Raisonné*. Williams College Museum of Art, Williamstown, Mass.

Mathews, Nancy Mowll. 1990. *Maurice Prendergast*. Exh. cat. Williams College Museum of Art, Williamstown, Mass./Prestel.

Wattenmaker, Richard J. 1994. *Maurice Prendergast*. National Museum of American Art, Washington, D.C./Harry N. Abrams.

RANGER

Becker, Jack. 1999. *Henry Ward Ranger and the Humanized Landscape*. Exh. cat. Florence Griswold Museum, Old Lyme, Conn.

Bell, Ralcy Husted. 1914. *Art-Talks with Ranger*. G. P. Putnam's Sons.

Riback, Estelle. 2000. *Henry Ward Ranger: Modulator of Harmonious Color: A Monograph*. Lost Coast Press.

REDFIELD

Fletcher, J. M. W. 1996. *Edward Willis Redfield, 1869–1965: An American Impressionist: His Paintings and the Man behind the Palette*. JMWF Publishing.

Fletcher, J. M. W. 2002. *Edward Willis Redfield: An American Impressionist, 1869–1965: The Redfield Letters, Seven Decades of Correspondence Plus 426 Photographs of His Paintings in Two Volumes*. JMWF Publishing.

Folk, Thomas. 1987. *Edward Redfield: First Master of the Twentieth Century Landscape*. Exh. cat. Allentown Art Museum.

Kimmerle, Constance. 2004. *Edward W. Redfield: Just Values and Fine Seeing*. Exh. cat. James A. Michener Art Museum, Doylestown, Pa./ University of Pennsylvania Press.

ROBINSON

Baur, John I. H. 1946. *Theodore Robinson, 1852–1896*. Brooklyn Museum.

Clark, Eliot C. 1979. *Theodore Robinson: His Life and Art*. R. H. Love Galleries, Chicago.

Johnston, Sona. 1973. *Theodore Robinson, 1852–1896*. Exh. cat. Baltimore Museum of Art.

Johnston, Sona. 2004. *In Monet's Light: Theodore Robinson at Giverny*. Exh. cat. Baltimore Museum of Art.

SARGENT

Adelson, Warren, Donna Seldin Janis, Elaine Kilmurray, Richard Ormond, and Elizabeth Oustinoff. 1997. *Sargent Abroad: Figures and Landscapes*. Abbeville Press.

Hills, Patricia. 1986. *John Singer Sargent*. Exh. cat. Whitney Museum of American Art, New York/ Harry N. Abrams.

Kilmurray, Elaine. 2010. "Sargent, Monet . . . and Manet." In *Sargent and Impressionism,* n.pag. Exh. cat. Adelson Galleries, New York.

Kilmurray, Elaine, and Richard Ormond, eds. 1998. *John Singer Sargent*. Exh. cat. Tate Gallery, London.

Ormond, Richard, and Elaine Kilmurray. 1998–2009. *John Singer Sargent: Complete Paintings*. 6 vols. Paul Mellon Centre for Studies in British Art/Yale University Press.

Simpson, Marc. 1997. *Uncanny Spectacle: The Public Career of the Young John Singer Sargent*. Exh. cat. Sterling and Francine Clark Art Institute, Williamstown, Mass./Yale University Press.

SCHOFIELD

Livingston, Valerie. 1988. *W. Elmer Schofield, Proud Painter of Modest Lands*. Exh. cat. Payne Gallery, Moravian College.

SHINN

DeShazo, Edith. 1974. *Everett Shinn, 1876–1953: A Figure in His Time*. C. N. Potter/Crown Publishers.

Ferber, Linda S. 1990. "Stagestruck: The Theater Subjects of Everett Shinn." *Studies in the History of Art* 37, pp. 51–67.

Wong, Janay. 2000. *Everett Shinn: The Spectacle of Life*. Berry-Hill Galleries, New York.

SPARHAWK-JONES

D'Harnoncourt, Anne. 1976. "Elizabeth Sparhawk-Jones." *Philadelphia: Three Centuries of American Art*. Exh. cat. Philadelphia Museum of Art.

Gurin, Ruth. 1964. Interview with Elizabeth Sparhawk-Jones. April 26. Archives of American Art, Smithsonian Institution.

SYMONS

Handley, Marie Louise. 1913. "Gardner Symons—Optimist." *Outlook* 105 (Dec. 27), pp. 881–87.

Parkhurst, Thomas Shrewsbury. 1916. "Gardner Symons, Painter and Philosopher." *Fine Arts Journal* 34, no. 10 (November), pp. 556–60, 562–65.

TWACHTMAN

Chotner, Deborah, Lisa N. Peters, and Kathleen A. Pyne. 1989. *John Twachtman: Connecticut Landscapes*. Exh. cat. National Gallery of Art, Washington, D.C.

Peters, Lisa N. 1999. *John Henry Twachtman: An American Impressionist*. Exh. cat. High Museum of Art, Atlanta.

WHISTLER

Dorment, Richard, and Margaret F. MacDonald. 1994. *James McNeill Whistler*. Exh. cat. Tate Gallery, London.

Lochnan, Katharine Jordan. 2004. *Turner, Whistler, Monet*. Exh. cat. Art Gallery of Ontario/Tate Publishing.

MacDonald, Margaret F. 2001. *Palaces in the Night: Whistler in Venice*. Lund Humphries.

Merrill, Linda. 1992. *A Pot of Paint: Aesthetics on Trial in Whistler v Ruskin*. Freer Gallery of Art, Smithsonian Institution/Smithsonian Institution Press.

Whistler, James McNeill. 1890. *The Gentle Art of Making Enemies*. William Heinemann.

Young, Andrew McLaren, Margaret MacDonald, and Robin Spencer with the assistance of Hamish Miles. 1980. *The Paintings of James McNeill Whistler*. 2 vols. Paul Mellon Centre for Studies in British Art/Yale University Press.

WIGGINS

Campanile Galleries, Chicago. 1970. *Guy C. Wiggins, American Impressionist*. Exh. cat.

INDEX OF ARTISTS